"Jerry Monkman is a master craftsman of nature photography who has a special talent for describing both the technical and the creative aspects of taking pictures. In this guide, he does a superb job of showing you how to bridge the elusive gap between the science and the art of taking pictures that go beyond snapshots."

—CHRISTOPHER ROBINSON
Editor, *Outdoor Photographer* magazine

"Jerry Monkman is simply a great photographer and teacher. He has a gift for making complex subjects easy to understand, and reading this book is like having a master photographer at your side, coaching you at every step, as you take a comprehensive course in outdoor photography."

—MICHAEL FRYE
Author, *Digital Landscape Photography: In the Footsteps of Ansel Adams and the Great Masters*

"Accomplished nature photographer Jerry Monkman brings us an accessible digital photography guide filled with helpful tips and techniques to use both out in the field and in post-production."

—HEATHER MARCUS
Photo Editor, *Yankee Magazine*

"In the *AMC Guide to Outdoor Digital Photography*, Jerry Monkman shares his many tips and techniques to help us focus on what nature presents to us, through the lens of our own cameras. Editing Jerry's images over the years has shown me that not only does he have a strong bond with nature, but he also communicates that vision to all of us. By capturing the essence of the great outdoors, he's able to open our eyes to the beauty and fragility of nature and demonstrate the importance of protecting it. The ideas and experiences he conveys in this book will give us new tools that we can take into the great outdoors as we venture into our own favorite and unexplored hideaways, using our unique vision and newfound skills to capture a special moment in time."

—DANITA DELIMONT
Agent and CEO, Danita Delimont Stock Photography

"Jerry Monkman is more than just an extraordinary photographer; he is also a passionate explorer of wild places. In his new book, Jerry shares with us the techniques he uses both in the field and in the digital darkroom to create images of nature that speak from the heart. Whether you are just beginning the wonderful journey into nature photography or you are a seasoned pro, this book will prove invaluable."

—JIM CLARK
Contributing Editor, *Outdoor Photographer* magazine

AMC GUIDE TO

OUTDOOR DIGITAL PHOTOGRAPHY

CREATING GREAT NATURE AND ADVENTURE PHOTOS

JERRY MONKMAN

Appalachian Mountain Club Books
Boston, Massachusetts

AMC is a nonprofit organization, and sales of AMC Books fund our mission of protecting the Northeast outdoors. If you appreciate our efforts and would like to become a member or make a donation to AMC, visit outdoors.org, call 800-372-1758, or contact us at Appalachian Mountain Club, 5 Joy Street, Boston, MA 02108.

To provide feedback on any of our books, email us at amcbookupdates@outdoors.org.

Distributed by The Globe Pequot Press, Guilford, Connecticut.

Cover photographs © Jerry Monkman
Interior photographs © Jerry Monkman, except on
 page 173 © Michael Penney
Cover design by Matthew Simmons, myselfIncluded.com
Interior design by George Restrepo, Rest Design

Library of Congress Cataloging-in-Publication Data
Monkman, Jerry.
 AMC guide to outdoor digital photography : creating great nature and adventure photos / Jerry Monkman. -- 1
 p. cm.
Includes index.
ISBN 978-1-934028-50-6 (pbk.)
 1. Outdoor photography. 2. Nature photography. 3. Photography--Digital techniques. I. Appalachian Mountain Club. II. Title. III. Title: Appalachian Mountain Club guide to outdoor digital photography. IV. Title: Guide to outdoor digital photography.
TR659.5.M66 2011
778.7'1--dc23
2011019012

The paper used in this publication meets the minimum requirements of the American National Standard for Information Sciences-Permanence of Paper for Printed Library Materials, ANSI Z39.48-1984. ∞

Outdoor recreation activities by their very nature are potentially hazardous. This book is not a substitute for good personal judgment and training in outdoor skills. Due to changes in conditions, use of the information in this book is at the sole risk of the user. The author and the Appalachian Mountain Club assume no liability for accidents happening to, or injuries sustained by, readers who engage in the activities described in this book.

Interior pages contain 10% post-consumer recycled fiber. Cover contains 10% post-consumer recycled fiber. Printed in the United States of America, using vegetable-based inks.

10 9 8 7 6 5 4 3 2 1 11 12 13 14 15 16

CONTENTS

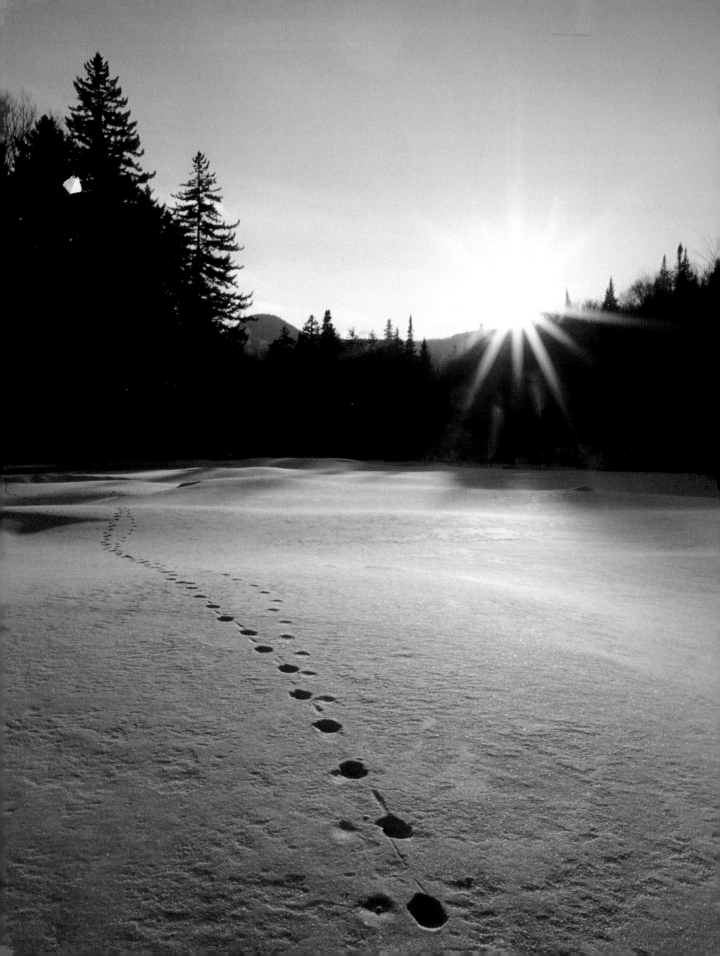

ACKNOWLEDGMENTS

I BELIEVE THAT ANY BOOK CAN SUCCEED ONLY THROUGH COLLABORATION, and while I am credited as the author of this book, I couldn't have seen it through to completion without the help of several other dedicated and talented individuals. First and foremost, I would like to thank my family, especially my wife, Marcy. While she encouraged me to fly solo on this project after co-authoring our previous eight books, she was with me every step of the way, keeping our business, EcoPhotography, running smoothly and keeping our kids happy and healthy as I retreated to my cave of a studio to write. Thank you, Marcy, for your undying support and belief in what I do. I also need to thank my kids, Acadia and Quinn, whose boundless energy and enthusiasm for exploring the world provides me endless inspiration. My mom, Pat, and Marcy's parents, Carol and Jerry Wolin, also deserve a great deal of credit for providing the wisdom and support that allows me to pursue my photographic dreams.

Of course, you wouldn't be reading this book without the hard work of the staff at AMC Books. I would like to thank Heather Stephenson for encouraging me to embark on this project, Kimberly Duncan-Mooney for providing thoughtful and spot-on editorial guidance, and Athena Lakri for helping me navigate the challenges of illustrating this book. I also want to issue a thank-you to the dozens of Appalachian Mountain Club staffers who have helped shape and support my outdoor photography career from its beginning in the mid-1990s. I am grateful to have had such a long and fruitful relationship with the organization.

It's not always an easy task to explain visual concepts in words, so I owe a big thank-you to photographers Bill Campbell, Corey Hilz, Dan Suzio, and Greg Miller (former chair of AMC's New York–North Jersey Chapter) for reading my manuscript and adding their expertise to the tips and techniques contained within the book. They were instrumental in helping to clarify some of the points I was trying to make, and I appreciate the time they volunteered to the project. All are members of the North American Nature Photography Association, a great group of individuals who have played a major role in shaping my career as a photographer. I can honestly say I would not have achieved success as an outdoor photographer without the mentoring I have received over the past seventeen years from countless NANPA members. I thank you all!

Coyote tracks traverse New Hampshire's Ammonoosuc River in winter.

INTRODUCTION

MOST EVERYONE I KNOW TAKES PICTURES OCCASIONALLY, and those of my friends who spend time outdoors tend to take a lot—they can't help it. Close encounters with the natural world can evoke strong emotions and excitement, and photographs are a great way to share that experience with others. For the vast majority of people, simple snapshots do the trick, but plenty of others get the bug that compels them to make more interesting and exciting photos to convey their adventures. It is for the latter group that I wrote this guide, and if you've picked up this book, I assume you are firmly in that camp. Like any good adventure, outdoor photography can be fun, exhilarating, and inspiring, as well as challenging. If you learn the techniques in this book, you will be well on your way to tackling the challenges and successfully making great nature and adventure photos.

My photographic journey began when I was in middle school in northern Illinois. My family lived at the end of a dead-end street adjacent to 2,000 acres of forest preserve, and I took pictures to capture the excitement I felt as I interacted with the natural world all around me. To my 12-year-old mind, nature was exotic, from the white-tailed deer eating our vegetable garden to the ring-necked pheasants I found on the edges of cornfields to the tufted titmice that visited our squirrel-ridden bird feeders. I quickly wore out my little Kodak Instamatic camera and upgraded to a Canon AE-1 before high school. When I saw the richly colored and detailed prints from these bigger negatives, I was hooked for life.

Still, I never considered photography to be something I would pursue professionally. (I majored in business in college and thought I would be managing rock bands!) In my early 20s I moved to New England with my wife, Marcy, and we were immediately drawn to the wilder parts of the region—the White Mountains, Baxter State Park, Acadia. As we explored high peaks and searched for wandering moose, the northern forests of New England were becoming a hotbed of conservation efforts, and my passion for photography was intersecting with my desire to help out with these land-protection initiatives. I bought a pack full of new camera gear and set out to refine my skills, while ignoring as many of my "day job" duties as possible.

This was back in the days before Facebook and Flickr, so I joined a camera club to learn from peers and get feedback on my work. I was immediately struck by how many club competitions were won by photos of western United States landscapes. Sure, they were beautiful, but it seemed to me they were winning ribbons mainly because they featured more dramatic landscapes than those images shot locally. Photographically, they weren't much more interesting, so I made it a goal to capture New England's wild places in a compelling way that portrayed the drama I felt in the landscape. This meant I had to study the nuances of composition and learn how to use light to my advantage. I read a lot of Galen Rowell and every issue of *Outdoor Photographer* magazine, cover to cover. I also took pictures whenever I wasn't working—Marcy and I spent almost every weekend and vacation out on the trails of New England's mountains with our cameras (ah, to be young and full of energy!).

It was great fun and hard work, and eventually my photos started to have the color and dynamic compositions I was striving for. I have been blessed to have made nature and adventure photography my full-time career for the past decade. In 2002, I began leading photo workshops and I soon learned that teaching photography has challenges: How do you nurture and inspire the artists within people when you have to teach them to create their art with technical tools? How do you get the logical and rational left side of the brain to complement the subjective and intuitive right side? Most new photographers are driven by their desire to create, channeling the right side of their brain and excitedly snapping pictures, only to be disappointed by the results because they don't understand the technical problems that doom their photos. By contrast, those with technical prowess get bogged down in doing things the right way, failing to take the chances that can result in truly interesting photos.

My goal in teaching has always been to keep things simple and to encourage my students to develop routines that create enough repetition for the technical aspects of photography to become rote. The best photos come from seeing a story or feeling an emotion in a scene and transforming that story or emotion through your personal vision into something unique. That is hard to do when theories about f-stops, filters, and Photoshop are bouncing around in your head like pinballs. You need to embed that knowledge so you don't have to think about it while shooting.

This book covers the essential techniques that I believe must be mastered to make great photographs, from capturing an image in the field to "developing" that image in the digital darkroom. It is primarily a technical discussion, but hopefully I have made it accessible to even the most right-brained reader. In Section 1,

I outline the basics of the camera gear needed for outdoor photography. Read Section 2: In the Field with your camera next to you—it will make much more sense if you try techniques as you read about them. Since this is book about photographing in the outdoors, I have written Section 3: In All Conditions to help you take advantage of special weather and seasonal situations, while safeguarding your gear in adverse conditions. Section 4: At the Computer details basic workflow and editing techniques using Adobe Photoshop and Lightroom, though many techniques will work in programs such as Aperture and Expression Media. Digital tools have changed the photography process for the better, making it much easier to create a final image that matches your photographic vision. I know that keeping up with changing computer technology can be challenging, so I have focused on those digital darkroom techniques that, once mastered, can be applied efficiently and with excellent results. Section 5: Case Studies looks in detail at 15 images, discussing both the shooting and post-processing techniques that went into making the shot. Throughout the book, I discuss specific brands of camera equipment or software. If it's in the book, I probably use it and like it, and I am in no way affiliated with any of the companies mentioned.

I believe that becoming a good outdoor photographer involves a combination of learning technique and spending as much time as possible in nature practicing your craft. If the weather is good, read a few tips and then step outside to look through your viewfinder. However, if Mother Nature isn't cooperating, settle down with a hot cup of tea or coffee, get comfortable, and start reading. Enjoy!

—Jerry Monkman, 2011

As I START THIS CHAPTER ABOUT photo equipment, I feel a confession is required: I am not a gear-head. I believe that lengthy discussions about topics such as the merits of one camera system versus another can get in the way of what photography is really about: finding and taking beautiful pictures. Tens of thousands of dollars of gear is not required to be a photographer. What is more important is learning to use the equipment you have and developing a style and vision for interpreting the world through photos. I learned this several years ago during a photo shoot at a historical fort near my house, where I was busily shooting away with a 35mm camera and a variety of lenses, only to run out of film in less than an hour because I had forgotten to bring my film bag. However, I had a medium-format camera in my car with a bunch of film, but only one lens. Shooting with only one focal length forced me to look at the fort differently since I didn't have the luxury of changing perspective simply by changing lenses. I had to work harder and out of my comfort zone, and I ended up with what I feel are the best images I've shot of the fort. Of course, I like to keep a variety of equipment with me on most photo shoots, but it's important to think of gear as a tool and not let it become the focus of your photography. My goal with this chapter is to get you thinking about the type of gear you need for the photographs you want to create. I buy a new piece of equipment only if I can afford it and I've been in at least three shooting situations where I felt I needed it.

Photo gear comes in all shapes, sizes, and prices. For the uninitiated, just choosing a camera can be a daunting task. The good news is that almost any new digital camera on the market today can take a decent photo that makes high-quality prints up to 8″ x 10″. The decision of what to buy depends on what your photographic goals and specialties are. Do you plan to make big, exhibition-size prints, or will you mainly make smaller prints or display your images on the web? Do you want to specialize in wildlife, action sports, landscapes, or close-ups? Do you expect to shoot in low-light conditions on a regular basis? Will you be carrying your gear long distances over rough terrain? Determining your goals and specialties, and of course your budget, goes a long way in helping you narrow down gear choices.

In this chapter, I will define some of the terms you will come across when researching gear choices, and describe the different types of cameras, lenses, and other equipment you will need for specific kinds of photography. This chapter is not an exhaustive review of photo gear, but instead a listing of what I find works well for various situations and opportunities. The listing also defines the balance among function, quality, and price. There are great online resources for researching gear that include reviews, user forums, and tutorials. See Appendix A for a listing of these resources.

CAMERAS

I bought my first digital camera in 2004, which was a little later than many of my professional

A kayaker takes a break in Maine's Acadia National Park.

friends. Late that year, two things happened that made me take the plunge. First, Canon introduced the 1Ds Mark II, which was the first digital SLR that produced images that rivaled or surpassed the quality I was achieving with my 35mm film cameras. The second event involved a photo shoot that went awry. I spent three days on an assignment in western Connecticut that involved several volunteer models and for which I shot 30-plus rolls of film. When I had the film processed, every single frame was out of focus because of a mechanical failure in the camera. What was worse was that I could see how good some of the pictures would have been had they been in focus! I had to go back and reshoot the entire assignment with my backup camera, arranging to meet my models one more time. If I had been shooting digitally, I would have noticed the problem immediately when looking at my images on the LCD screen. I ordered my 1Ds Mark II as soon as I got home and have been happily shooting digitally ever since.

Today's digital cameras can be broken down into several categories, from the built-in camera in your cell phone to expensive digital medium- and large-format cameras. I'm going to assume that readers of this book fall somewhere between those two extremes and are using either some kind of point-and-shoot camera or a digital SLR with multiple lenses. SLR stands for "single lens reflex" and describes what we think of as a 35mm camera that has interchangeable lenses. SLRs have a mirror that reflects the light coming through the lens up to the viewfinder. This mirror flips up when you press the shutter button as the shutter—basically a metal or plastic curtain—opens up to expose the film or sensor. (A "DSLR" is simply a digital SLR camera.) When deciding which camera to buy, there are several basic features and specifications to consider:

Sensor Size and Megapixels

These two features are related, with larger sensors generally having more megapixels. A pixel is a point on the sensor that captures picture information, with a megapixel representing 1 million pixels. The more pixels on the sensor, the more information the camera captures with each exposure. With more real estate, larger sensors can contain more pixels than smaller sensors. However, pixels can be different sizes, so as pixels get smaller, camera manufacturers can fit more of them onto same-size sensors. The more pixels crammed onto a sensor, the greater the likelihood that noise—little black or colored specks will be introduced into an image. In general, if two different-size sensors contain the same number of pixels, the larger sensor will produce images with less noise. However, camera makers have gotten pretty good at producing cameras that minimize noise as they increase megapixels. If you anticipate shooting often in low-light situations with high ISOs (ISO refers to the light sensitivity of the sensor), then you will want to invest in a higher-end camera with the biggest sensor you can afford.

Since more pixels capture more information, cameras with sensors that contain more pixels allow you to make bigger prints. For example, the Canon Rebel T3i has an 18-megapixel sensor (5184 x 3456 pixels), which equates to an image file that is approximately 17″ x 11.5″ at 300 dots per inch, or dpi (the standard dpi for inkjet printing). This means it is possible to make prints from this camera up to that size without having to use software to enlarge the image. If you don't expect to make prints any bigger than this, then 18 megapixels should be all you need. If you expect to make larger prints you will want a camera with a bigger megapixel count. However, if you shoot with good technique (good light, proper

exposure, sharp focus) and use high-quality lenses, most digital images can be enlarged to about twice their original size—in this case almost 2′ x 3′—with good results.

Sensor size also affects the effective focal length of your lenses. "Full-frame" sensors are the same size as a piece of 35mm film, so a 50mm lens on a full-frame sensor looks the same as a 50mm lens on a 35mm film camera. "Cropped" sensors are smaller in size, effectively increasing the magnification of a lens, which is determined by using a sensor's "crop factor" (by multiplying a lens' focal length by the camera's crop factor, you get the lens' 35mm camera equivalent focal length). Most DSLRs with cropped sensors have a crop factor of 1.5 or 1.6, though there are some models with crop factors as low as 1.3 or as high as 2.0. A 50mm lens on a camera with a crop factor of 1.5 will effectively be the same as using a 75mm lens with a full-frame sensor.

If you shoot a lot of wildlife or sports action, cropped sensors are a big advantage since you effectively extend the reach of your longer focal length lenses. Of course, the crop factor applies to wide angle lenses as well, so if you often shoot with wide angle lenses (35mm or shorter) you will find that having a cropped sensor reduces the wide angle effect, and you will need to buy even wider focal length lenses like those in the 10mm-to-20mm range—which will look like a 15mm-to-30mm lens on a camera with a crop factor of 1.5.

Cropped sensors also give you more depth of field (the amount of an image, from front to back, that appears in focus) than a full-frame sensor. Again, this can be both an advantage and a disadvantage. If you find you like to shoot with a very narrow depth of field to separate your main subject from the background, you will need to buy lenses with a larger maxi-

mum aperture to get the effect, or buy a camera with a full-frame sensor. Of course, there are other camera options besides SLRs—medium-format cameras with 40+ megapixels on big sensors and point-and-shoots with very small sensors—so in the end, camera decision comes down to what you want to do with your photography and what you can afford.

When choosing a camera, pixel count and image quality should be at the top of your priority list, but there are other features you should consider based on how and what you tend to shoot.

Point-and-Shoot vs. DSLR

Point-and-shoot cameras are self-contained units with one lens built into the camera. They are light and great for anyone who is unwilling, or unable, to carry the extra lenses and other gear that go with a DSLR.

Point-and-shoots can be as small as a cell phone or almost as big as a small DSLR. In general they have much smaller sensors than DSLRs, although many have megapixel counts that rival some DSLRs. Their main advantage over DSLRs is convenience and lighter weight, which makes them excellent for outdoor adventures. The smallest point-and-shoots seem to be falling by the wayside as camera phones match them in quality and features. However, the larger, more robust point-and-shoots can still be a viable alternative for some photographers.

Features to look for in a point-and-shoot include a quality zoom lens with an effective focal length from wide angle to medium telephoto (28mm to 200mm is a good range), a good on-camera flash (and/or the ability to connect an additional flash), a tilting LCD, minimal shutter lag, continuous autofocus (for tracking action), and the ability to shoot in RAW format.

It is possible to do a lot of great, creative

photography with a point-and-shoot, but for most serious photographers, the advantages of a DSLR are worth the extra investment. DSLRs allow much more flexibility when it comes to using different focal lengths or sophisticated lighting techniques. Image quality is usually higher with DSLRs because of their larger sensors, though this may not be apparent in smaller prints. The larger sensors in DSLRs are also better at dealing with noise issues and usually let you shoot at higher ISOs than is possible with point-and-shoots. DSLRs also give better control over depth of field, as the tiny sensors in a point-and-shoot make it very hard to get a narrow depth of field in most shooting situations. In general, DSLRs also have better autofocus performance as well as the ability to shoot multiple frames per second.

LCD. The LCD (liquid crystal display) is the screen on the back of your camera that displays the camera's menu and your images. Look for bigger, high-resolution screens. Some DSLRs also offer tilting LCDs like those found on some point-and-shoots. These are excellent for reducing glare and for shooting at unusual angles when it may be impractical to look straight at the screen. Many DSLRs also have Live View, which means the LCD shows the image preview as you are composing your shot. This doesn't always help in bright daylight, but in lower-light conditions Live View aids in composition and is helpful for zooming in on details in the scene to check your focus.

Frame Rate. Frame rate represents how many frames per second the camera will shoot as you hold down the shutter button. Frame rates range from 2.5 to 10 frames per second. Obviously, higher frame rates are a big advantage when

shooting wildlife and action sports. Related to frame rate is the number of frames a camera can shoot before the frame rate slows down as the camera writes data to the memory card. This is usually called the "continuous shooting rate" and the number will be different depending on whether you are shooting JPEGs or RAW files. The continuous shooting rate is usually much higher for JPEGs since their file size is smaller than RAW files.

Durability. Some cameras can take more of a beating than others. Getting extra durability can cost you anywhere from two to eight times more. More-durable cameras are built with titanium bodies as opposed to plastic, and are sealed against dust and moisture with rubber gaskets around the openings to the electronics on the body (though most aren't waterproof). More-durable cameras also come with shutters that will last longer, usually for 200,000 to 300,000 shutter actuations versus less than 100,000. Obviously, how often you shoot and what conditions you shoot in will determine if it is worth the extra investment for a more-durable camera. I know from personal experience that my Canon 1Ds' bodies have survived falls that would have seriously damaged other cameras.

Size and Weight. If you do a lot of trekking with your camera, its weight can certainly be an issue; however, the lenses you choose to carry are probably a bigger factor. More-durable cameras usually weigh more than their plastic counterparts (though if weight is a serious concern, opt for a point-and-shoot for longer trips). The size and weight of a camera also affect how it feels in your hand, so try a camera in the store before purchasing it so you can determine if its ergonomics fit your shooting style.

Autofocus Capability. Autofocus has come a long way from the days of the camera simply focusing on the center of the frame. Today, photographers can choose from several focus points within the frame and select from different autofocus modes. You can either simply point, focus, and shoot, or you can track a person or animal in action, with the camera constantly adjusting the lens to keep a moving subject in focus. I find that having as many focus points as possible is a big benefit. I also research a camera's ability to autofocus in low light and how well it tracks in continuous focus mode. This ability can vary widely between camera models, so read camera reviews and specifications before making your purchase if these features are important for the type of shooting you plan to do.

High-ISO Performance. In general, shooting at lower ISOs results in images with less noise (similar to film grain). But in lower-light situations it is often necessary to increase a camera's ISO in order to capture an image that is not blurred due to camera or subject movement. All digital cameras give you the ability to change ISO depending on light conditions. Minimum ISOs range from 50 to 200 on most models, but the high end can vary from ISO 800 on point-and-shoots to 128,000 on some of the newest DSLRs. If you expect to shoot often in low-light situations where you need to use ISO 800 or higher, make sure to buy a camera that handles noise effectively at these higher ISOs. Most DSLRs handle noise well at ISO 800, but there is a lot of variability between camera models in noise performance at higher ISOs. (Noise can also be dealt with in post-processing, which I describe in Section 4.)

Mirror Lockup. As I mentioned at the beginning of this section, SLRs have a mirror that is used to reflect the image up to the viewfinder, and which must move out of the way when the shutter button is pressed so that light can reach the camera's sensor. At slow shutter speeds (generally 1/15 second to 1/4 second), the vibration caused by the mirror flipping up can cause enough camera shake to blur your photo, even when you're using a tripod. To avoid this, some cameras have a feature called mirror lockup, which allows you to lock up the mirror before exposing your image, therefore removing the possibility it will cause vibrations during exposure. If you plan on shooting landscape scenes at slower shutter speeds, look for a camera with this feature.

LENSES

Choosing the lenses you shoot with is just as important as choosing a camera body. While pixel count, sensor size, and sensor quality have a big effect on image quality, lenses greatly affect the quality of the light hitting that sensor, determining the color, contrast, and sharpness of your image. Individual lenses can easily cost more than your camera, so budget is also a big consideration. In addition to budget, there are several factors to consider when buying lenses, including maximum aperture, focal length, zoom versus prime, image stabilization, and manufacturer.

Maximum Aperture

In general, lenses with a larger maximum aperture (or f-stop) will provide higher-quality images than those with a smaller maximum aperture. For example, a lens with a large maximum aperture like F2.8 will create better-quality images than the same focal length with a maximum aperture of F5.6. This higher quality comes from the lens having a larger diameter, which reduces the amount of light distortion that occurs around the edges of the frame. Having the

choice of shooting at a larger aperture also gives you the ability to shoot more narrow focus images, as larger apertures have less depth of field than smaller ones. They also allow you to shoot with faster shutter speeds or lower ISO settings. Lenses with larger maximum apertures will also be much bigger and heavier than smaller-aperture lenses because they need a bigger front element to let in enough light to shoot at the bigger aperture, so weight may be a consideration in addition to price when making this decision.

Focal Length

Most photographers carry several lenses of different focal lengths to shoot close-up and distant subjects, as well as to shoot with different perspectives (see "Lens Choice and Perspective" in Section 2). I love to shoot both adventure and landscapes with wide angle lenses ranging from 14mm to 35mm (remember to apply your crop factor to these numbers if you are using a cropped sensor). Anything wider than 24mm creates optical problems such as edge distortion and line curvature, so most lenses in this range are now made with "aspherical" designs to compensate for this distortion; those that aren't produce a fish-eye effect. Wide angle lenses are usually smaller and easier to hand-hold than lenses with longer focal lengths, but I still like to buy wide angles with a maximum aperture of F2.8 or bigger to have that extra stop of light when I need it.

I also regularly use longer focal lengths (up to 300mm) to pick out details in the landscape or to isolate a main subject such as an animal or hiker. Longer lenses are inherently bigger and heavier than wide angle lenses, so they usually require the use of a tripod. Really long focal lengths (300mm and higher) are almost always too big to effectively hand-hold and are primarily used for shooting wildlife or sports when it

is unsafe or impractical to get close to the subject. When investing in a wildlife lens, consider how close you will need to get to make your potential subjects big enough in the frame (e.g., you'll want a longer lens for shooting birds than shooting moose), and then consider if your budget—and your back!—can afford it. Most cost several thousand dollars.

Zoom vs. Prime

A prime lens has a fixed focal length, while zoom lenses let you vary your focal length by twisting or pulling the lens barrel. On average, prime lenses have a higher image quality than zoom lenses, but many modern zooms are of a quality that rivals prime lenses; most pros use a variety of zoom lenses because of their convenience and the weight advantage of not having to carry a bag full of primes. Like many factors in digital photography, the quality differences between zoom and prime lenses usually aren't noticeable until you start making very large prints. Today, primes are used mostly for specialty purposes: very long lenses for sports and wildlife; dedicated macro lenses for close-ups; tilt-shift lenses for architectural photography; fish-eye lenses to create distorted, hemispherical images; and large, maximum-aperture, medium focal length lenses for portrait work.

I use three zoom lenses for 90 percent of my photography: 16mm to 35mm, 24mm to 70mm, and 70mm to 200mm. The zoom ranges for these lenses are relatively small. In general, I shy away from bigger zoom ranges because they show more quality issues than the smaller range zooms. However, they are a good option when traveling with several lenses is not practical or when your budget doesn't allow buying several lenses. The prime lenses I use are a 500mm lens for shooting wildlife and a 100mm macro lens for

close-up work. Five may seem like a small number of lenses for a professional photographer, but I've used this combination for more than a decade and rarely have I found myself needing an additional lens.

However, I also own a pair of teleconverters to supplement my 500mm and 70mm-to-200mm lenses. These are small magnifiers that mount between the lens and the camera, and they multiply the focal length of the lens either 1.4x or 2x. These are great for getting more reach with telephoto lenses without having to invest in a larger lens. They do reduce quality a bit and can also affect the autofocus capabilities of a lens, but they are a small and relatively inexpensive way to extend the reach of your lenses. When buying teleconverters, choose them to match your lens. For example, if you have a Canon 500mm lens, buy the Canon teleconverters meant to work with that lens. You will usually achieve better results that way.

Image Stabilization

Most longer focal lengths, and some wide angle lenses, are now manufactured with built-in image stabilization or vibration reduction, which attempts to reduce blurring due to camera movement. With image stabilization, you can shoot sharp photos with shutter speeds that are on average two to four times slower than is possible on a non-stabilized lens. (This reduces the blurring effects of camera movement only, not subject movement.) This is especially helpful when hand-holding in low-light situations with long lenses, as they can be hard to hold steady because of their size and weight.

Image stabilization on most newer lenses can also be used effectively on a tripod, where the high magnification of very long lenses can show camera shake even with relatively fast shutter speeds, such as 1/125 or 1/60 sec-

ond. If you plan to use image stabilization on a lens mounted on a tripod, be sure it is designed to be used that way, and realize that some lenses have a separate mode for tripod use.

Manufacturer

The major DSLR manufacturers (Canon, Nikon, Olympus, and Sony) also produce a wide variety of lenses to go with their cameras. Each camera make uses a different mount, so, for example, Nikon lenses won't work on Canon cameras, or vice versa. Several third-party manufacturers also produce lenses for DSLRs, most notably Sigma, Tamron, and Tokina. Third-party lenses are usually up to 50 percent cheaper than the lenses made by camera manufacturers. There is a lot of variability in quality between manufacturers and even within a specific product line. All lens makes have a line of "pro" series lenses, which typically have larger maximum apertures, better weather sealing, and more-durable construction than their "consumer" series lenses.

I usually buy lenses with bigger apertures and higher durability when I can afford them. However, when I need to watch my budget, I won't hesitate to buy a consumer series lens or a lens by a third-party manufacturer, as the image quality on many of these lenses is excellent when you are shooting at middle-range apertures like F8 or F11. You do sacrifice image quality at other apertures with these lenses, but if that's all you can afford, there's not much you can do. Some of the forums and review sites listed in Appendix A are great places to research lens purchases and find the best value for what you can afford.

MEMORY CARDS

Unless you are shooting with your camera connected to a computer, you need a memory card to store images in the camera. There are a variety

of formats, but most DSLRs use either compact flash cards or Secure Digital (SD) cards. When purchasing memory cards, consider two factors: data capacity and data transfer rate. Data capacity determines how many photos you can store on a card. How much capacity you need depends on how much you shoot on average before downloading images to your computer. I have several 4 GB and 8 GB cards that I bring on any shoot, giving me the capacity to shoot several thousand images before I run out of memory.

Data transfer rate determines how fast your camera can transfer images from the camera's memory buffer to the memory card. If you do a lot of continuous shooting of wildlife or action sports, purchase cards with a higher transfer rate. In general, a transfer rate of 30 mb/s (megabits per second) can keep up with most cameras, though 60 mb/s or 90 mb/s is advisable for cameras that have a very high continuous frame rate or if you are often shooting in movie mode. However, not all cameras have the electronics to take advantage of faster cards, so review your camera's specifications to determine if you need to spend the extra money on faster memory cards. Faster cards also allow you to download images to a computer faster, which can be a factor if you shoot in situations where you have to process a lot of images quickly.

As for reliability, the solid state flash memory in memory cards is much more reliable than the disc in a hard drive or optical media such as a DVD or CD. Still, some card manufacturers have a reputation for producing cards with higher reliability. I have been using SanDisk memory cards since I started shooting with digital cameras and I have never had a problem with a card being corrupted or losing data. Other reliable manufacturers are Lexar and Delkin.

FILTERS

Back in the film days, photographers often carried a separate bag of filters for special effects or to balance color. Since different types of film were optimized for different light (daylight, tungsten, fluorescent, etc.), filters were needed to compensate for the difference between the actual light and the color balance of the film. Since digital cameras compensate for the color of light with the white balance setting, these filters are no longer needed. The same is true of special-effects filters, since many of these effects are easily accomplished with software.

I carry only a handful of filters today: a polarizer, two graduated split neutral density filters (or grad filters, for short), and a variable neutral density filter. These are explained in more detail in Section 2. While the effect of grad filters, which darken only the top portion of an image, can be accomplished in the computer, I find it is usually much easier to use the filters in the field. The polarizer and variable neutral density filters have properties that can't be easily replicated in postprocessing and thus must be used in the field.

Like lenses, filters vary in price and quality. I opt for the highest-quality filters since a cheap filter can easily turn your $500 lens into a mediocre piece of glass. When buying polarizers, I like those made by B+W. For my grad filters I use both Singh-Ray and Lee. For variable neutral density filters, Singh-Ray is the current industry standard.

Most camera store employees will suggest you buy a skylight or UV filter to use as a layer of protection over your lens. These filters don't alter the look of an image much, if at all, but using a low-quality version can compromise your image quality. I don't use these filters because I want the highest image quality I can get, but if you're accident prone they might be a good idea.

Instead, I carry insurance on my equipment that covers accidental damage.

Filters are either circular and screw onto the front of your lens or they are square or rectangular, requiring the use of a filter holder that screws onto the lens. I suggest buying the rectangular grad filters with a filter holder because then you can easily adjust where in the frame the gradation occurs. Otherwise, either option works fine. If you have lenses with different-size front elements, buy a separate filter for each lens or use "step-up" rings, which go between a filter and your lens, changing the size of the filter to match your lens. I don't recommend using step-up rings on wide angle lenses, however, as they place the filter farther from the lens, resulting in images with vignettes (dark corners). With very wide angle lenses (20mm or shorter), even without a step-up ring you may need to buy special thin mount filters to avoid vignetting.

TRIPODS

I try to use a tripod for almost all of my photography. (The one exception is when I'm shooting action sequences and I need to be more mobile.) Using a tripod serves two purposes: keeping the camera still to avoid camera shake and blurry images, and giving you the opportunity to study a composition without the camera moving. In my workshops, I inevitably have a couple of students who are completely opposed to using a tripod because it takes more time or they don't want to carry the extra weight, but I convince almost all of them to use one by the end of our sessions. Tripods are absolutely necessary to achieve sharp images when shooting at low ISOs and small apertures, because this usually means shooting at shutter speeds slower than 1/60 second. And taking the time to slow down and really study your compositions translates into more precise

and meaningful photographs.

Tripods are composed of two parts, the legs and the head, and you will probably want to buy them separately based on your shooting needs. A tripod's legs provide the stable base you need to dampen any camera vibrations. Outdoor photographers use a variety of brands, most commonly Manfrotto, Gitzo, Induro, Feisol, and Slik. Most brands offer both aluminum tripods and those made of lighter-weight carbon fiber. Carbon fiber tripods are a great choice for outdoor photographers because they are easier to carry for long distances, but in general a heavier tripod will do a better job of dampening camera vibrations. Though pricey, I love Gitzo carbon fiber tripods because the leg clamps are easy to operate and they are lightweight, yet sturdy enough to keep my images sharp.

Buy a tripod that can be extended to be tall enough so you can look through the camera without having to stoop over. This is better for your back, and it also gives you the opportunity to maximize the height of the camera when compositions require a high camera angle. Some tripods come with a center post that you can use to raise the camera higher than is possible just by extending the legs to their maximum height. However, I suggest not using the center post because it diminishes the ability of your tripod to keep your camera steady. Make sure your tripod extends high enough without the center post.

I also like a tripod that lets me get my camera as close to the ground as possible, such as those without a center post and with legs that can be adjusted to lie flat. This means the camera is just a few inches off the ground, which is helpful for both macro photography and landscape photography when a low camera angle is preferred. Some tripods have a center post that can be moved horizontally as well as vertically, al-

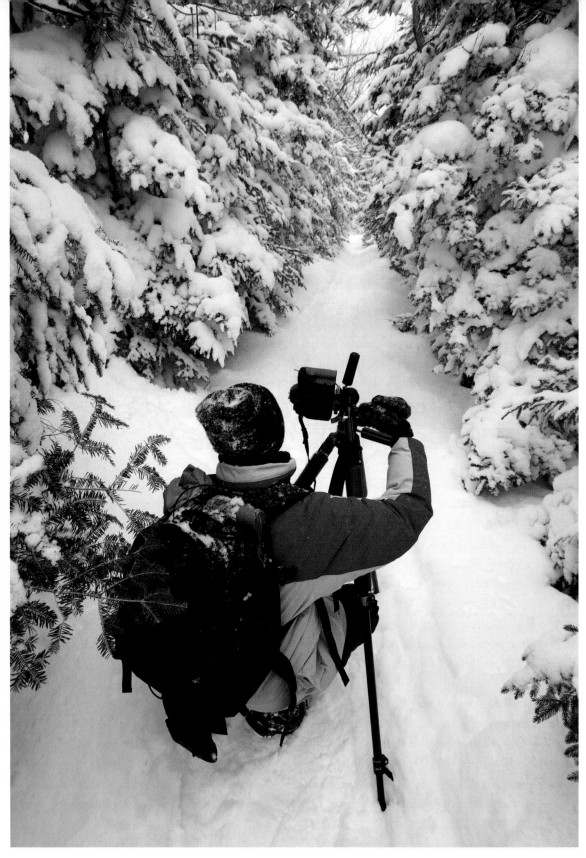

A photographer sets up his tripod on a snowy trail.

lowing you to position your camera lower to the ground. (Benbo makes the most popular of this type of tripod.) These tripods give you more options than a standard center post, but they won't be as stable as tripods without the center post.

While a tripod's legs provide support, the head is where you attach the camera and what you use to move it around when composing an image. There are several styles of tripod head, but most photographers use either a tilt-and-pan head or a ball head.

Ball heads are great for outdoor photography, as they let you easily move your camera in any direction and lock it in place. Ball heads come in different sizes, with smaller heads being able to support less weight than bigger heads. When shopping for a ball head, make sure it is rated to support the heaviest camera and lens combination you expect to use. The major ball head manufacturers are Kirk Photo, Arca Swiss, and Really Right Stuff. I have been using Kirk ball heads for years, primarily the BH-1 model, which easily supports all of my lenses from my 16-to-35mm zoom to my 70-to-200mm zoom. It also works with my big 500mm lens, but for shooting wildlife and action with a big lens I use a different head called the Kirk King Cobra, which is like a curved metal arm that makes it easy to rotate the big lens and follow wildlife. A similar popular wildlife lens head is made by Wimberley.

When choosing a tripod head, look for fluid movement so it is easy to change your camera position quickly. Also check that when you lock the head in place it holds your camera and lens without drifting or slipping. If it can't lock in place, you need a sturdier head.

All of the ball heads listed require you to attach a quick-release mounting plate to the bottom of your camera (or lens if it has a tripod collar that allows you to mount the lens to the tripod), which you then mount on the head. Mounting plates make it quick and easy to mount your camera and eliminate the chance that your camera will come unscrewed from the tripod. You can also buy L-shaped quick-release brackets that let you mount your camera in a horizontal or vertical orientation. This makes it easier for the head to keep your camera steady when you're shooting verticals.

If you are reluctant to carry a tripod, borrow one for a few photo outings and get a feel for using it. I believe it will have a positive impact on your photography.

LIGHTING

During a recent photo shoot I did for New Hampshire's state parks, I was photographing a climber on a large boulder set in a forest of tall pines and hemlocks. I was able to position myself on the boulder to create a dramatic view of the climber clinging to the rock with the forest in the background. Unfortunately, the sun was shining through the trees behind the climber, which meant his face was in dark shadow. If I had moved to the other side of the rock so that his face was in direct sunlight, I would have lost the dramatic view. The solution was to stay put and use a flash that would illuminate the climber without overexposing the background. It was a challenge to stand on the rock while holding a camera and the flash, but I wouldn't have gotten the shot if I had relied on natural light.

While most outdoor photographs are lit by Mother Nature, there are times when a photo can be improved by adding light with a flash or reflector, or by softening existing light with a diffuser. Many cameras come with a built-in flash, and these can work fine in some situations when you need to add a little light to bring out shadow detail in a subject close to the camera.

However, sometimes you need a more powerful flash, which means buying a separate flash head that attaches to the camera directly on a hot shoe (the grooved connection on the top of a SLR) or with a sync cord. A sync cord is a wire that connects to your camera's hot shoe on one end and your flash on the other. I prefer using a sync cord because I can vary the angle of light coming from the flash so that it looks more natural.

Camera manufacturers make proprietary flash units that work best with their cameras, but you can also buy third-party flashes that are usually cheaper and work just as well. Popular third-party flash manufacturers are LumoPro, Metx, Photoflex, and Sunpak. Unless you aspire to shoot outdoor fashion features, you won't need extremely powerful flash units or to sync up multiple flashes. The main feature you will want your flash to have for nature and adventure photography is manual control. This will allow you to manually adjust the flash output so you can better balance the flash's light with the natural light. In addition to a sync cord, you may want to add a flash bracket to your camera bag. A flash bracket mounts the flash off to the side of your camera so you don't have to hold it.

Reflectors do what their name suggests: reflect light. Reflectors usually have a rigid or semirigid frame that holds a reflective material in place. You then hold the frame and position the reflector so that it reflects light toward your subject. Reflectors can be a matte-white material or a shiny, metallic material that is gold or silver. These different options let you vary the quality and color of light that is being reflected. Collapsible reflectors fold down into smaller packages for carrying. I find the standard-size reflectors too big to bring with me on longer outings, even when collapsed. On those excursions, I usually carry a small pocket reflector, which folds down to a disc about 3 inches across. These won't necessarily help much with big subjects, but they work great for close-up photography.

A 5-in-1 reflector kit comes with a set of sleeves (gold, silver, white, and black) that fit over a translucent frame. The translucent frame is actually a diffuser that you hold between the light source and your subject to soften the light. Diffusers are excellent for improving the harsh light of midday when doing close-up photography.

PACKS AND HARNESSES

Unless you photograph with a point-and-shoot that can easily fit into a side pocket of a day pack or backpack, you will need some way to carry all of your gear. A camera bag serves two purposes: to protect your camera and lenses from the elements or from being damaged in a fall, and to make it easy and comfortable for you to carry your equipment. There are three basic types of camera carrying systems for outdoor photographers: backpacks, waist packs, and harnesses.

Backpacks and waist packs will seem very familiar to the outdoor adventurer. They are similar to what you are probably already using to carry your clothing, food, tent, and other supplies when traveling in the outdoors, except that they are well padded to protect your camera gear. When shopping for a pack, make sure it will easily accommodate your camera, lenses, and accessories, and try it on, fully loaded, to confirm that it fits your frame well and will keep you as comfortable as possible over the long haul. The other feature to look for is a rain cover. Many packs have one attached to the pack, stored in a pouch on the outside bottom of the pack where it can be easily reached in bad weather.

I opt for a waist pack when hiking long distances, because I can still carry another backpack for my food, jacket, and any other gear I may

need. By keeping my photography essentials in the waist pack, which I turn around so that it is in front of me, I can readily grab my camera and start shooting without even taking off my pack. I can't carry all of my gear in a waist pack, so I store less frequently used items in my backpack or leave them at home. Since waist packs don't offer as much support as a backpack, I have to limit the amount of gear in my waist pack to avoid straining my back.

On shorter outings when I want to have all of my gear accessible, I use a larger camera backpack. These packs let me bring all the gear I need for a shoot in one bag. If you have a lot of gear, make sure your camera backpack has a good support system, including a waist belt and sternum strap to help stabilize the pack and distribute its weight among your shoulders, torso, and waist. Some photographers like to use shoulder bags, but I find these impractical for outdoor photography when hiking long distances over uneven terrain. (For camera packs, I prefer those made by LowePro and Clik Elite.)

Harness systems use a lightweight harness that goes over your shoulders and hugs your torso. Some models let you attach your camera directly to the harness, while others have pouches that contain your gear. Harnesses aren't as good at protecting your gear from the elements, but they are very useful for action photography—you can have your camera ready at all times while actively hiking, skiing, or paddling. You will probably still want a backpack to carry most of your gear for when the weather turns. For ease of access, a harness is much preferable to just hanging your camera around your neck, as it keeps your camera snug against your body, easing neck strain and keeping the camera from banging into rocks and other objects.

Remember: Try a pack, loaded with your gear, before purchasing it. Camera bag makers excel at making packs that fit all of your gear into nice little compartments, but packs vary widely when it comes to comfort and fit. Not every pack is going to fit your frame well and it is difficult to determine how comfortable a pack will be until you try it on.

In addition to using a pack or harness, many photographers like to use a photo vest with big pockets on the front, which makes it easy to have a variety of gear easily accessible. Vests also distribute the weight of your gear well, putting less strain on your back and shoulders. In situations when only a small amount of of gear is required, using a vest and leaving your pack in the car is a comfortable and viable option.

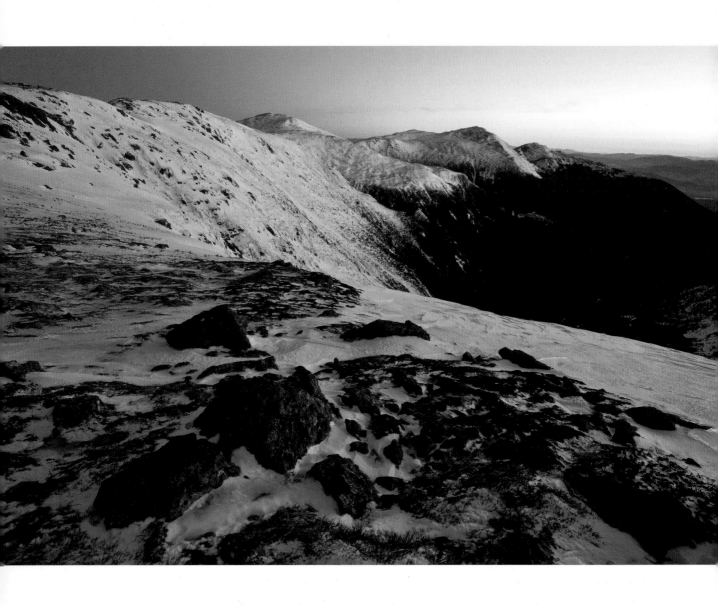

SECTION 2 ▶ IN THE FIELD

IT WAS COLD, ABOUT 4 DEGREES ABOVE ZERO, but I was feeling warm and toasty after three hours of hiking from the valley floor to the northern shoulder of Mount Washington in New Hampshire's White Mountains. Deep orange and blue hues filled a cloudless, predawn sky. The high-elevation silence was interrupted only by the sounds of my breathing and the clicking of crampons on the ice. My two hiking companions and I reached our destination at the top of the Great Gulf headwall about twenty minutes before sunrise. There was only a breath of wind. Looking through my camera's viewfinder, I searched for some interesting foreground rocks and set up a composition in which the rocks and ice dropped away to a breathtaking view of the Northern Presidentials perched above the drama of the largest glacial cirque in the Northeast. With great scenery and light, the resulting photos were relatively easy to make—being in the right place at the right time and having mastered the basic skills translated into great photos. Outdoor photographers strive to find moments like these. After all, most of us are nature photographers because we love being in nature. Although spending time in front of a computer helps us create finished pieces of art, it all starts with getting out there in the real world and taking pictures.

If you are like most nature and outdoor photographers, you turn to photography as a way to share the beauty of what you encounter in the natural world. You bring along your camera on adventures and snap photos from scenic overlooks and mountain summits, feeling awe at the scene in front of you. The drama of these places usually makes for pretty pictures regardless of the skill of the photographer, but often these photos replicate postcards, lacking the emotion found in great images (this still happens to me regularly). A lot of things conspire against you as you try to capture a scene in a compelling way, even when the result is sharp and properly exposed. At a basic level, most of the less-inspiring photos I see are a result of unappealing light and a poor understanding of composition combined with the lack of an obvious story or subject with impact. The causes of these problems are rela-

tively easy to learn and avoid. More challenging is taking your photography to the next level by developing your own style and vision through the use of different lenses, perspectives, depth of field, and subject matter.

In this section, I will explain the technical aspects of shooting, from exposure and composition to the use of filters and tripods. Once you understand these skills and techniques, you will undoubtedly see an improvement in your photography. But to find your own vision and style, you need to practice these skills over and over. Find a place close to home where you can shoot and learn the difference between shallow or deep depth of field, how to use a graduated split neutral density filter, or how to read a histogram to get a perfect exposure. That way, when you are in an exotic locale and the light is fading fast, you can concentrate on capturing your vision of the

By hiking to my shooting location about 30 minutes before sunrise, I was able to take this photograph when the light was as dramatic as the landscape.

scene as opposed to figuring out the technical aspects of shooting. In those fleeting moments, you need to focus on making the best image possible and what story you want to tell, not how to take a picture.

TUNING IN TO YOUR SUBJECT

At the risk of sounding like a New Age guru, I am now going to encourage you to "tune in to your subject" to make better pictures. For me, understanding your subject matter is just as important, and in some ways more important, than understanding the relationships among f-stops, shutter speeds, and ISO, or how to add a layer mask in Photoshop. My best pictures usually are taken in places I know well and have spent more than a day or so exploring. This is particularly true for outdoor photography, where I don't have control of a scene like I do in the studio. Before I ever take a picture, I usually make a point to take the following steps in order to improve my chances of turning that great image into a photograph.

Research and Previsualization

Before going on a photo shoot, I spend as much time as possible learning about the location to improve my chances of being in the right place at the right time. I read guidebooks about the region to get a feel for the habitats I might find and to learn the locations of streams, waterfalls, and overlooks. I'll also read about the nature of the region. This helps me notice natural history stories that I might otherwise pass by, whether they be rare flowers, unusual tidal influences, or even just what type of forest I can expect to encounter.

Many of my assignments are in locations that are not big tourist draws, so I have to rely on other sources of information, including talking to someone familiar with the area or searching image databases online. Any tidbits I can glean

ahead of time regarding potential scenic views, wildlife, flora, or stands of big trees can make or break a photo shoot, especially when time is limited. Then I'll pore over topographical maps of the area to look for other potential "hot spots."

All this research leads to planning a shoot, using what Ansel Adams called "previsualization." Whether going to a familiar location or someplace new, I create a short list of images I think I can make based on what I know about

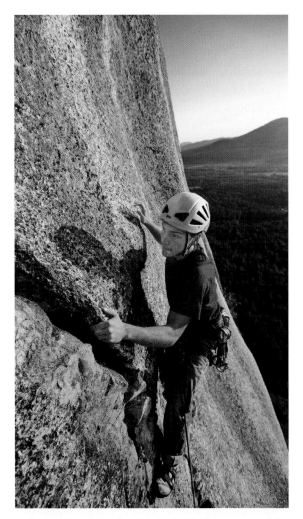

This photo of a climber on Cathedral Ledge in New Hampshire's White Mountains required planning and previsualization. The cliff faces east, so I met the climbers at first light so I would be able to photograph in low-contrast, low-angled light. Later in the day, the cliff would have been in the shade or in harsh, mid-day light.

the place. For me, this list always includes a big view that can serve to set the base of a story about the location. My list also includes medium and close-up shots of what my research indicates might be encountered, such as waterfalls, forest scenes, wildlife, flora, or images of people enjoying the wilderness. In addition to identifying subject matter, previsualization also involves determining the type of light that will best represent that subject matter and planning the best time for capturing the ideal light. This might mean I have to be on the trail before sunrise, and I have to know how long it will take me to get to my shooting location, leaving enough time to set up my composition (see the "Exposure" section on page 37).

Of course, the risk of previsualization is that you can be so focused on getting the shot you envisioned, you don't pay enough attention to other photo opportunities that you stumble upon. This brings us back to the idea of balance. Have a plan, but be open to the possibility of adjusting that plan to take advantage of serendipitous moments.

Participating in the Landscape

All outdoor photographers owe a debt to Ansel Adams and the way he defined landscape photography, and I'm no different. However, Galen Rowell was my biggest influence. He was one of the twentieth century's greatest mountaineers and outdoor photographers. When I started my career in the early 1990s, I read with great interest several of his books on photography, including *Mountain Light* and *The Art of Adventure*, and eagerly awaited each new column he wrote for *Outdoor Photographer* magazine. Rowell believed in being at the right place at the right time to shoot great subjects in great light. He espoused "participating in the landscape" to make better outdoor photographs.

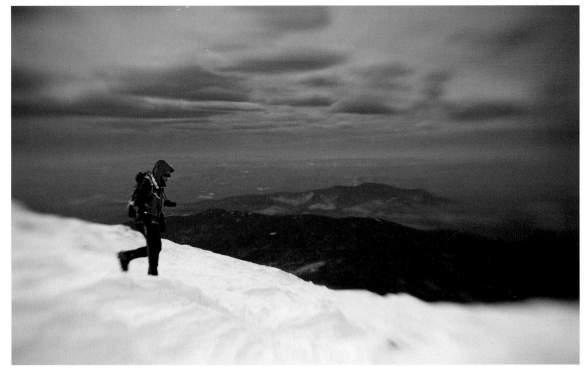

A photographer hikes through the wintry landscape of Mount Washington, participating in the landscape

The best nature and adventure photographers don't make great photos by driving up to the Scenic View sign and snapping off a few photographs. They get to know a place through research and then by getting out in it. You don't need to climb K2 or scale El Capitan like Rowell did, but you definitely need to get away from your car and walk, bike, or paddle through the landscape. You'll get to know a place better and leave behind thoughts of work, chores, or finances that can muddy your thinking and sap your creative energies.

If you find yourself out in wilderness, but nothing seems worthy of shooting, take a break. Find a good rock to sit on, eat a snack, drink some water, or even take a nap (you're probably tired from getting up at 4:30 A.M. for that sunrise hike anyway!). Stop, look, listen, and let your mind tune in to your surroundings. You will start to notice the little things, and even if that great scenic image isn't calling to you, you'll stand a much better chance of finding something else interesting and photo-worthy.

Tell a Story

Okay. If you've done your research, made some previsualizations, and you're out participating in the landscape, pretty soon you will get the urge to take out your camera. Before wildly shooting (using all the techniques I'll soon be describing), take a moment to think about why you want to take a picture. What is the story you want to tell? What excited you? Why did you get out your camera? When deciding on what lens and depth of field to use, and whether or not to use a filter or a particular shutter speed, think about your story and how your photo will tell that story. Your subject—and therefore the story you are telling—needs to be emphasized by the light, by its size in the frame,

and by its relationship to the rest of the scene.

For instance, when photographing a flower, do you want to shoot a tight close-up to highlight the subtle details of the flower, or do you want to use a wider angle lens and show the flower in its natural habitat? Both can make nice photos, but they tell different stories. Similarly, when photographing a climber high on a cliff, do you want to emphasize the facial expression or climbing techniques of the climber with a tightly cropped photo, or do you want to accentuate the size of the cliff, by making the climber a smaller element in the photo? Of course, you can take both photos, but by taking a moment to identify the type of story you want to tell, you can focus on making the appropriate images for that story. This will result in photos with more impact and eliminate those uncomfortable moments of explaining to someone what your photo is about.

In addition to the subject matter, think about the emotion of the photo and how it will be depicted. The mood in a nature or adventure photo could be quiet or energetic, subtle or dramatic. You express moods in your photos by stopping or blurring action; emphasizing bold or muted colors; and using strong, colorful light or quiet, diffuse light. Making a good photo with a great story that imparts emotion is a challenging exercise, but thinking about what you are trying to accomplish will go a long way to helping you decide which photographic techniques to use in order to achieve your goal.

COMPOSITION

You are now tuned in to your subject (the "participating in the landscape" part is fun, isn't it?). When it comes time to actually set up your outdoor photo, the first step is usually creating the composition. I'll explain exposure, filters, tripods, and other aspects a little later in this section, but

Both of these photos depict hikers, but they have very different moods and stories. Before taking your photos, think about the story you are trying to tell and use the appropriate techniques to emphasize that story.

By moving the horizon line of this photo (original, above) closer to the top of the frame, I expanded the foreground, which added sufficient depth to the image to better convey the feeling of open space (right).

those topics are technical and fairly easy to master. By contrast, composition mixes technical skills with creativity, which is a bigger challenge and one that all photographers face no matter their experience or skill level. Composition requires you to decide not only what to include in your photo and where in the frame to place your main subject, but also how that subject sits in relation to the rest of scene. Composition is affected by your physical proximity to the scene, which lens and perspective choices you make, where you focus, and what depth of field you choose. The following compositional techniques can help you overcome one of the fundamental challenges of photography—taking a scene that you see in three dimensions and translating it into a simple, yet compelling two-dimensional photo.

While I'll mention a couple of composi-

tional rules, you are by no means obligated to follow them. Use them to help you when you first start composing a scene, but also use your instincts to decide what looks best for emphasizing your main subject and imparting the mood you envision for your photo.

Simplify

A simple, distraction-free image that boldly emphasizes your subject is the goal of your photograph. Pay close attention when you are deciding what to feature in your composition and remember what you are excited about when composing the scene.

Nature is a messy, three-dimensional space, and while your brain can concentrate its attention on your main subject, the camera can't do that on its own. Not only will it capture that

beautiful lady's slipper in the foreground, but it will also record the jumble of branches from a downed tree off to the side or the power lines overhead. As the photographer, you are responsible for every millimeter in the image frame. If there is something in the frame that steals interest from your main subject, your job is to eliminate this distraction from your image. Always take the time to scan the edges of your viewfinder for things that don't belong, including wayward tree branches, candy wrappers, or even your own or your tripod's feet. For most images, simple is better. Think "Less is more."

Balance, Dominance, and the Rule of Thirds

Simplifying a composition is a good first step, but you also need to arrange a photo's elements in a way that creates visual interest. Where you place objects in a composition determines a photo's balance and plays a role in defining scale and the dominant element in a scene. The easiest technique to employ when composing an image is the rule of thirds. For centuries, visual artists have been using the rule of thirds to add tension to their work, creating a dynamic feel that is lost when the main subject is perfectly centered. Centering your subject may expertly reveal its entirety and make for perfect balance, but it conveys a static feeling that lacks movement or emotion. The rule of thirds is a good place to start when trying to add visual excitement to an image. It creates an asymmetrical balance, forcing the viewer to visually explore a photograph and notice more of its details.

To employ the rule of thirds, simply imagine that your viewfinder has four lines that divide the frame into thirds, both horizontally and vertically,

▷ TIPS FOR SIMPLIFYING A COMPOSITION

Besides recomposing to remove distracting elements, there are several other techniques that help simplify a photo:

1. Move closer to your main subject, either physically or by using a telephoto lens, so that your subject fills more of the frame and there are fewer competing elements.

2. Use a shallow depth of field if background elements prove distracting but you cannot position your camera in a way to eliminate them from the frame. You can selectively focus on your main subject, causing the rest of the image to remain out of focus. This works particularly well with people, wildlife, and flower close-ups, as your main subject will seem to pop out of the out-of-focus background. Of course, your main subject should be very compelling if it is the only part of your picture that is in focus.

3. Pan your camera to achieve a similar effect with a moving subject. For example, when photographing a mountain biker on a forest trail, use a slower shutter speed (the length of time a camera's sensor is exposed to light), such as 1/30 second, and follow with your camera as the biker rides past you, shooting all the while. The image of the biker will be relatively sharp while the potentially distracting trees in the forest will blur into a nice colorful background that complements and emphasizes the biker's movement.

4. Capture your main subject as a silhouette by using backlight (in which the main light source is located behind your subject.) This works well if your backlight has a lot of color, like at sunrise or sunset, but your main subject needs to have a very distinct shape since it won't show any detail.

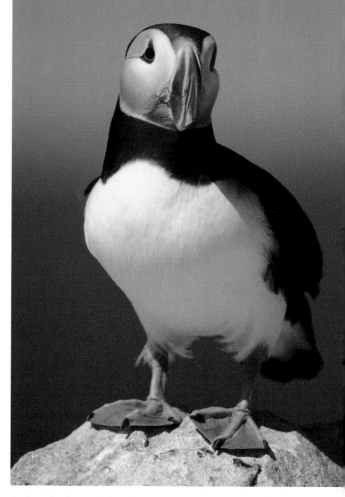

A clean background like in this photo of an Atlantic puffin helps your main subject stand out.

Using silhouettes is a great way to simplify a photograph.

like a tic-tac-toe grid. Then place your main subject on one of the lines or one of the four points where those lines intersect. Avoiding centering your subject in the frame creates a tension in your image that will hold the viewer's attention. The viewer's eye will have a more natural place to start exploring your photo. The extra space (to either side of and above or below the main subject) has more visual weight than if the space were evenly divided around a centered subject. In a well-composed photo, this space provides additional interest that complements the main subject.

When the main subject occupies a large portion of the frame, such as in a portrait, place the most important part of that subject (usually the eyes, in this case) at one of the imaginary

For portraits, it often works well to place the person's (or animal's) eyes in the upper third of the frame.

intersections. For landscape photos, avoid placing the horizon line in the center of the frame. Even with a stunning field of wildflowers in the foreground, a photo will lack impact if half of it is filled with sky—that's not your story. For a scene with a compelling foreground and middle-ground, place the horizon in the top third of the frame to emphasize the landscape. If a dramatic sky is what you'd like to highlight, put your horizon in the bottom third, accentuating the sky.

Over time, using the rule of thirds has become my natural way of seeing. Now I consciously use it only when I'm having trouble coming up with a good photo of a subject that I know has interest. Thinking about the rule of thirds forces me to reposition the camera, moving higher, lower, or from one side of a subject to another. These changes in the camera's position can dramatically change the look of the image, eventually leading to a photo that captures the drama of the scene.

By simplifying your composition and using a technique such as the rule of thirds to emphasize one part of a scene over another, you are giving your main subject the dominance it needs to become your story. Dominance is also expressed through size, shape, and color. Obviously, the largest object in your photograph will usually dominate, but a small object that is brighter or bolder in color than the rest of a composition can also have dominance. Strong shapes, especially those silhouetted against a bright background, can be dominant as well. Before pressing the shutter button, study your composition and identify the dominant element. Make sure it is the subject you want to emphasize.

Lens Choice and Perspective

On the simplest level, wide angle lenses capture a wider frame of view than telephoto lenses, which

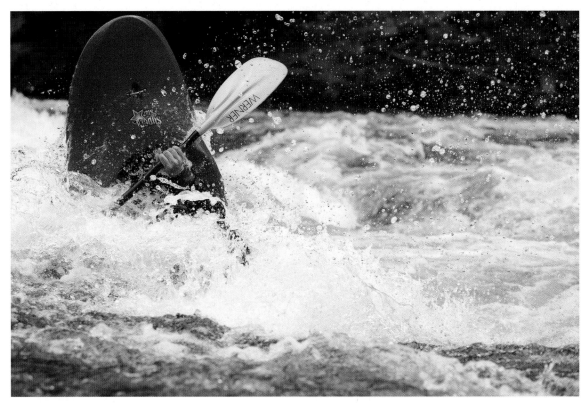

This composition follows the rule of thirds, both vertically and horizontally.

By placing the horizon in the top third of the frame, I included more of the ridgelines, which gave this photo much more depth than if the horizon had been in the center of the image.

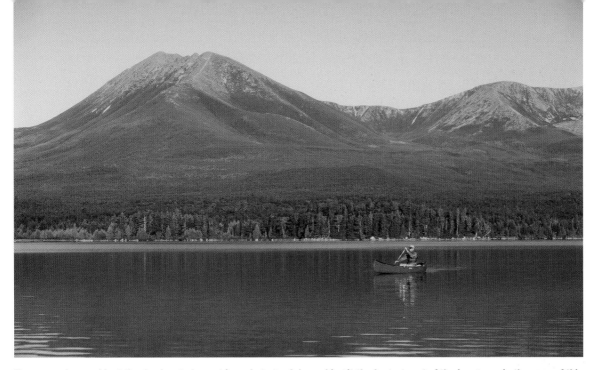

You can make an object the dominant element in a photograph by making it the largest part of the image, or, in the case of this canoe, by making sure it is the most colorful object you include in the scene.

allow you to make your subject bigger without moving physically closer. However, choosing a particular lens for a scene has implications beyond what part of the landscape you are fitting into the photo. Lens choice plays a major role in a photo's perspective and depth of field, both of which can change the way the viewer relates to your image. While sometimes you have no choice but to use a certain focal length for the subject at hand, it is important to understand how the lens affects the final look and feel of your photograph.

Wide angle lenses are generally those focal lengths 35mm and shorter on a full-frame sensor, and 24mm and shorter for cropped sensors. They take in a wide field of view and because of that they stretch a scene by making objects seem farther away from each other than they appear in reality. Wide angle lenses also provide a deeper depth of field than longer focal lengths, making them an ideal choice for landscape photos, which often require having sharpness throughout the image.

I regularly use wide angle lenses to make "big view" landscape photos of a place. A strong foreground element anchors the scene and provides a focal point where the viewer's eyes can start exploring the photo. A sharp foreground leading to a sharp background, combined with a wide field of view, creates a sense of place and makes viewers feel they are part of the scene. They can imagine reaching out and touching foreground details like rocks or flowers, while standing in a big open space of mountains, coastline, or fields.

Telephoto lenses have focal lengths of 70mm or longer for full-frame sensors and 50mm or longer for cropped sensors. While wide angle lenses allow you to involve your viewer with the scene, telephoto lenses create a more detached feel, as if the viewer were standing at a scenic view pull-off and looking into the scene, as opposed to being part of it. For this reason, images shot with telephoto lenses work best when they have simple, strong lines, shapes, and textures, or when they capture a compelling portrait or some kind of action, like a coyote running or a kayaker paddling whitewater. The two features of telephoto lenses that have the most impact on the look of

a photo are their relatively shallow depth of field and the fact that they compress a scene, making objects appear closer to each other than they are.

Shallow depth of field is ideal when you have a strong main subject, such as an animal, a tree, a person, or a flower. By focusing on your subject and using a large f-stop like F4, you separate your subject from the background, adding emphasis and simplifying the image. Compressing a scene using a telephoto lens is an excellent way to add drama to your images. For example, receding ridgelines in a mountain scene might seem tame using a wide angle lens, but a telephoto lens allows you to make the mountains larger in the frame and renders the ridges as being closer together, implying a ruggedness to the terrain that is missing from the wide angle view. Similarly, using a telephoto lens to photograph a person or animal against a mountain backdrop will have more impact if the mountain in the background seems closer and looms large over your subject. Unless you are very close to that mountain peak, this is possible to describe only using a longer focal length lens.

Depth of Field

Depth of field refers to how much of an image, from front to back, appears to be in focus. While you focus your camera on only one point in the scene, parts of the image in front of and behind that focus point will also appear to be in focus. There are three main factors that affect depth of field: focal length of the lens, aperture (measured in f-stops), and the camera's distance from the subject. As I mentioned in the previous description of lens choices, wide angle lenses provide more depth of field than telephoto lenses. Smaller apertures, which have larger f-stop numbers like F11 or F16, create more depth of field than larger apertures, like F4 or F2.8. Depth of

▶ **TIPS FOR MAKING A WIDE ANGLE LANDSCAPE PHOTO**

1. **Anchor the scene with a strong foreground element, such as** rocks, leaves, flowers, or a hiker. Get close to this subject so that it is large enough in the frame to capture the viewer's attention.

2. **Use the rule of thirds.** Place your foreground subject in the lower right or lower left of the image and place your horizon line in the top third of the frame. You may need to move the camera up or down until you achieve this.

3. **Use a small f-stop like F11 or F16 to ensure a large depth of field, creating a sharp image from foreground through the** horizon. (The f-stop, also called aperture, is the size of the lens opening that lets light in to the sensor. The higher the F-number, the smaller the lens opening—e.g., **F11** is a larger lens opening than **F16**.)

4. **Keep your image simple.** With such a wide angle of view, you need to be sure not to include any distracting elements.

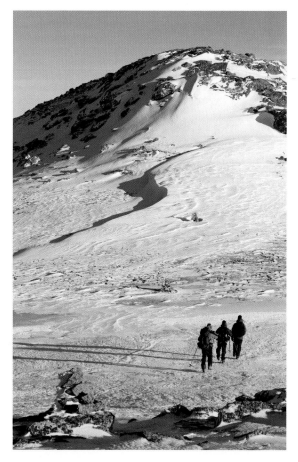

A telephoto lens compresses the scene, making elements seem closer together. In this photo, shot at 200mm, that compression reduced the apparent space between the hikers and the peak, making the peak seem taller and adding drama.

These two wind turbine photos were shot on the same day, at the same location, but show the differing perspectives of wide angle and telephoto lenses. Top: This photo, made with a 20mm wide angle lens, highlights the closest wind turbine and gives the viewer the sense of standing under it. Bottom: I used a 200mm telephoto lens here to compress the landscape, highlighting both the number of wind turbines and the ruggedness of the terrain.

Wide angle landscapes often work best when you create depth by placing a strong subject (like this horseshoe crab) in the lower third of the image and the horizon in the top third.

field also increases as your camera-to-subject distance increases. For instance, if your main subject is 12 inches in front of the camera, you may be able to achieve only about 6 inches of depth of field. However, with the same focal length and aperture, you can get an infinite amount of depth of field if your subject is 50 feet away.

Because depth of field lets you determine what and how much of your image is in focus, it is one of the most important creative decisions a photographer makes. For this reason, I highly recommend getting in the habit of shooting in Manual or Aperture Priority exposure modes. (See "Exposure" on page 37 for details on how to use these modes.) You don't let the camera

Use a telephoto lens if you want the sun or moon to loom large in your photos. This image of the sun behind Balance Rock in Arches National Park (Moab, Utah) was made with a 500mm lens.

decide what to photograph, so why would you let it determine how the photograph will look by using a program mode that chooses an f-stop, and therefore the depth of field, for you?

When you are setting up your composition, think about how depth of field will affect the resulting image. If you want to create a sense of place by showing everything in focus in a landscape shot, use a wide angle lens and a small aperture (bigger f-stop number) to maximize depth of field. If, however, you want to highlight just one part of a scene, use a longer lens and larger aperture (smaller f-stop number) to minimize depth of field and set your main subject apart. Of course, you can make myriad depth of field choices between these two examples, and that's where your creative vision comes into play. You can also bracket exposures to shoot the same scene with different depths of field by shooting three photos: one at F4, one at F8, and one at F16 (adjusting the shutter speed as you go to maintain proper exposure if you are shooting in manual exposure mode). You can pick the result you like best once the photos are on your computer. In general, use maximum depth of field for documentary-style photos or for creating that classic Ansel Adams-style landscape, and use narrow depth of field when the main subject requires a more intimate interpretation.

Visual Depth and Scale

Depth of field also plays a part in giving a photo visual depth. Depth is obvious in the three dimensions of the real world, but it doesn't always translate into the two-dimensional space of a photograph. The large depth of field inherent in wide angle lenses does a great job of giving depth to a photo when you have a strong foreground element that gives way to a lot of space leading to the distant horizon. This is one reason why put-

▷ UNDERSTANDING AND APPLYING HYPERFOCAL DISTANCE

When you focus on an object in your viewfinder, your image will have a depth of field determined by your f-stop, focal length, and distance from your subject. One-third of the depth of field range will be in front of your focus point, and two-thirds will be behind it. When trying to maximize depth of field—for a wide angle landscape image, for instance—the key is to determine a focusing distance that will give you a depth of field that stretches from your closest foreground element to the horizon (or infinity). This distance is called the hyperfocal distance and there is a different hyperfocal distance for every focal length and f-stop combination. There are several online and smartphone applications that will calculate the hyperfocal distance for you (see Appendix A), but I keep a laminated version of the following chart in my camera bag for reference.

There are three numbers in each box in the chart; the middle is the hyperfocal distance for that particular lens/f-stop combination. The first number represents the closest point that will appear in focus. The third number is always infinity, meaning that when the camera is focused at the hyperfocal distance, everything behind that point will appear in focus.

To understand how it works, let's assume we are shooting a scene with a 24mm lens. If the closest foreground subject we want to appear in focus is approximately 3 feet away, we could use an f-stop of F11, and then focus the camera on an object approximately 5.7 feet away. The resulting image will have sharp focus from 2.85 feet to infinity.

There are some practical considerations with this technique.

First, how do you actually focus at the hyperfocal distance? In the old days, most lenses had a distance chart printed right on the lens barrel so you could just turn the focus ring to the correct distance by lining up the distance number on the lens. Unfortunately, most modern lenses lack this feature, so you need to either bring a measuring tape or just make a rough estimate, which is what I usually do. In the above example, I would just take a guess at where 5.7 feet is and focus the camera on that point.

Second, should you use manual focus or autofocus? Either is fine. If you choose to use autofocus, point your camera at the place you've determined is 5.7 feet away and depress the shutter halfway to focus. Then, turn the autofocus off and recompose your picture using the composition you chose while setting up your shot. Otherwise, the camera will focus again on a different point when you take the shot.

Third, you'll notice that in most cases, much of the scene looks out of focus through the viewfinder, even if you've focused at the correct hyperfocal distance. That's OK! Your camera's viewfinder always shows you what the image will look like at your lens' maximum aperture, which can be anywhere from F1.2 to F5.6 (cameras use a lens' maximum aperture for the viewfinder because it allows the most light in, making a brighter image that is easier to use when composing your shot). Since big apertures have a shallow depth of field, much of your scene looks out of focus. When you depress the shutter button, the lens

stops down (changes aperture) to the f-stop you have chosen from the depth of field chart. Your resulting photo will have a depth of field based on this f-stop, not the camera's maximum aperture.

Some cameras have a depth of field preview button that will stop down the lens so what you see through the viewfinder is what you get in terms of depth of field (since smaller apertures let in less light, this viewfinder image will appear very dark). Many of the newest cameras have live view on their LCDs, and some will let you use the depth of field preview button while in live view mode. I like using this feature on my cameras, zooming in on the screen image to check sharpness in various parts of the scene, while holding down the depth of field preview button.

If all of this seems too complicated, or if the light is fading fast and you don't have time to do the calculations, just set your camera to a small aperture, like F11 or F16 (I don't use F22 because the added depth of field is usually offset by an overall reduction in sharpness caused by light refraction due to the small aperture), focus on your foreground subject, and fire away. If you've used the rule of thirds to set up your composition, your foreground subject will be about a third of the way into the scene. Your foreground subject will be tack sharp and you'll usually get pretty good sharpness in the rest of the image.

When using telephoto or macro lenses (specialty lenses used for close-up photography), you will be dealing with very narrow depths of field. For example, a 500mm lens shot at F4 might give you only an inch or two of depth of field, based on the subject distance. With macro lenses, small depths of field are the norm since the camera-to-subject distance is so small. In both cases, shooting at smaller f-stops will achieve a modest amount of increase in depth of field, but this requires shooting at slower shutter speeds, which isn't always possible since extremely long lenses and macro lenses are often used to photograph subjects that are in motion.

Depth of Field Chart for Wide Angle Lenses

Note: This chart is applicable for cameras with full frame sensors. Cropped sensors will exhibit a greater depth of field than is described here. *Distances are measured in feet.*

FOCAL LENGTH	F8	F11	F16	F22
12 MM	1 2 ∞	0.7 1.4 ∞	0.5 1 ∞	0.35 0.7 ∞
14 MM	1.35 2.7 ∞	.95 1.9 ∞	.65 1.3 ∞	.5 1.0 ∞
17 MM	2 4 ∞	1.45 2.9 ∞	1 2 ∞	.7 1.4 ∞
20 MM	2.75 5.5 ∞	2 4 ∞	1.35 2.7 ∞	1 2 ∞
24 MM	3.95 7.9 ∞	2.85 5.7 ∞	1.95 2.7 ∞	1.45 2.9 ∞
28 MM	5.35 10.7 ∞	3.9 7.8 ∞	2.7 5.4 ∞	1.95 3.9 ∞
35 MM	8.35 16.7 ∞	6.1 12.2 ∞	4.2 8.4 ∞	3.05 6.1 ∞

Longer focal lengths exhibit less depth of field than wide angle lenses. Note the shallow depth of field in this photo of shorebirds, shot with a 500mm lens at a small aperture of F16.

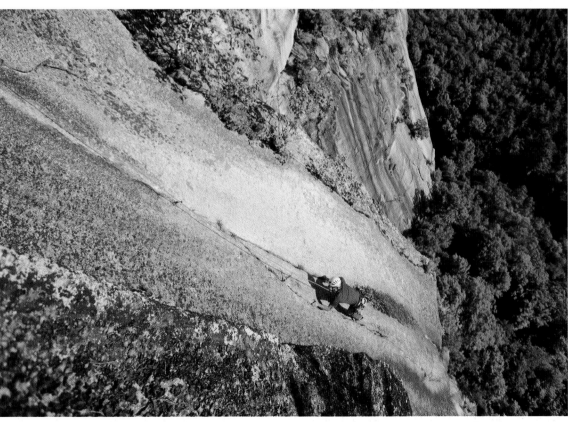

This rock-climbing image, shot with a 16mm lens, has a deep depth of field despite being shot with a large aperture of F3.5. Wide angle lenses inherently result in a large depth of field.

ting your horizon in the top third of a photo is so important for landscape images—it stretches the field of view in a way that implies distance and depth. This type of depth can also be implied through the use of converging lines that lead to the horizon.

A narrow depth of field can also imply depth because the object in sharp focus is obviously closer to or farther from the camera than out-of-focus elements in the scene. This effect seems to work best when the out-of-focus objects have enough of a recognizable shape to give the viewer a sense of where and what they are.

Like visual depth, scale doesn't always translate from the real world into photographs. We have all taken photos of mountains, sand dunes, or trees that seemed awesome to the eye when we

took the photo, but looked average in our photos. We define scale in a photograph through the perspective created by the specific focal length of the lens we are using combined with the placement of objects of known size in the scene. For example, to make a mountain range loom large, it needs to take up a big portion of the image and be given scale by including a person, animal, or building that is much smaller in comparison and with which viewers are familiar. Usually, the compression achieved by a telephoto lens enhances the effect. By comparison, to properly interpret the breadth of the wide-open spaces in a prairie or desert, impart scale by using a wide angle lens that stretches the prairie from the bottom of the image frame to the top third of the frame. Any object of known size, such as a

I made these two images of a blue flag iris on the Maine coast at F16 (left) and F2.8 (right), without changing the focusing distance between shots. The extended depth of field of a small aperture like F16 is ideal for landscape scenes like this one.

► MACRO PHOTOGRAPHY AND DEPTH OF FIELD

Close-up and macro photography is a specialty of many outdoor photographers. The details, colors, and textures seen in subjects like flowers and butterflies at close range open up a magical world not usually seen at greater distances. You'll face two technical challenges when photographing small subjects close up—the minimum focusing distance of a lens and a narrow depth of field.

To make small subjects appear large in a photograph you need to be able to focus on the subject from a short distance. For instance, to fill the frame with an object that is only 1.5 inches across with a 100mm lens, the camera needs to be about 12 inches away from that object. However, a non-macro lens of that focal length won't focus on something that close. My 70-to-200mm zoom lens can focus only as close as 4.5 feet. To focus closer, you have one of three choices. The first is to buy a macro lens that is designed to focus at a closer distance. A true macro lens will focus close enough to give you a 1:1 representation of the image, which means that at its closest focus point, the camera will render the subject lifesize—it will be the same size on your sensor as it is in real life. Macro lenses are the most expensive option, but they give you the ability to create macro images without sacrificing quality or reducing the amount of light reaching the sensor.

The second, less expensive, option is to add extension tubes between your camera and the lens. Extension tubes will let your lens focus closer without affecting image quality, but they reduce the amount of light reaching the sensor, requiring the use of slower shutter speeds. The third option is to use close-up filters, which are magnifying filters that screw on to the front of your regular lens. Relatively inexpensive, close-up filters don't change the amount of light reaching the sensor, but the cheaper brands can degrade overall image quality compared to a dedicated macro lens or a normal lens used with extension tubes. (I recommend using Nikon or Canon close-up filters.) Both extension tubes and close-up filters can be stacked, allowing you to achieve varying levels of magnification.

Once you are able to focus your lens on macro subjects, a whole new world of photography opens up. All of the techniques relating to composition, exposure, light, etc., apply to macro photography, but close-up and macro photography have challenges and opportunities in regards to depth of field. The extremely close subject-to-camera distance results in a very narrow depth of field, often measured in fractions of an inch. For some photos, this is an advantage as you can easily make your main subject stand out from its surroundings, and also create ethereal, abstract qualities in your images as the shapes and colors of your backgrounds blur and blend together. The farther your background is from your main subject, the greater the blur, especially at large apertures like F4 and F2.8, where your depth of field may be only a quarter of an inch.

However, for some macro subjects, especially insects and larger flowers, you may want more depth of field than a quarter-inch. Stopping down the lens to F11 or F16 will buy you some depth of field, but this also requires slower shutter speeds, which can be a challenge with blowing flowers or moving butterflies.

Another option is to reposition your camera so that more of the subject is parallel to the camera. While the camera focuses at only one distance, if you can position the camera so more of the subject is in that plane of focus, more of the subject will be in focus. For example, if you shoot a butterfly head-on, you may get its eyes in focus, but its wings will be out of focus. If you turn the camera so that it is directly above the butterfly, when its wings are spread out, most of the butterfly will be in the plane of focus, resulting in both the eyes and wings being sharp, regardless of your f-stop.

In macro photography, you can overcome a very narrow depth of field by placing the camera parallel to your main subject, as with these butterfly images.

The shallow depth of field inherent in shooting at close range is excellent for separating subjects, like this rose pogonia orchid, from the background.

person or tree, that stands near that horizon line will appear very small, driving home the point that there is a great deal of space between the foreground and background.

Abstractions

With most of my photography, I try to depict the reality of the outdoors in a beautiful way, but sometimes the best way to simplify a scene or emphasize a subject is through a more abstract interpretation. Creating abstract photos is a fun way to experiment and try to break through creative barriers in your photography. When making abstract images, I either look for a rhythm in repeating lines and shapes or I blur my subject to create impressionistic compositions that feature the light, lines, and colors in a scene. Abstract images usually impart a strong mood that is rep-

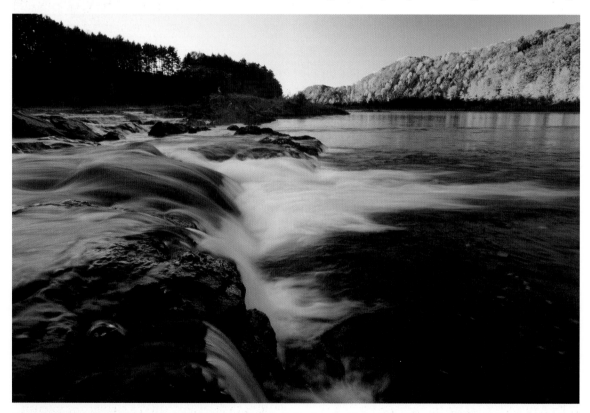

By placing the horizon in the top third of this photo and achieving a sharp image from foreground to background, I gave this photo more depth than if the horizon were lower in the frame.

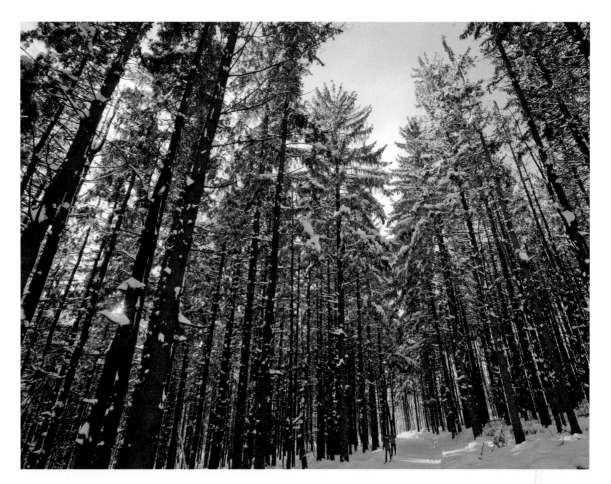

Scale can be difficult to determine in a two-dimensional photograph. In this photo, the skiers provide a reference that the viewer uses to understand the size of the trees.

resented by the shapes, tones, and colors present in the composition.

Patterns are everywhere in nature. Tightly cropped photos of ripples in the sand, the rough textures of tree bark, or the triangular shapes of ferns make ideal subjects for abstract compositions. For these types of photos, use a small aperture to ensure sharpness throughout the image, and when possible use a composition that includes a small object of different color, tone, or shape to break up the pattern. This gives the viewer's eye a place to land when looking at the photo. By contrast, you can use a narrow depth of field to subtly define the sensuous shape of a flower petal awash in a blur of color in the surrounding flowers and background.

You can create impressionistic, abstract images by using slow shutter speeds to blur your subject. This results in an image that is defined not by a precise interpretation of the subject, but by a soft blending of light, color, and shape. Blur can be introduced either by the movement of your subject or by camera movement. One of my favorite abstract subjects is moving water, especially when there are richly saturated colors reflecting on the surface. These photos work best when a stream or river is in the shade but the trees, cliffs, or buildings on the opposite bank are in direct sunlight. By moving your camera up or down relative to the water, you can change the intensity of the reflections. Use a shutter speed of 1/4 second or slower to blur the moving water, creating

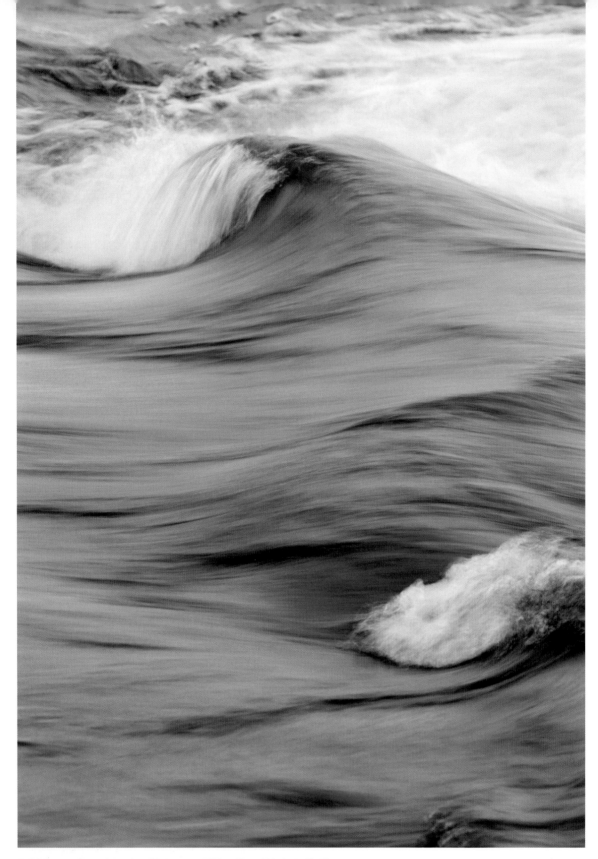

Fall foliage reflects in the rushing waters of New Hampshire's Swift River.

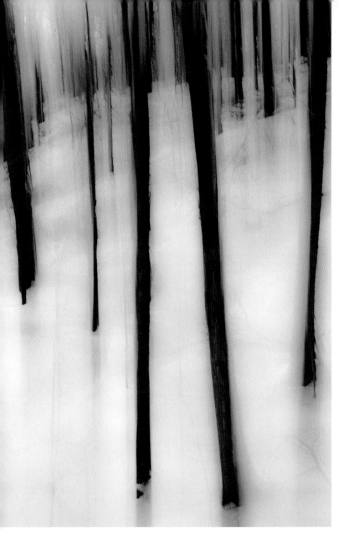

Moving the camera up during a two-second exposure created this abstract of trees in winter.

an abstract mix of color, light, and shape. Compose your image to feature the interesting curves or diagonal lines in the scene, and experiment with including rocks or standing waves to anchor the composition (remember the rule of thirds).

One technique that has become popular in recent years is to use a slow shutter speed and introduce blur by moving your camera during exposure. For this technique, I'll use a shutter speed of 1 second or slower and move my camera in a direction that emphasizes the lines or shapes present in the scene. For example, in a forest scene I'll move the camera up or down because the dominant shape will be the vertical lines of trees. Of course, since you are creating an abstract

image, no rules really apply—move your camera in any direction and see what happens. Since absolutely nothing in this type of photograph will be in focus, the best images have strong repeating shapes like tree trunks or the soft, graceful curves formed by objects such as clouds or ocean waves.

EXPOSURE

On a recent muggy summer day, I hiked 2 miles through boggy, bug-infested spruce forest to reach a rocky promontory on the east side of Maine's Great Wass Island. The cool breeze coming off the Gulf of Maine kept the bugs at bay as I set up my tripod to capture the drama of the rugged and undeveloped shoreline. I noticed almost immediately that the high summer sun was masking the beauty of the scene by turning the rich brown and red colors of the rock ledges into a muddy gray and creating dark shadows without detail. Instead of continuing to shoot, I enjoyed basking in the sun for a couple of hours and then set the alarm on my watch to wake me early the next morning so I could return when the light was more to my liking. Though I had to get up at 4 A.M. and walk an hour in the dark, I ended up with several photos that are now part of my portfolio.

No matter how well you compose a shot, the resulting image can fall flat if not photographed in the right light. After all, the word "photography" is derived from the Greek phrase for "drawing with light." Light can be warm or cool, harsh or soft. Without understanding how light affects the scene, you can't master the art of photography. The quality of light determines how colors appear in your photos and the degree to which textures in a scene are revealed. The direction of light defines shapes and lines in your photos and determines which objects are highlighted and which are relegated to the shadows. Learning to

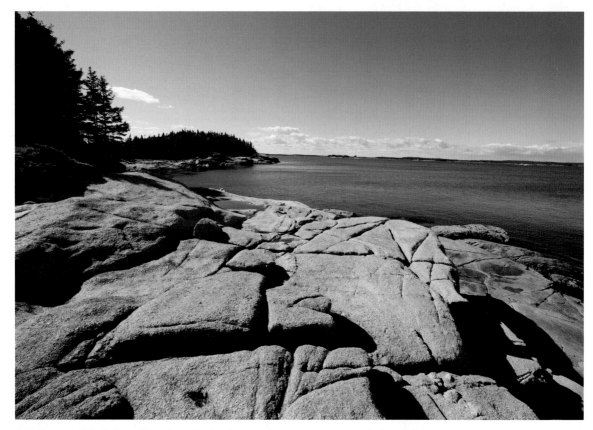

This photo of Maine's Great Wass Island lacks vibrant color due to the harsh mid-day sunlight.

see the qualities of light and understanding how light is recorded in a photo is one of the most important exercises a photographer can undertake.

Mid-day Sun

The least flattering light for outdoor photographs is the harsh light of mid-day sun in clear skies. The bluish light of midday mutes warm colors like reds, oranges, and yellows, and creates unflattering skin tones. The high angle of the sun, combined with its brightness, makes the light harsh and creates extreme contrast in the scene (very bright highlights with very dark shadows), making it nearly impossible for a camera's sensor to record detail in both the highlights and shadows. I shoot in mid-day light sparingly, using it only for scenes that receive direct light at no other times of the day, such as narrow streets or dark notches and canyons, or when I know there is no chance I can return to a subject in better light. I am rarely satisfied with mid-day light photos, but when I have to shoot at this time, I compose an image to contain either primarily highlights or primarily shadows in an effort to reduce the amount of jarring contrast that inevitably will result.

The Golden Hour

Most outdoor photographers seek out "Golden Hour" light, the warm, low-contrast light when the sun is low on the horizon, just after sunrise or before sunset. The orange, yellow, or reddish tones of this light give photographs warmth that is pleasing to the eye and enhances the color of a scene. The low angle of the sun also creates long shadows, revealing textures that aren't seen in

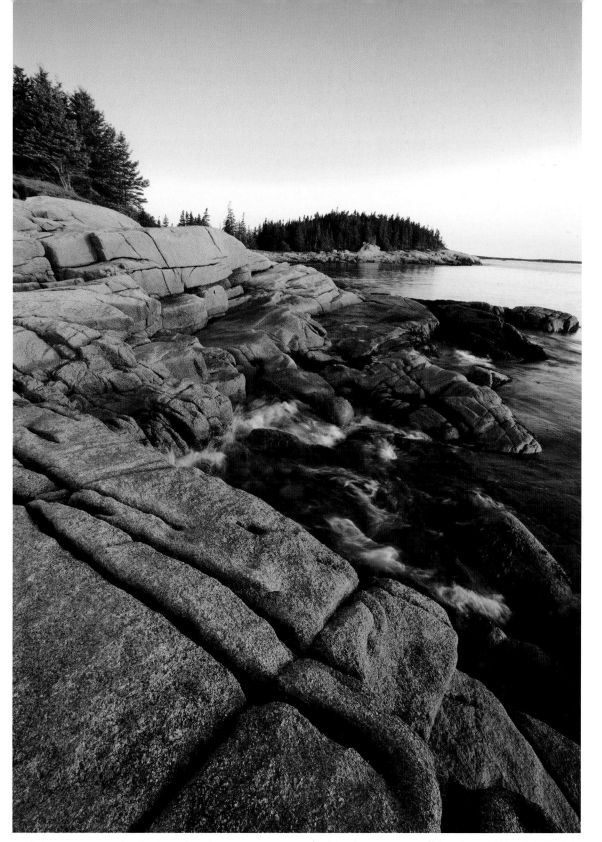

I shot the same rocks on Great Wass Island in Golden Hour light, just a few minutes after sunrise. Notice the more-pleasing color, shadows, and textures compared to the mid-day light image.

other forms of light, and because the light does not exhibit the extreme brightness of midday, those shadows are not too dark and thus retain detail. These shadows, textures, and color work together to create drama.

This is the best light for many subjects, especially big landscape scenes where you want to emphasize shapes and elements like the ripples in sand, the S-curve of a river, or patterns in snow. The length of the Golden Hour varies based on latitude, season, and atmospheric conditions. In summer, it can last as little as 30 minutes when the skies are relatively free of moisture and particulates. At times, it can last for an hour or more.

If you make the effort to shoot during the beginning and end of the day, you will quickly come to recognize the quality of Golden Hour light and see dramatic improvements in your photos.

Overcast Light

If you often shoot in forested areas as I do, then you will become very good friends with the diffuse light of overcast, foggy, or drizzly days. The dappled light in a forest on a sunny day may be pleasant for a walk in the woods, but it can wreak havoc on a photograph by creating a blotchy mess of bright spots and dark shadows that confuses the viewer's eye. With clouds overhead, this

Forest and waterfall scenes often look best in diffuse, overcast light.

contrast disappears, allowing you to capture all the subtle details in a scene that might otherwise be lost in dark shadows or blown-out highlights. The softer light of overcast days is excellent for flower close-ups and forested landscapes, as well as stream and waterfall photos. However, as opposed to the line- and shape-defining quality of direct sunlight, the shadow-free light of an overcast day reveals less texture in subjects and does little to define shape. This makes it necessary to define shape through the use of composition and color, and by recognizing subtle differences in tone.

You should also take care to avoid including any sky in your compositions on overcast days (with the exception of foggy landscape scenes). With forest scenes, any sky that creeps into your frame will be very bright, if not overexposed, compared to the rest of the scene, and will steal your viewer's attention. Our natural tendency is to see the brightest part of a photograph first. Take the time to find a way to compose your photo to eliminate as much of the sky as possible. The good news is that you'll have plenty of time, as unlike Golden Hour light, which fades fast, overcast light lasts as long as there are clouds in the sky and the sun is above the horizon.

Weather

One challenge facing outdoor photographers is the fact that we rely on natural light for most of our photographs, and unfortunately, we can't control the weather (I can't anyway!). All we can do is decide what the best light for our subject is and then make the effort to be there when that light exists. I'll plan shoots based on the weather. When clear or partly cloudy days are forecast I'll shoot in open landscapes, getting up early for sunrise and staying out until the sun is well below the horizon. When clouds are forecast, I'll

head into the woods and look for forest scenes, streams, waterfalls, ferns, flowers, and mushrooms. I also shoot medium-range and close-up forest shots on sunny days, simulating overcast light by photographing entirely in the shadows. However, this shadow light can have a strong blue cast, making it necessary to adjust your white balance, either in the camera or later when processing images in the computer. Overall, take advantage of the light you have and shoot a subject in the light that portrays the mood and story you are trying to create.

Exposure Basics

By the time you are ready to press the shutter, you have already done a lot of creative work—finding a subject, composing your photograph, and using light in a way that best captures the moment. Now it is time to use all the buttons and dials on the camera to properly expose your image the way you envision it. Exposure refers to the amount of light that reaches your camera's sensor for the brief amount of time the shutter is open. It is controlled by two factors: shutter speed (the length of time the sensor is exposed to light) and aperture (the size of the lens opening that lets light in.) A third factor, ISO, controls the sensitivity of the sensor in recording that light.

Modern cameras are very good at approximating the right combination of shutter speed and aperture to properly expose an image. The meter in a camera measures the light reflecting back to the camera from your subject, which means if you are standing in the shadows but your subject is lit by sunlight (or vice versa), the meter reads the light coming from your subject, not what is present at the camera's location. At a basic level, exposure meters are attempting to choose exposure settings based on the premise that a scene is a middle gray tone, halfway

between black and white. For many landscape scenes, there is a range of tones (dark shadows, bright highlights, and areas of medium brightness, called midtones) that might average out to mid-tone gray. However, meters can be fooled if a large portion of the frame is filled with very bright or very dark tones. For instance, a snowy landscape scene is primarily white, but the camera's meter doesn't know that and will give an exposure setting that renders the snow a muddy gray color. The opposite happens with very dark subjects, like a black bear or dark-black volcanic rock. In these cases, you will need to manually adjust the exposure to compensate for the discrepancy, which I describe how to do below.

To set the exposure with your camera, use two controls: the exposure meter (which measures the light in the scene) and the exposure mode (which determines the camera's shutter speed and aperture). Most modern DSLRs and some point-and-shoot cameras have several exposure metering options, which usually include a spot meter mode, a center-weighted mode, and an averaging mode (Canon calls this "evaluative metering" and Nikon calls it "matrix metering"). I find the spot metering mode useful for determining exposure in some situations (see page 44), but since the advent of the histogram, which I'll be explaining below, I use evaluative metering for 95 percent of my photos.

When you point your camera at a scene and depress the shutter halfway, you'll see an exposure chart at the bottom of the viewfinder or LCD with several short vertical lines and a 0 in the center. The goal when first setting up a scene is to get the exposure to line up with that 0. Cameras have several exposure mode options, including Program, Aperture Priority, Shutter Priority, and Manual. When using a camera's Program exposure mode, the camera chooses a shutter speed and aperture for you to get the exposure chart to line up properly. In Aperture Priority, you choose an aperture (or f-stop) and the camera selects a shutter speed to get the proper exposure. In Shutter Priority mode, you choose a shutter speed and the camera sets the aperture. In Manual mode, you need to adjust both your shutter speed and your aperture until the exposure chart in your viewfinder indicates a proper exposure.

Like I described in the depth of field section, for most photos I am going for a certain look based on depth of field, so I use Manual exposure mode to choose an aperture and then adjust my shutter speed until the camera's meter

The dark version of this image is underexposed, muddying tones and losing details in the shadows compared to the properly exposed version.

says I'll get the right exposure. Alternatively, you can shoot in Aperture Priority mode, selecting your f-stop and then letting the camera's meter choose the correct shutter speed for you. The only time I don't choose my aperture first is if there is something moving in a scene and I need a specific shutter speed to either stop the movement or blur it. Then I'll choose a shutter speed and adjust my f-stop until I reach the proper exposure (you can also use Shutter Priority mode, choosing the shutter speed and letting the camera set your f-stop).

Meters measure light in units called stops. Every time you add a stop to your exposure setting by using a slower shutter speed or larger aperture, you are doubling the amount of light reaching the camera's sensor. Conversely, when you reduce your exposure by one stop, you are halving the amount of light reaching the sensor. For example, a shutter speed of 1/250 second lets in twice as much light (or one more stop) as 1/500 second. F-stops (aperature settings) are a little more confusing in regards to stops. Until about 25 years ago, you could adjust the aperture only in one-stop increments, using the following f-stops: F1.4, F2, F2.8, F4, F5.6, F8, F11, F16, F22, F32 (some lenses could go higher or lower than these numbers). The larger the F-number, the smaller the aperture, so F16 lets in half as much light as F11 and twice as much light as F22. Today's cameras allow you to adjust both shutter speed and aperture in one-third or one-half stop increments.

When considering exposure, you should also be aware of a concept called dynamic range, which is basically the ratio between the brightest part of the scene and the darkest part of the scene in which detail can be discerned. The human eye can see detail in a much wider range of tones than a camera's sensor. This explains why when

you take a picture of a sunset, your photo might expose the sky properly, but the foreground displays as almost black, even though your eyes saw plenty of detail in all parts of the scene. Just changing your exposure won't fix this problem, but in some instances you can "help" the camera by adding light with a flash or reflector, using a graduated split neutral density filter, or using software and several exposures to create a High Dynamic Range (HDR) photo. I explain all of these techniques below.

Reading a Histogram

Once you have chosen what you think is an f-stop and shutter speed that will give you a properly exposed image, take a picture and then look at the image on your camera's LCD. You can get an overall sense of exposure from the LCD screen image, but don't rely on it; its brightness and contrast might not accurately reflect your photo, depending on the light hitting the LCD. Instead, display the histogram for the image (if you don't know how to do this, check your camera's owner's manual). The histogram is a bar graph that charts exposure by showing you the number of pixels in your photo at each tonal gradation, from black on the left to white on the right.

There is no one correct shape for a histogram, as every photo has a different set of tonal values, but there are things to look for that will help you determine whether you achieved the best exposure. First, check both the right and left sides of the graph for "clipped" pixels, or pixels that are over- or underexposed to the point of having no detail information. If there is no gap between the histogram and the right side of the histogram box, you have clipped highlights — overexposed pixels that are pure white with no detail. If your histogram extends all the way to the left of the box with no gap, you have clipped shadow detail,

▶ DETERMINING EXPOSURE THE OLD-FASHIONED WAY

Back in ancient times (like 2002), when I shot with film I didn't have the luxury of using a histogram to check my exposure (see "Reading a Histogram," page 43). I could bracket exposures, taking multiple shots of the same image at different exposures, but this was expensive as every frame of slide film cost me about a quarter to buy and process. To save money, I learned to use my camera's spot meter to meter parts of a scene that I recognized as a certain tonal value and made my f-stop and shutter speed choices based on the meter reading and my understanding that the meter saw whatever I was pointing it at as a mid-tone gray. Here are the three basic ways I approached spot metering. They still work with digital cameras, and understanding these techniques will help you even if you are relying on the camera's histogram.

1. Meter a Friendly Middle Tone. This technique in its basic form is the simplest way to produce proper exposures. It simply involves taking a meter reading from a middle-toned object in the landscape and using that reading for your exposure setting. Using manual or aperture priority exposure mode, first choose the aperture in order to achieve the depth of field you envision, and then let the meter determine the shutter speed. The key to the success of this technique is to make sure that your main subject is in the same light as your friendly middle tone. Nature abounds with recognizable middle tones to use as metering subjects, and with practice you will develop your own list of favorites. Until then you can rely on a few standards. The first is to place a gray card in the same light as your subject, set your exposure, and compose your image without the gray card and without changing the exposure settings from the gray card reading. (A gray card is an 8" x 10" card manufactured to be exactly the middle-tone gray—18 percent gray—that camera meters are calibrated to. They are available from most camera stores.) If you prefer not to drag a gray card into the field, you can rely on a few classic neutral tones. One is the northern blue sky on a sunny day. As long as your subject is in full sun, just meter off of the sky, recompose, and shoot. Other objects to use as middle tones are the trunks of trees such as maples, oaks, beeches, and white pines, and the green grass of mid- to late summer.

2. Meter a Friendly Non-Middle Tone. Known middle tones are not the only handy metering tools in nature. Once you know the brightness value of any object, you can take a meter reading and then adjust your exposure. I use this technique all winter long when the ground is covered with snow. If you take the time to meter a patch of snow and compare that meter reading to a gray card in the same light, you will find that in general, snow is 2 stops (2½ stops if it's fresh and the sun is bright) brighter than 18 percent gray, so I know that middle-toned subjects will be properly exposed by adding 2 stops to a reading taken off of the snow. (Remember that your meter assumes you are looking at a gray card so it will give you a meter reading that makes the snow appear gray; adding light to this reading brightens the scene back up.) In the summer, my friendly non-middle tone is the green foliage of a hardwood forest. I have found that the leaves of hardwood trees in summer are almost always two-thirds of a stop darker than middle-tones, so I meter off of this foliage and add two-thirds of a stop to the meter reading to reach an 18 percent gray exposure value.

Once I have determined this proper middle-toned exposure value, I apply it the same way as if I had metered off a gray card. I make sure my subject is in the same light as my metering object, then make any necessary minor adjustments for very dark or light subjects. You can also use objects you bring with you in the field on a regular basis as a friendly non-middle tone, such as your camera bag or the palm of your hand. Before you leave home, use your meter to compare the brightness levels of these objects to a gray card, memorize the difference (e.g., my hand is two-thirds of a stop brighter than 18 percent gray), and then you can leave the gray card at home.

3. The "You Choose" Method of Creative Exposure. The technically perfect exposure is not always the perfect creative exposure, and the perfect exposure for one part of your scene may not be right for another part. As a photographer you have every right to purposefully under- or overexpose an image to create a desired look or feel. This approach works very well for landscape photography because representing nature subjects in critically perfect colors and tones is nowhere near as important as it is in people or product photography. With the "you choose" method, simply take a meter reading off of the most important subject in your scene and then choose if you want it to appear middle-toned or if you want to add light to make it brighter or subtract light to make it darker. This is a great technique for backlit situations, including sunrises and sunsets. Meter the area of the sky you want to be middle-toned and start shooting. If you want a more uplifting feel, add two-thirds of a to 1 stop of light. For a darker, moodier look, subtract light.

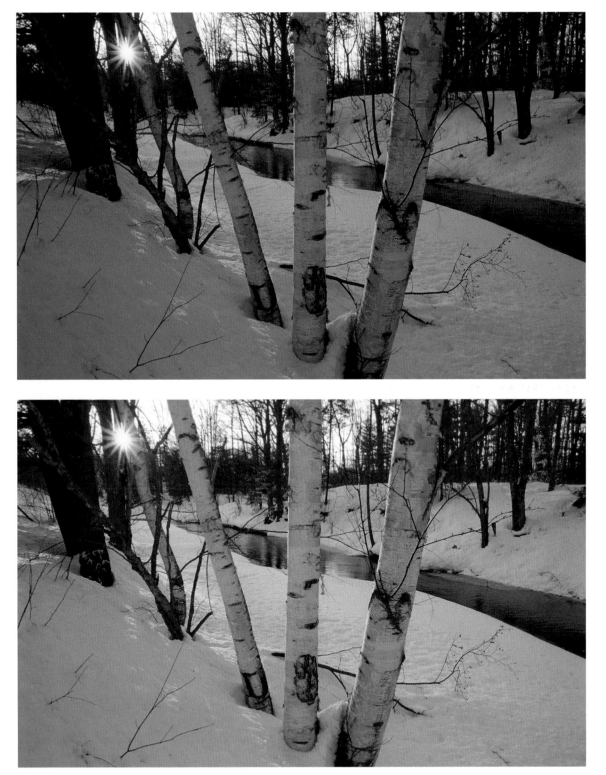

While there is usually a "correct" exposure, you can purposely over- or underexpose an image for creative effect. In this winter scene, the brighter of the two images is the "correct" exposure (bottom). However, I like the colder look of the slightly under-exposed version (top).

This histogram (above, top) shows a lot of blank space on the right side, which indicates the photo is very underexposed. This is obvious when viewing the image (above, bottom). Also notice the spike on the left, which indicates clipped pixels on the black end of the histogram. Whenever you see a histogram with blank space on the right, increase the exposure by using a slower shutter speed or larger aperture.

This is the same photo shot with two more stops of light (above, bottom). The f-stop for both images was F16. The shutter speed for the dark photo was 1/60 second. For the correct exposure, it was 1/15 second. Obviously, this photo is preferable to the underexposed version. You can see good detail and color in the trees, which become the main subject.

This spike on the right side of this histogram indicates clipped highlights, which is evident in the overexposed portions of the sky in the photo (above, bottom). While it may be possible to recover some of those clipped highlights in post-processing, you can achieve better results by making exposure changes at the time of capture.

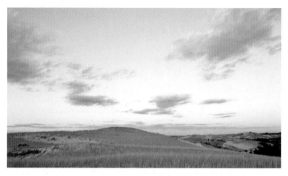

By shooting the same image with a faster shutter speed (1/4 second versus 0.4 second in the brighter version), I reduced the exposure and was able to create an image without any overexposed pixels in the sky. Though the change is subtle, the darker exposure results in richer colors in the sky without losing detail in the dunes.

This histogram (above, top) represents the low-contrast image below. Since the image is composed primarily of midtones, all the pixels are bunched up in the middle of the histogram. For this type of photo, set an exposure that puts the biggest spike of the histogram somewhere in the middle or just to the right of middle. Low-contrast images like this usually look very flat as a RAW file (RAW files are described on page 54).

This is the same photo as the washed-out version at left, but I've added contrast by increasing the amount of blacks in the image using the Blacks slider in Lightroom (see Section 4). This was an easy change that quickly created the pop and color saturation that better represents the scene.

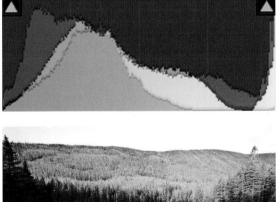

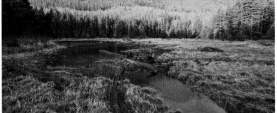

This image has both overexposed highlights and underexposed shadows. Changing the exposure can't fix both problems. Adding more light will reveal more shadow detail, but overexpose even more of the sky. Reducing the exposure will capture sky details but darken the foreground to an unacceptable level.

Both of these images were shot with the same exposure settings (F11, 1/6 second), but for the second photo I retained detail in the bright sky by using a graduated split neutral density filter (see "Filters," page 59)) to reduce exposure in the sky without losing detail in my foreground.

which means there are areas in the photo that are pure black. Your goal should be to create an exposure with no clipped pixels. In reality, this isn't always practical because the dynamic range of the scene (the range of brightness from shadows to highlights) may exceed the dynamic range of the camera's sensor.

I usually aim to get a combination of shutter speed and aperture that exposes my highlights as close to the right side of the histogram as possible without clipping any highlights, for two reasons. First, I want to avoid clipped highlights because these overexposed, detail-free areas can be major distractions in a photo. Second, by exposing my image as brightly as possible, I'll capture not only highlight details, but also the maximum amount of detail in my midtones and shadows. This becomes very important in post-processing because any time you try to brighten shadow detail using a program such as Photoshop, you introduce a varying amount of digital noise to those shadows. The less brightening of an image you do in post-processing, the cleaner your image will look when you enlarge it. In addition to using the histogram for checking for clipped highlights, you can check for "blinkies" in playback mode. These are clipped highlights that blink between black and white in an image when you view it on the LCD.

After reading your histogram, if you decide you need to reduce the exposure amount because of clipped highlights or, conversely, add exposure to brighten the overall image, just dial in the exposure change, shoot again, and recheck your histogram. If you're shooting in Manual mode, use a slower shutter speed (or larger aperture) to add light, or a faster shutter speed (or smaller aperture) to reduce exposure. If you are shooting in Aperture or Shutter Priority mode, use a feature called exposure compensation, which lets you tell the camera to use a negative amount of expo-

sure compensation to produce a darker image, or a positive amount of compensation to create a brighter image.

Here's an example of how exposure compensation works. Let's say you are shooting in Aperture Priority mode and set the aperture to F8, and the camera selects 1/250 second to get what it thinks is the proper exposure. Take a picture and check your histogram. If you see a big spike on the right side of the histogram, indicating clipped highlights, you will want to add a negative exposure compensation. Most cameras let you choose this negative compensation value in increments of one-third of a stop of light. In this case, if you dial in an exposure compensation of -1 and leave your aperture at F8, the camera should then use a shutter speed of 1/500 second to reduce the amount of light reaching the sensor by one stop. If you decide you need to make your image brighter, use a positive exposure compensation value.

If your image has properly exposed highlights but there are still clipped pixels on the black end of the scale, changing the exposure won't fix the problem. There are a few other options. First, look at your photo and identify where those dark shadows are in your composition. If the darkest areas are just a few shadows under rocks or behind trees, and they don't detract from the overall look of the image, then it is fine to leave your exposure settings as is. A few black shadows can add some nice contrast to a photo. However, if the black areas are large or distracting, recompose to eliminate them from the scene, or try to balance your photo by adding light with a fill flash or reflector. If you are shooting a landscape scene that is very bright in the sky and has a well-lit background but there are deep shadows in the foreground, you can use a graduated split neutral density filter to bal-

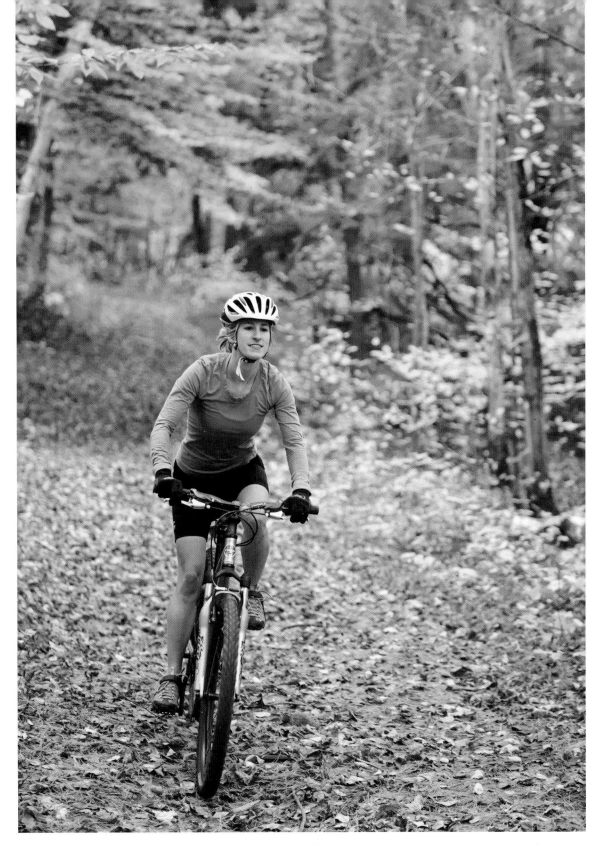

To stop action in this mountain-biking image, I wanted to use a shutter speed of at least 1/250 second. In the woods on an overcast day, this was possible only by shooting at a large aperture (F2.8) and a high ISO setting (ISO 1600).

▷ SHUTTER SPEED AND MOTION

While I often choose my aperture first when setting exposure in order to achieve a certain depth of field, shutter speed is always a consideration as well because it affects whether things in motion appear sharp or blurred in a photograph. The amount a subject can blur in a photo depends not only on shutter speed, but also on how fast it is moving; its distance from the camera and how much it is magnified (either by a macro or telephoto lens); and whether it is moving across the frame or perpendicular to it. Here are some guidelines to follow when choosing a shutter speed:

1. To keep moving people or wildlife sharp, use a shutter speed of at least 1/250 second if the subject is moving toward or away from the camera, and 1/500 second or faster if it is moving across the frame. Use an even faster shutter speed if the subject is filling the frame because it is close or because you're using a telephoto lens.

2. If you want to feature the motion of moving wildlife or people, use a shutter speed of somewhere between change fraction to 1/4 and 1/60 second, while keeping the camera still during exposure. This results in a sharp background and foreground, but a blurred main subject. The right amount of blur depends on the speed and direction of the movement, so you will need to experiment with different shutter speeds to get the effect you want.

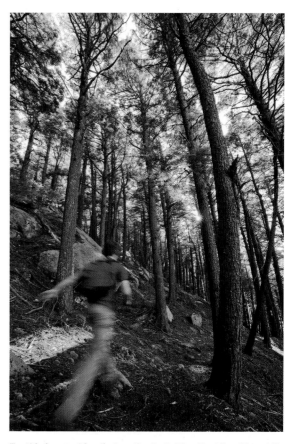

For this image, I implied motion by letting the hiker blur while keeping the background sharp. The shutter speed was 1/13 second.

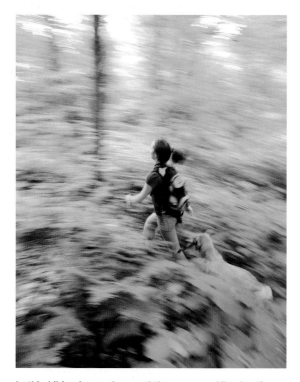

In this hiking image, I panned the camera while shooting at a relatively slow exposure of 1/8 second. This camera motion blurred the background while retaining some sharpness in the hiker.

3. To feature motion by panning with a moving subject, hold the shutter down (be sure it's in a continuous drive mode) as you pan. This creates an effect in which the subject is relatively sharp, while everything else in the image blurs into streaks of color and light. This process requires experimenting with different shutter speeds to get the right blur effect while still producing a relatively sharp main subject. I usually try shutter speeds in the change fraction to 1/4 second to 1/30 second range for this technique.

4. For close-ups of plants in a wind, use at least 1/30 second in a gentle breeze, or 1/125 or faster in a stronger wind to stop the motion.

5. For whitewater and waterfall images, use change fraction to 1/4 second or slower to produce a milky white blur effect in the water, or 1/250 second or faster to create sharp images of the falling and crashing water.

Depending on the light conditions, you may need to increase your ISO to achieve the faster shutter speeds needed to stop action. Conversely, you can use a neutral density filter to reduce the amount of light reaching your camera's sensors when you want to use a slower shutter speed for more blur.

To stop action in this image, I used a shutter speed of 1/2000 second.

ance the exposure (see "Filters," page 59). You can also photograph a series of images and use HDR (High Dynamic Range) software to combine them into one image that captures details throughout the image (see Section 4).

The key to properly exposing images in the digital age is to understand and utilize your histogram for every scene. With this knowledge, you can be confident that every scene you shoot will be well exposed.

ISO

As I mentioned earlier, your camera's ISO setting adjusts the light sensitivity of the sensor. The higher your ISO setting, the less light the sensor needs to properly expose an image. To get this higher light sensitivity, the camera pumps more electricity through the sensor, which can result in more noise in your photo, especially in the shadows. Manufacturers have done a good job of reducing this noise in recent cameras, and with most newer DSLRs, you can readily shoot at ISO 400 and 800 and get good results, but ISO 100 and 200 still produce the cleanest images. Noise usually won't be very noticeable when images are output as small prints or in low-resolution online galleries, but when you start making enlargements, noise can quickly detract from the details in your photos. A good way to understand what noise looks like is to shoot the same image at different ISO settings and then compare them on your computer. Be sure to zoom in to 100 percent in Photoshop or 1:1 view in Lightroom to make the best comparison.

My recommendation is to shoot at the lowest ISO that will still produce a sharp image. As long as you are using a tripod and shooting subject matter that is not moving, you can use very slow shutter speeds and get sharp images. If that's the case, use ISO 100 or 200 to get the least noise. However, sometimes you need to use a faster shutter speed in order to stop motion, whether it is subject motion or camera motion (if you are holding the camera). In this case, you will need to increase your ISO to properly expose your image using a faster shutter speed. If your choice is between getting a blurry image, a noisy image, or no image at all, dial in a high ISO and opt for the noisier image, as some noise can be eliminated in post-processing. At the worst, you will have an image that can be enlarged to 8″ x 12″ or so before the noise gets distracting.

White Balance

Digital cameras control the color balance of an image with the white balance setting. As I mentioned in "Exposure" (see page 37), light can be warm or cool in color. The white balance setting takes the color of the light into consideration when determining how to render the colors of a scene in the resulting image. With traditional photography, color balance was built into the film. Most films were balanced either for the color of mid-day light or for the light coming from tungsten lightbulbs. To make adjustments based on the color of light, photographers had to use color filters to match the light to the film. With digital cameras, the white balance setting can be changed for every photograph.

Most digital cameras have the following white balance choices: auto, daylight, cloudy, shade, tungsten, fluorescent, flash, color temperature, and custom. Typically, I stick with the auto white balance setting, which sets a white balance for the vast majority of outdoor scenes. I shoot in RAW mode, which I'll explain shortly, and white balance is one of those camera settings that can be adjusted in post-processing for a RAW image without degrading the image in any way. However, when shooting in JPEG mode, you will

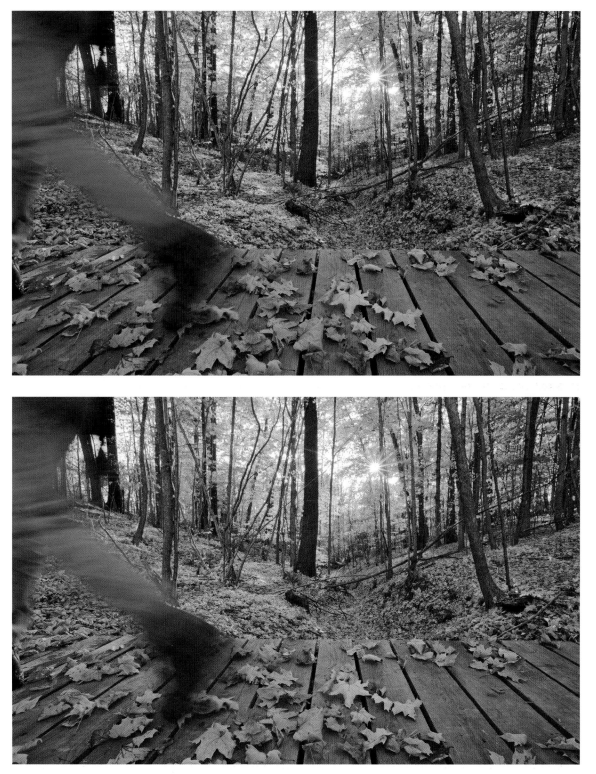

White balance is set before capture, but can easily be adjusted in post-processing, especially with RAW files. I exposed this image with my camera set on the Shade white balance setting, which resulted in the very warm, orange version of the image (bottom). I didn't care for this version, so I adjusted the color in Lightroom, making it cooler with the White Balance sliders (top).

▶ SETTING A CUSTOM WHITE BALANCE

Sometimes the auto white balance setting on a camera can be thrown off, especially if your scene has a majority of one color (such as when you fill the frame with a carpet of green moss). If choosing one of the white balance presets (daylight, cloudy, shade) doesn't fix the problem, you have three options:

1. Adjust the White Balance in Post-Processing. Using a RAW image processing program like Lightroom, you can adjust an image's white balance after capture. You can do this manually by adjusting the Temperature and Tint sliders, or automatically by using the Eyedropper tool. This is explained in detail in Section 4.

2. Set a Custom White Balance Using a Neutral-Toned Object in the Scene. For this technique, find an object that is neutral gray or white and in the same light as the subject you are photographing. Take a picture of this object, being sure to fill the frame with it. You can then tell the camera to use this image for setting a custom white balance. I keep a commercially produced white balance card (like a gray card) in my camera bag in case there is no neutral-toned object nearby.

3. Set a Custom White Balance Using a White Balance Filter. I sometimes use a white balance filter by ExpoDisc to set a custom white balance. This is basically an opaque white filter that you place over the camera's lens. With the white balance filter on your lens, point your camera at your light source (not your subject) and take a picture. Then set the camera's custom white balance to use this image for determining white balance.

want to attempt to correctly adjust your white balance while shooting, choosing the daylight, cloudy, or shade white balance setting to match the light. If you still notice a strange color cast in a particular image, you can set a custom white balance (see explanation above).

It should be noted that many outdoor scenes contain more than one color temperature. On a sunny day, part of the scene will be lit directly by the sun, which will have a daylight color temperature, while other parts will be in the shadows, which will have a cooler (bluer) color temperature. In this case, you can't choose one white balance setting that will be correct for the entire scene. Instead, choose a white balance that is correct either for the highlights or the shadows. A daylight white balance will result in the directly lit part of your scene having a correct color balance, while your shadows will have a blue color cast. A cloudy or shade white balance will warm up your shadows, but it will also warm up the rest of the scene. It's up to you to decide which looks best for the image you are making.

Shooting in RAW

If you are planning to maximize the look of your images by learning and using the digital darkroom techniques described in Section 4: At the Computer, you will want to get in the habit of shooting your images using your camera's RAW format. A RAW file is like a digital negative that contains the image data as captured by a camera's sensor. That "raw" data gives you the maximum amount of flexibility when using a RAW processor, such as Adobe Camera Raw or Lightroom, to make changes to tone and color when optimizing an image for output, whether on a computer screen or in a print.

By contrast, if you shoot in JPEG format, the camera is applying those tonal and color changes for you using the camera's software. For many images, this may work fine, but if you need to make changes to things like exposure, white balance, or color saturation, a RAW file will give you much more leeway than a JPEG before the image begins to degrade and show digital artifacts like banding (unnatural looking transitions between tones and colors) or noise. It is also much easier to recover detail in overexposed highlights from a RAW file than it is from a JPEG. For this reason, I always shoot using my camera's RAW format.

The disadvantages of shooting in RAW are file size (RAW files take up much more memory than JPEGs) and the need for post-processing (JPEGs are ready to email or print right out of the camera, while RAW files must first be converted to a JPEG or TIFF.) For me, the advantage of being able to better manipulate RAW

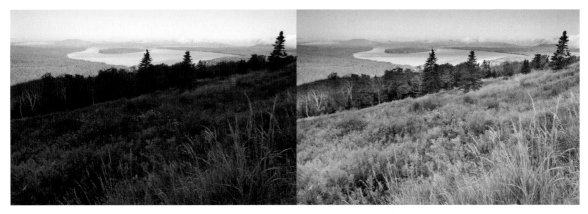

Above, left: Shooting in RAW format makes for smoother tonal changes in post-processing. This photo is how the file looked coming out of the camera. Above, right: This is the same image after processing the RAW file in Lightroom.

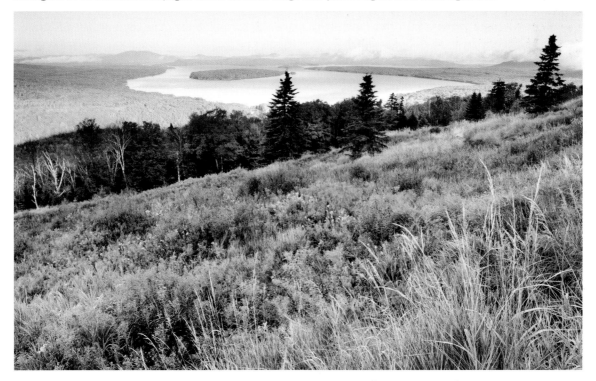

This is the image processed in Lightroom from a JPEG, rather than RAW, version of the image.

files versus JPEGs outweighs the disadvantage of having to do that during post-processing. As you'll see in Section 4, it is easy to create efficiencies in your post-processing workflow to reduce the amount of time you spend on the computer.

If you find yourself shooting in JPEG mode due to camera memory or time constraints, take care to do three things at capture:

1. Nail down the exposure using your histogram (which you should always do anyway).
2. Achieve proper white balance using the techniques described previously.
3. Learn how to set your camera's custom settings for contrast and saturation based on different lighting situations. You will want to take the time to learn and experiment

with these settings under various lighting conditions, and have custom settings set ahead of time for cloudy conditions, Golden Hour light, and high-contrast mid-day light. Check your camera manual to determine how to set up custom settings for your particular camera.

Controlling Light

With outdoor photography, you are usually relying on natural light, but there are situations where you can improve a photo by controlling that light to some extent. I'll often add light when a person's face is in shadow, and I regularly add or subtract light when photographing close-up subjects like wildflowers, mushrooms, and ferns. There are three techniques that I use: adding light using a flash, reflecting light into the scene, and diffusing existing light.

Dedicated flash units have become very easy to use over the past decade, as manufacturers have done a great job of automating the process and making it easy to add fill light to a scene or even synchronize multiple flash units. (Fill light is light added to the shadows of a scene without noticeably adding light to the highlights.) Setting up complicated, multi-flash photographs is beyond the scope of this book, but using a single flash to fill shadows is an important and relatively easy skill to learn. Use fill flash when a majority of your image is in direct light but part of the main subject is in shadow. By adding fill light to these shadows, you bring out detail in the subject that might otherwise be lost.

My goal in using fill flash in an outdoor photograph is to bring out detail in a shadow area without making it look obvious that I used a flash. To do this effectively, I use several tech-

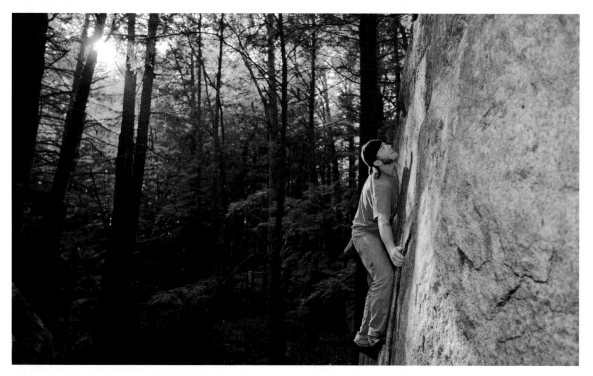

Because the sun backlit this scene, I was concerned about retaining detail in the climber's face, which was in shadow. I added fill light by using a flash unit held off-camera and covered with a LumiQuest SoftBox. This brought out the detail in the climber without overexposing the highlights in the scene.

I photographed this toad on an overcast day. The diffuse light reduced the amount of detail visible on the toad, so I decided to use some fill flash (with a SoftBox and -1 stop of exposure compensation on the flash). The direct light of the flash brought out more detail in the toad.

niques. First, I usually try to avoid using the flash in the camera's hot shoe (the flash attachment on top of the camera) by holding the flash off to the side and connecting it to the camera using a sync cord. I'll vary the location of the flash, and check my images on the LCD until I get a shot in which the angle of the light looks natural. Second, I soften the light of the flash by attaching a flash diffuser, such as a SoftBox by LumiQuest or a collapsible Lightsphere by Gary Fong. Third, while I will use the flash's automatic exposure mode (usually called TTL or ETTL), I will adjust the exposure on the flash to be brighter or darker based on how my image looks on the LCD. How much you adjust the flash depends on the situation, so it is really a trial-and-error process. By varying these three techniques and making adjustments based on how things appear on the LCD, you can easily get a variety of looks (and hopefully one that you like!) without having to get extremely technical.

An alternative to fill flash is to add fill light by reflecting light into your shadows using a reflector or even a large piece of white foam core board. Reflectors come in various sizes and colors. Large reflectors may be impractical for backcountry locations, but I usually carry a small, pocket-size reflector that I can use for macro-photography. The purpose of reflectors is the same as with flash — to add fill light to a shadowy area in order to bring out details in your subject. It is amazing how a little reflected light can change the qualities of a photo.

By using different color reflectors, you can add different colored light to your subject that balances with existing light. With a white reflector or foam core you add in white light. During Golden Hour light, you can use a gold reflector to add warm, golden light to your subject. The biggest challenge with a reflector is positioning it just right so it reflects existing light onto your subject. You may need an assistant to hold it, or

Using a gold reflector added a warm light to this close-up of a violet, as seen in the image on the right.

Using a diffuser on close-up shots creates even light without shadows, as seen in the tulip image on the right.

you can use a reflector bracket or an adjustable clamp, or just lean it against a rock or your tripod's legs.

The third way I control light is to diffuse direct sunlight using a translucent white diffuser. This works superbly for close-up photography on bright, sunny days when you want a softer light than the harsh mid-day sun provides. You can buy ready-made diffusers in rectangular frames or umbrellas, but I use a cheap and portable handmade version. My diffuser is a large rectangular piece of translucent white nylon that I bought at a fabric store. I've sewn sleeves on two sides that slide over my hiking poles, which I can then hold up over my subject to remove the harsh shadows caused by direct sunlight.

By placing the diffuser as close as possible to my subject, I get a nicely diffused, bright light that makes for good exposures. As when using reflectors, you may need a friend to hold the diffuser for you while you shoot, unless you can find a way to lean it against your tripod and a rock or tree trunk. You can also use your camera's self-timer to give you a few seconds to hold the diffuser in place before the shutter fires. As a last resort, I'll shade a subject with my body or camera bag when I don't have my diffuser. This does the job of removing shadows, but it also adds a bluer cast to the photo compared to using a diffuser—be sure to check your white balance if using this method.

Filters

Filters are pieces of glass or plastic that you place over your lens to change the tone or color of light reaching your camera's sensor. With the white balance setting on cameras adjusting for different colors of light, only filters that affect exposure are needed with digital cameras. There are three types of filters that are still regularly used by outdoor photographers: polarizing filters, neutral density filters, and graduated split neutral density filters.

A polarizing filter, or polarizer, is a rotating filter that screws onto the front of your lens. You adjust the polarizing effect by rotating the filter. Polarizers are used for two main purposes: to darken a blue sky or to saturate colors by reducing glare on surfaces in the photo. Polarizers have the greatest effect when the camera is pointed at a 90-degree angle to the sun. For this reason, care must be taken when using a polarizer to darken your sky; depending on where the sun is in relationship to your subject, you may end up with a very unnatural-looking sky that is part polarized, part not polarized. Also, I don't recommend taking big landscape photos with a polarizer and a wide angle lens, as the field of view may be so large as to include parts of the sky that are not polarized.

I primarily use a polarizer when photographing forest or water scenes, especially on overcast days. Foliage often reflects quite a bit of light, whether it is from dew or rain or the waxy covering of the leaves. These reflections of white or blue light detract from the natural colors of the foliage. A polarizer can reduce these reflections, giving your photos more natural and saturated colors. Streams, rivers, and ponds can also turn an ugly gray or white from the light reflected on their surface. A polarizer can remedy this problem by reducing glare and darkening the water. This is especially effective on small, shallow streams, as a polarizer makes the rocks and other objects under the water more apparent. The effect of a polarizer in these situations varies depending on the angle of the light, but you can always see the results through your camera's viewfinder, making it easy to determine whether a polarizer is beneficial.

Neutral density filters are neutral-toned filters that screw onto a lens and reduce the amount of light reaching the sensor without

affecting the color of the scene. They come in different strengths, reducing the light by anywhere from 1 stop to 6 stops. However, I use a variable neutral density filter by Singh-Ray that lets me adjust the strength of the filter from 2 stops to 8 stops, rather than using separate filters for each stop. Use a neutral density filter to reduce the amount of light reaching your sensor any time there is too much light to get a properly exposed image using a particular shutter speed. For instance, you may want to use a large f-stop to get a very shallow depth of field, but even at your lowest ISO and fastest shutter speed there is too much light to get a properly exposed image. Or you may want to use a very slow shutter speed

such as 4 seconds to blur a waterfall or rushing stream in your image. In either case, by using a neutral density filter, you can reduce the amount of light reaching your sensor and thus use a slower shutter speed to get the proper exposure.

Graduated split neutral density filters are rectangular filters that are half neutral density filter, half clear. They can be attached to the front of a lens using a filter holder or they can be held in front of the lens by hand. They are a necessary filter when shooting landscape scenes where the top of your photo is in direct sunlight but the foreground is in shade. In this situation, the well-lit portion of a scene may be so much brighter than the foreground that there is no one

This scene was shot twice, with a polarizer (left) and without (right). A polarizer is ideal for forest scenes, as it reduces reflections on the leaves, allowing the true color of the leaves to come through.

Another scene shot with a polarizer (right) and without (left). In this case, the polarizer eliminated glare on the stream.

exposure that can capture detail in both high-lights and shadows. If you find yourself taking early-morning or late-afternoon landscape photos with beautiful skies and muddy foreground subjects lacking in detail, use this filter.

By matching up the horizon line in your photo with the center of the filter you can balance the exposure in the scene by darkening the bright, top portion of the scene without affecting the foreground. The gradual nature of the filter helps mask the filter's effect. Like straight neutral density filters, graduated split neutral density filters come in varying strengths. I find a 3-stop filter to be the most useful. You can also get these filters with either a soft edge (where the neutral density part of the filter meets the clear part of the filter) or a hard edge. Soft edges are good for scenes where the demarcation line between

shadows and highlights is variable (with trees or mountains, for example, in the way). Hard-edge filters work well only with very well-defined horizons, such as in ocean or prairie scenes.

SHOOTING SHARP IMAGES

Unless they are intentionally adding blur to an image for creative effect, most outdoor photographers strive to achieve maximum sharpness in their images. Not only is sharpness the hallmark of a well-crafted image, it greatly affects the size to which an image can be enlarged. A little camera shake might not be visible in a small 4″ x 6″ print or a thumbnail in a web gallery, but once that image is bigger, the blur caused by that camera movement will significantly detract from its effectiveness. Lens quality affects sharpness, but as I mentioned in the gear section of this book,

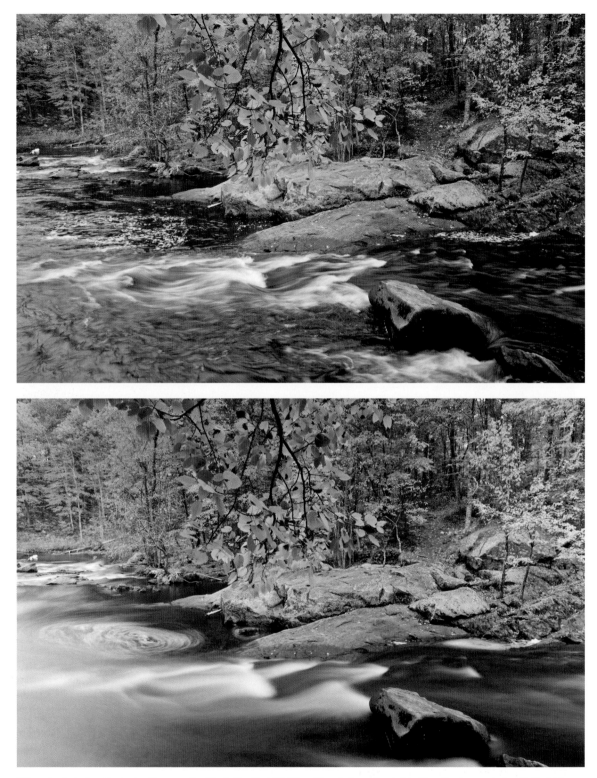

This pair of photos illustrates the use of a Singh-Ray Vari-ND filter. The photo without the filter (top) was shot at F16, 1/5 second. With the filter (bottom), I was able to shoot at F16 and 15 seconds, blurring the water and introducing the swirl created by an eddy in the stream.

you should buy the sharpest lenses you can afford and then work with what you have. By using the following techniques you can maximize sharpness no matter what lens you are using and get good results when enlarging your photos.

1. Hand-hold your camera only when using a tripod is impractical, such as when you are photographing fast-moving action or you can't afford to carry the weight of a tripod. When hand-holding your camera, the general rule of thumb is to use a shutter speed at least as fast as the inverse of the focal length of your lens. For example, for a 50mm lens, use a shutter speed of 1/50 second or faster. However, in practical terms, the ideal shutter speed varies based on your ability and on whether your lens or camera has some sort of image stabilization. In general, I try to use a shutter speed of 1/250 second for non-stabilized lenses and 1/125 second for stabilized lenses, though I'll sometimes try around 1/60 second for very short focal lengths. Learn your limits, and if you can't achieve a fast enough shutter speed to stop camera movement, use a tripod.

2. Use a tripod! Tripods are a necessity for keeping an image sharp, especially when shooting with small apertures and slow shutter speeds. The heavier your tripod, the better it will be at stopping camera shake, both from your own handling of the camera and from wind. If your tripod has a center post, avoid cranking it up too high, as this negates the stabilizing effects of the tripod legs. You are better off using a tripod with longer legs and no center post. If you are unwilling to carry your tripod on a hike or other remote adventure, brace the camera against a tree, rock, backpack, or jacket to get sharper images, as long as your shutter speed isn't too slow (1/4 second or slower).

3. Use a remote shutter triggering device to remove the chance of camera shake caused by pressing the shutter button. Some cameras come with an infrared shutter remote. Those that don't have a place to plug in a cable release, which is basically a button attached to the camera via a cable that lets you trip the shutter without touching the camera. You can also purchase expensive radio-controlled remote triggering units, but these are necessary only if you need to trigger the shutter from a location more than a few feet from your camera. By using a cable release or other triggering device, you eliminate any camera shake introduced when you press the shutter button. This camera shake can be quite noticeable at shutter speeds of 1/30 second and longer, so you will def-

▶ **MASTERING THE GRADUATED SPLIT NEUTRAL DENSITY FILTER**

Using a graduated split neutral density filter is a terrific way to improve your landscape photos shot during the Golden Hour. It is an easy filter to master, but you first need to recognize the situations in which it should be used. It is common near sunrise and sunset to have a foreground that is in shadow and a background or sky that is lit by low-angle sunlight. If you face this situation and you need to get details in both your foreground and your background, break out this filter and give it a try. If you want to get technical, you can take separate meter readings off your foreground and background to measure the difference in brightness between the two parts of the scene. I typically use my graduated split neutral density filter whenever this difference is 4 stops of light or greater. For example, if my foreground requires an exposure of F16 and 1/2 second while my background requires F16 at 1/30 or faster, I'll use the filter to balance the exposure.

To use the filter, place it in front of the lens, hold down your camera's depth of field preview button, and look through the viewfinder, sliding the filter up and down until it matches the scene's horizon. This will give you a more accurate view of how the filter will affect your photo. Once you have the filter in place, meter the scene and shoot. Then check your histogram and adjust your exposure accordingly to ensure you are getting the brightest exposure possible without clipping any highlights.

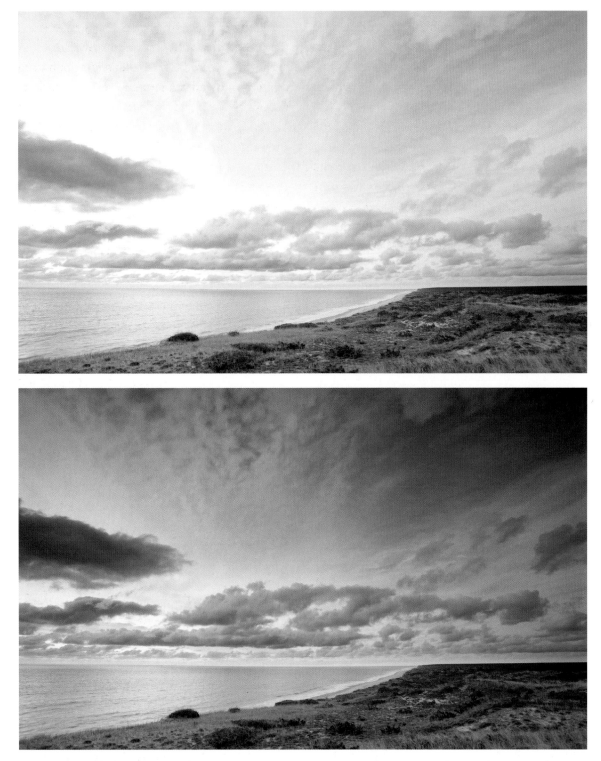

These images were shot with the same exposure settings, F11, 0.8 seconds. Top: In the image without a filter, the sky is overexposed. Reducing the exposure would have solved that problem, but the foreground would have been much darker, losing detail. Bottom: To retain the foreground detail, I used a 3-stop, graduated split neutral density filter to darken the sky without affecting exposure in the foreground.

initely want to get in the habit of using a cable release at these speeds. Alternatively, you can use your camera's self-timer feature. Set it to fire two seconds after you press the shutter, and the camera shake introduced by pressing the shutter will dissipate before the shutter actually fires.

4. Use the mirror lockup feature if your camera has one. SLRs have a mirror between the lens and the shutter that reflects the image to your viewfinder so you can compose your images. When you press the shutter, the mirror flips up to allow the shutter to open and light to reach the sensor. This action can cause enough camera shake to introduce a small amount of blur to an image at slower shutter speeds (somewhere around 1/30 second and slower). Some SLRs have a mirror lockup feature that lets you lock the mirror in place before taking your picture. This makes the viewfinder go black, so compose your image first, lock up your mirror, and then press the shutter, preferably with a cable release. (If you are using your camera's live view feature, it has already locked the mirror up.)

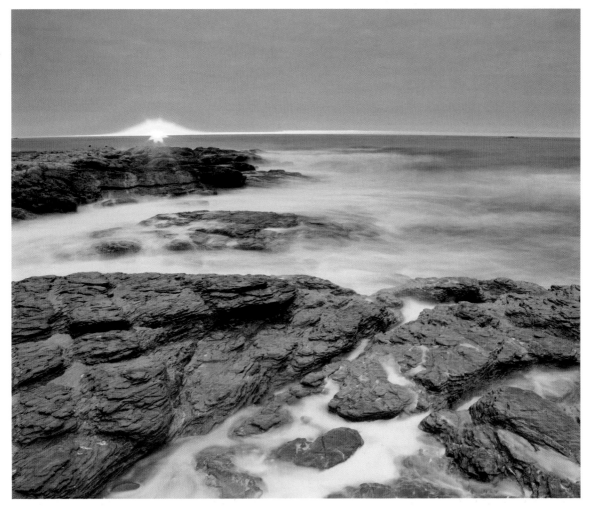

Landscape images like this seascape require sharpness from foreground to the horizon. To achieve that sharpness in this image, I used a small aperture (F16). For the correct exposure, I needed a shutter speed of 2 seconds. I used a tripod, cable release, and mirror lockup to dampen any camera shake, avoiding camera blur.

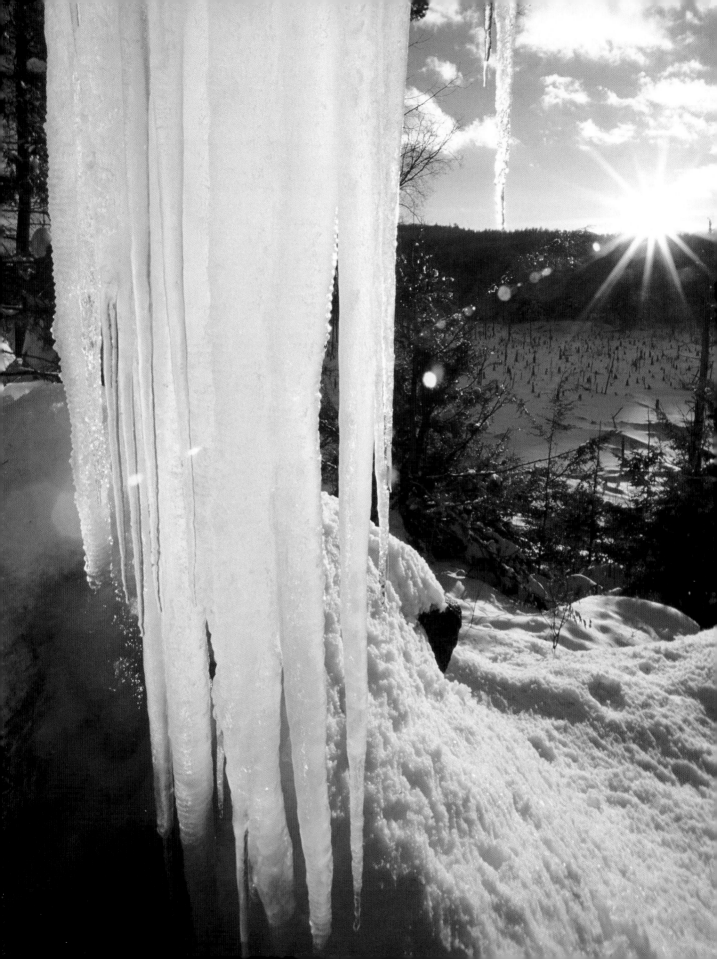

I HAD SPENT MOST OF THE DAY HIKING THE APPALACHIAN TRAIL IN MAINE, struggling to keep myself dry in a constant rain that fluctuated between light mist and steady showers. I was mostly concerned about making mileage, lost in thoughts of getting warm and dry in my tent, when I came across a cascading stream set in a forest of trees with fresh spring buds. The new foliage seemed to drip with color in the wet and overcast light, and the stream, swelling with water from the rain, provided the contrast and drama I needed to make a classic photo of spring in a New England forest. Changing my mental focus, I stopped my march, retrieved my camera from its protective coverings in my pack, and settled in to make the photograph.

While the shooting techniques described in Section 2 apply to all conditions, different seasons and weather bring additional challenges and opportunities to the outdoor photographer. In fact, many photographers seek out bad weather because it often results in more-dramatic lighting conditions. Knowing what to expect and look for in different weather conditions is an important skill for any outdoor photographer, and in this section, we'll look at how to approach the variations of light, color, and moisture that can affect images of the outdoors.

PROTECTING YOUR GEAR

Before heading out in inclement weather, care must be taken to protect your camera and lenses. Moisture is especially damaging to camera equipment as it can quickly render the electronics of a camera or lens inoperable. As I mentioned in Section 1, many camera packs now come with a built-in rain cover. No matter how you carry your gear, make sure you have some sort of waterproof covering with you in case of rain or snow — the zippers on most packs won't keep out water. If you are planning to be out for a long time when downpours are possible, consider also bringing some big Ziploc bags to place your gear in for extra protection. I would also use these techniques in windy conditions in the desert or in beach areas where blowing sand could be a problem.

Shooting while it is raining or snowing requires additional precautions. First, if your lens came with a lens hood, use it. This will help to keep drops from forming on the front of your lens. Second, you need some way of keeping rain off your camera while you are shooting. The simplest solution is to use an umbrella (this will keep the rain off you too!). The challenge is holding the umbrella and shooting at the same time. I'll clamp my umbrella to my tripod using a Manfrotto Super Clamp. A willing helper holding the umbrella is an even better solution.

If you don't want to carry an umbrella, you can use plastic bags and rubber bands as an inexpensive way to keep your gear dry. Cut a hole in the bottom of the bag and slide it over your camera so that one opening is at the back of the camera and the other opening is at the end of your lens. Use the rubber bands to secure the bag in place.

Alternatively, you can buy rain coverings

Icicles dominate this winter landscape.

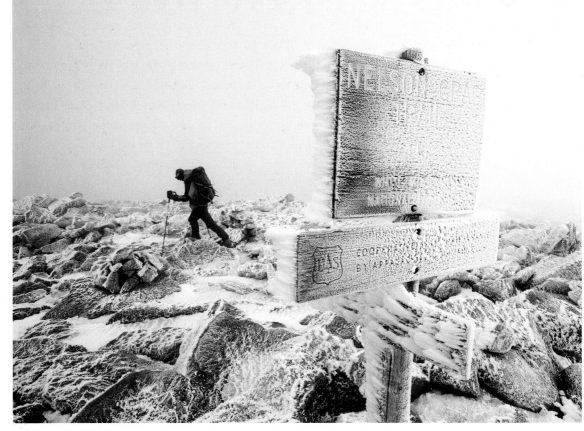

A hiker leans into 50-mile-per-hour winds on the summit of New Hampshire's Mount Washington.

that are specifically designed to cover your gear but still allow access to your camera's controls. These rain covers range from inexpensive, glorified plastic bags that cost under $10 to sophisticated waterproof nylon covers that cost as much as $150. These covers come in different sizes to match different-sized SLRs and lenses. I typically use a midrange Storm Jacket by Vortex Media that has elastic bands that cinch over the front of the lens and the back of the camera, as well as a Velcro bottom opening where I can reach in and work my camera's controls.

In really wet conditions, water will accumulate on your gear even with a camera covering. Use a cotton T-shirt or small towel to wipe moisture off your camera body and lens barrel and a microfiber lens cloth to keep the front of your lens dry. It is good to have a few of these in your bag since after a few wipes they will be too wet to be of much use.

In warm, humid environments you may need to wipe your gear regularly even if it is not raining. For trips in the tropics, humidity is a big concern, and in addition to keeping towels handy you should store your camera and lenses in your pack with silica gel desiccants, which will absorb moisture and prevent mold from forming in and on your gear.

Of course, even in good weather, photographers are drawn to water. When paddling in a canoe or kayak, store gear in a dry bag to keep it safe from incidental splashing and from water pooling in the bottom of the boat. If there is any chance of capsizing, double-bag your camera

and lenses beforehand; even dry bags can leak in some instances, which I learned during my inaugural season of whitewater kayaking, when I was prone to being flipped by rocks and waves.

Of course, eventually you will get your camera out and shoot. Short of encasing your camera in an expensive waterproof housing, all you can really do to keep it from getting wet when paddling is to be cautious: Know your limits when paddling in moving water and wavy conditions. The main thing I do to keep my camera from falling in the water is to wear my camera strap around my neck, even when using a tripod. (I've seen more than one tripod tip over into water, destroying the camera). Inevitably, you and/or your tripod are going to get wet. If your tripod has been partially immersed in mud, sand, or salt water, rinse it in fresh water after your shoot to keep it from corroding.

Winter conditions create problems for your gear. Snow can actually be easier to deal with than rain, especially if your camera is cold enough that the snow won't melt on it. However, whenever snow gets on my camera, I use a Giotto Rocket-Air Blower (basically a rubber bulb and tube that you squeeze to blow air) to blow the snow off; using your hands can melt the snow onto your camera.

A drizzly spring day can be ideal for forest scenes. This image was shot at F11, 1.3 seconds, with a cable release and an umbrella keeping the camera dry.

A bigger concern is condensation. Whenever you bring your camera in from the cold, the warm and moist indoor air will immediately condense on your camera body and lens, and can even condense on interior elements in the lens. You won't be able to shoot for hours if you have a fogged lens, and if you head back outside it will instantly freeze. This is a good way to ruin a photo outing and potentially damage your camera. When going inside after a cold-weather shoot, leave your camera gear tightly stowed in your camera pack until it has warmed up to near room temperature. Be sure to stow it *before* you go inside. (You can also place your gear in sealed plastic bags before heading indoors if you need your gear to warm up a little faster.) For the same reason, do not try to warm up your camera inside your jacket after it has been out in the cold. The enclosed, warm environment next to your body contains plenty of moisture that will immediately fog your lens.

Cold is not as much of a problem as moisture in the winter since it typically won't damage a camera. However, cold weather does sap battery power much more quickly than warmer conditions. Lithium batteries hold their charge better in the cold than alkaline batteries, so if you have a choice, invest in lithiums for winter outings. Most rechargeable batteries specifically designed for the camera (this is usually the case for DSLRs) are lithium batteries. If using rechargeables, make sure they are fully charged before heading out and carry one or more spares, depending on how cold it is and how long you plan to be out.

Carrying batteries in a pants or shirt pocket next to your body will keep them warmer and make them last a little longer than if stored in the cold recesses of your camera bag. You can also extend battery life by using your LCD and autofocus sparingly, as these tools are big power users. You can keep spare batteries fresh by storing them with chemical hand warmers. For extended trips when you will be out for several days and unable to recharge batteries, you will need to bring more batteries or purchase a separate power pack that can be plugged into the camera.

IN SNOW, ICE, AND COLD

Winter is a beautiful time for photography, but it is cold and wet, relegating some photographers to spending the season inside, working on their computers and organizing the thousands of images they shot during the past spring, summer, and fall. This is a mistake. When snow blankets the landscape, it creates a visual calm that mirrors the quiet of the season. Snow covers many of the distracting elements that confound compositions during other times of year, like downed tree limbs and tangled vines. The light can be easier to embrace than in other seasons as well. The sun hangs lower in the sky, and the atmosphere holds less moisture, dust, and pollution, making for clearer skies and cleaner light. Deciduous trees have lost their foliage, which allows more light to reach the forest floor, opening up shooting opportunities that don't exist in the dappled light of summer. Ice makes for a great subject too. It is translucent, yet also reflects light. It forms into all manners of shapes and textures that work well as compositional elements in both big landscape scenes and tight abstracts.

Succeeding at winter photography begins with keeping your body warm, which in turn keeps your brain working. By learning to dress properly for the conditions, you can comfortably shoot for hours in winter conditions. Dress in layers, starting with a thin layer of silk or polypropylene to wick moisture away from your body. Add an insulating layer of wool or fleece and an outer layer of water- and wind- resistant Gore-

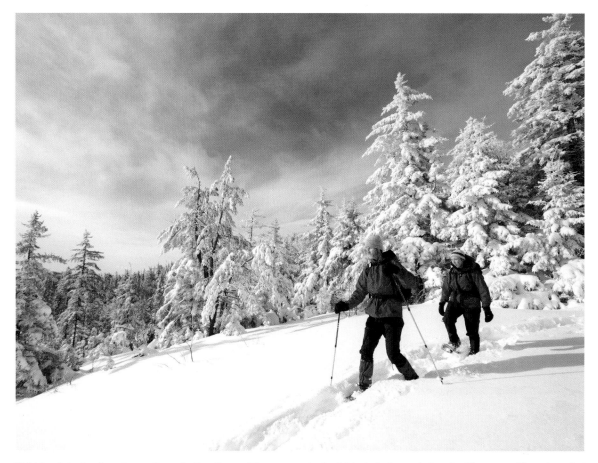

Light in winter is often cleaner than at other times of the year, and a fresh blanket of snow helps simplify compositions. Learning proper winter outdoor skills is essential to succeeding at winter photography.

Tex or other breathable fabric. The key to all of these layers is not to wear cotton, which will get wet with sweat or water and lose its insulating properties, making you cold and uncomfortable at best and hypothermic at worst. Add or subtract insulating layers depending on how cold it is and how much heat you are generating from physical activity. Wear a hat or balaclava and insulated boots with a waterproof shell. Also, drink water and snack regularly because your body needs the fuel to generate the heat it is losing to the cold air.

Keeping your hands warm in winter is especially challenging when doing photography as you need to use your fine motor skills on a regular basis. I recommend wearing a pair of thin silk or polypropylene glove liners under wool or fleece mittens. If it is especially cold, windy, or snowy, wear a pair of water- and windproof over mitts. Keep these on while you search for your photo opportunities, and take them off only when you need to shoot. Most glove liners are thin enough to allow you to work your camera's controls. They will keep your hands much warmer, because as you touch your camera with bare hands, the cold metal and plastic sucks the warmth from your skin quickly. If you shoot often in very cold weather, place a pair of chemical hand warmers in your mittens to reheat your hands quickly when they get too cold to shoot.

An in-depth primer on winter outdoor skills is beyond the scope of this book, so if you are planning on undertaking winter adventures for

Snowy scenes tend to fool a camera into underexposing images. Top: The image was shot at the camera's suggested exposure, F2.8, 1/1000 second. Bottom: I then added two stops of light, shooting at F2.8, 1/250 second to expose the second image properly.

the first time, I recommend you read up on the subject on the Appalachian Mountain Club website (outdoors.org), read the *AMC Guide to Winter Hiking & Camping*, or take a winter skills course from an outdoors organization in your area. AMC has several offerings in the northeastern United States every winter.

With a warm body, you are ready for winter photography. As I mentioned earlier, composition can often be easier in winter because snow simplifies the landscape. Three photographic elements I concentrate on when shooting in winter are exposure, the color of light, and texture.

Exposure can confound photographers who shoot in program mode and just point and shoot at a winter scene without making any adjustments. Since a camera meter is basing exposure on middle gray, it is often thrown off in winter because a snowy landscape is usually 1½ to 2 stops brighter than middle gray, causing the

The warm light of sunrise imparts a yellow hue to the snow and ice lit by the sun in this winter scene. However, the shadows appear blue—the opposite color of the direct sunlight.

Clear skies and clean winter air can make for richly saturated colors before sunrise and after sunset.

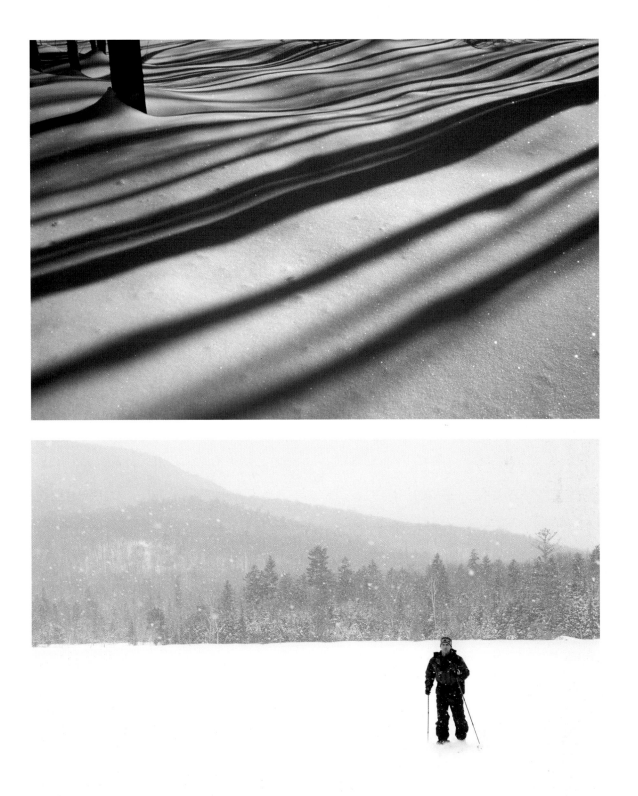

Top: The beautiful variety in the texture of snow is best featured by direct sunlight, especially low-angled side lighting or back lighting. Bottom: Diffuse, overcast light results in a soft, featureless look to the snow.

camera to underexpose the scene. To ensure that your snow is properly exposed, you will need to add that 1½ to 2 stops of exposure to your meter reading. You can easily nail down exposure in a winter scene by spot-metering on a section of snow and adding 2 stops of light. Take the shot and then check your histogram. You should have pixels reaching all the way to the right side of the graph if you are exposing the scene correctly.

The color of light takes on added importance in winter photography because snow perfectly reflects the warm hues of direct light and the cool colors in the shadows, making it an integral part of any winter composition. When we're out in it, snow almost always looks white because we expect it to be white; we don't always pay attention to the color casts that might exist. However, camera sensors don't have that mental filter, so the true color of snow is recorded, whether it's white, gray, blue, yellow, orange, or purple.

Snow always reflects the color of light illuminating it. At Golden Hour time, snow lit by direct sunlight is usually yellow or orange, while at midday it is white and sometimes blue on very clear, blue-sky days. In the shadows on a sunny day, snow will appear as the opposite color of direct sunlight. With yellow or orange sunrise and sunset light, the shadows will have a blue or even purplish cast. In midday, shadows will be black or gray. On shadow-free, overcast days, snow will usually appear white, but can have a bluish cast in areas that would be shaded if the sun were out, such as in a gorge or valley where the sun is behind a mountain.

You can always compensate for color casts in the snow by adjusting your white balance or using other post-processing techniques. However, I find the different colors reflecting off

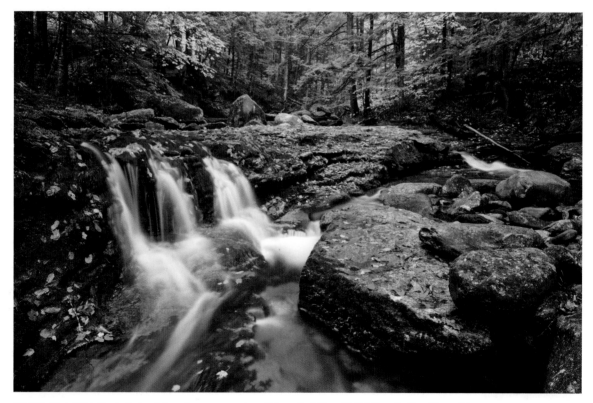

On wet days, I like to photograph forest scenes, such as this waterfall and fall foliage in New Hampshire.

Sometimes it is necessary to get into the water to make the best compositions. For this photo, I was standing in the surf, hand-holding the camera but keeping the camera strap around my neck to lessen the possibility of immersing my camera in salt water.

snow to be one of the most compelling features of winter photography and I prefer to leave my snow the color that was captured by the camera.

One aspect of winter photography that seems to resonate with photographers is the incredible texture found in fresh snow, wind-blown snow, frozen snow, or any kind of snow. The texture of snow varies, of course, but when it's photographed properly, viewers feel like they can almost reach out and feel the individual snow crystals, enhancing the sense of place inherent in a photo. Texture can become a major compositional element in a winter photo, such as when there are repeating patterns of windblown snow ripples. Texture can also be an element that subtly enhances the overall image, such as when low-angled light brings out spectacular highlights in snow crystals after a storm.

The appearance of texture is greatly affected by the quality and direction of light. Diffuse, overcast light casts virtually no shadows, so you won't see many details in snow in this type of light—the snow appears very soft and featureless. Direct sunlight reveals the most texture, as the light casts shadows into every nook and cranny on the surface of the snow. While overhead, direct sunlight shows more details than overcast light, low-angled side light and back light reveal the most texture in snow—just one more reason to shoot in early morning and late afternoon.

IN RAIN AND NEAR WATER

Rain and fog, and the water in streams, ponds, and the ocean, also create opportunities for photographers. Despite the challenges of keeping your gear dry in bad weather, the extra effort can pay big dividends because the cloud cover creates a beautiful diffuse light that imparts a quiet, sometimes somber mood to a scene. When storms break, they are often accompanied by dramatic light as the sun streams through breaks in the clouds, creating a brilliant contrast between dark clouds

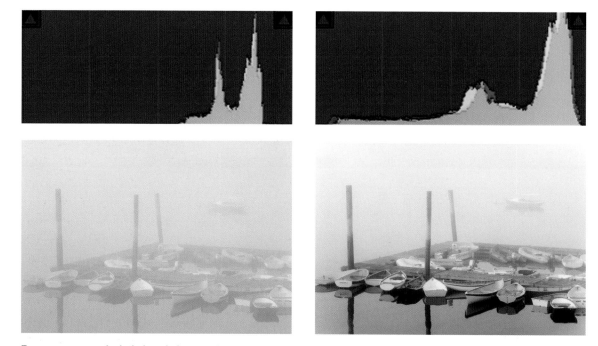

Foggy scenes can look dark and gloomy unless exposed a stop or so brighter than the camera suggests. Left: Note how the histogram for this foggy harbor scene is skewed toward the bright side of the graph. However, because of the low contrast of the scene, the resulting photo lacks "pop." Right: This is the same photo after adding blacks using the Blacks slider in Lightroom. This added contrast to the scene and brought out some of the color in the boats.

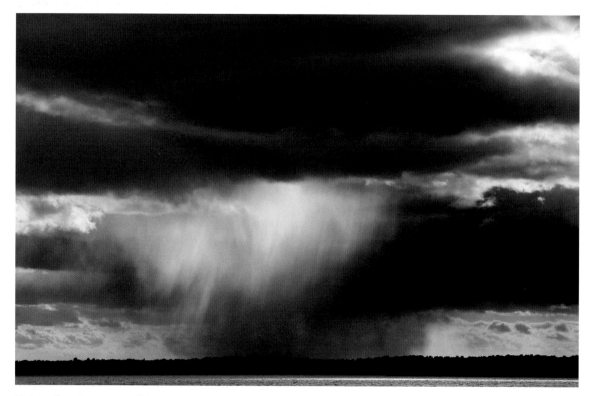

Bad weather often creates light that turns an ordinary scene into a dramatic one.

and brightly lit elements in the landscape. And, of course, rainbows can't happen without some rain.

Forest landscapes look great in wet conditions, as the moisture on the foliage seems to amplify color in the even light. To accentuate that color, it is usually necessary to use a polarizing filter to reduce the glare of reflections on the leaves (see page 59). A polarizer will also help to reduce the white glare on streams and rivers in your forest scenes. Take care to eliminate as much sky as possible from your forest compositions—find an angle you can shoot without the sky peeking through the trees. Because the forest is a dark place in the rain, those patches of white sky will be much brighter than the rest of your photo. Since our eyes are immediately drawn to the brightest part of a photograph, those white patches can greatly distract from the lush colors of the forest.

In mountain landscapes, low-hanging clouds can add drama to a photograph. In this case, include just enough of the clouds to show that drama. Use the top third of the image for the cloud and its intersection with the landscape where this edge helps define the cloud. Showing too much sky can result in large areas that are white and free of detail, lessening the impact of the photo. Be sure to check your histogram to ensure you are exposing the scene brightly enough. Expose your image so the whitest parts of the cloud are bright, but not overexposed. Usually, this will be sufficient to create both well-exposed midtones and shadows, but if the darker parts of the image seem a little muddy, try using a graduated split neutral density filter to balance out the exposure (see page 63).

In the fog, you will end up with very low contrast light, with a narrow range of tones. Your histogram will show a bell curve that is only 1 or 2 stops wide. Choose your exposure based on the mood you want to create. If you want a lighter mood, expose your image so that the bell curve is in the right half of the histogram; this will show the fog as bright white. For a more mysterious or somber mood, make a darker exposure, so that the histogram's bell curve is about 1 stop brighter than midtone gray. This gives the fog some brightness while retaining detail. Because of the narrow range of tones, foggy images almost always need some tweaking when you process the RAW file in order to add enough contrast to saturate what colors exist in the scene. This is often accomplished simply by adding blacks using the Blacks slider in Lightroom or Adobe Camera RAW (see page 101).

Of course, you don't need wet weather to use water as a powerful compositional element. Some of my favorite images have been shot on sunny days from a kayak or canoe, or while I was standing in a pond, stream, or ocean surf. I'll use a tripod when possible, but I often hand-hold my camera for these shots because a tripod just isn't practical.

In still water, look at the color of the water, which is always reflecting either the sky or objects at the water's edge. Move your camera to different angles and heights until you see the best reflections; sometimes this means being just above the water's surface. At the ocean or near whitewater, look for interesting shapes and lines in the moving water to use as compositional elements. Both techniques can invoke strong feelings of motion and power. Adjust your shutter speed to either blur or stop the action, depending on the mood you want to create, and be sure to properly expose that whitewater—it should be as bright as possible without being overexposed.

IN FALL FOLIAGE SEASON

Fall is, of course, a favorite time for photographers, as the cool colors of summer forests give way to a kaleidoscope of hues. Having lived in

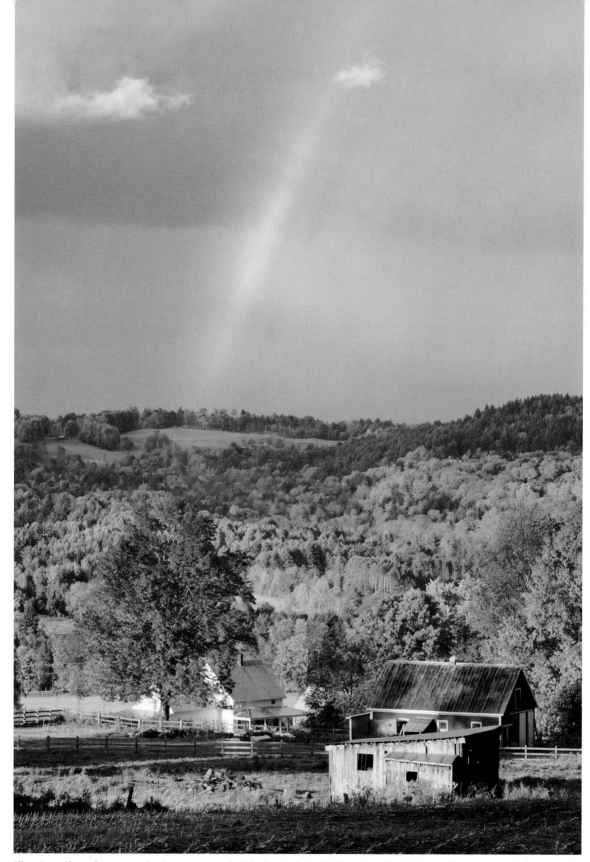

Like at any time of year, open landscape scenes in fall often look best in the dramatic light just after sunrise or before sunset.

New England for more than twenty years, I have been lucky to experience some of the best fall foliage on Earth, yet every year I am surprised by and in awe of the brilliant color that erupts for a few short weeks in October. Making successful fall photos involves a combination of timing, light, and technique.

Timing a fall photo outing requires research and planning. You can often find average peak foliage times for the area you plan to shoot by visiting state tourism websites, many of which include a foliage report during the fall. In New England, peak foliage times vary from the last week of September to the last week of October, starting at higher elevations in the north and moving south and down in elevation as the weeks pass. You will need to be flexible. If you arrive at your destination before or after peak, move to another location farther north or south or higher or lower in elevation. If conditions are pre-peak, look for individual trees that have changed, which can provide a nice contrast from the sea of surrounding green. If it is past peak, head into the woods. While the canopy may have lost its color, the sub-canopy can still show brilliant color, with details on the forest floor. Look for backcountry ponds, streams, and waterfalls where just a splash of color is needed to enhance the scene.

In peak conditions, it is easy to get overwhelmed by all the color. Slow down and think about the stories you want to tell and concentrate on compositional techniques that will make great photographs, regardless of the color. Find a scenic overlook or hike to a rocky ledge to take in

Fall colors brighten the forest along the Kancamagus Highway in New Hampshire's White Mountains. Timing peak fall colors requires planning as well as luck.

When colors aren't peaking overall, seek out colorful details, or look for forest compositions where there is still good color in the understory.

the big picture. Then concentrate on the smaller details—veins in leaves, frost on the edges of fall wildflowers, or the impressionistic reflections of color in a rippling pond.

The biggest complaint I hear from workshop participants is that their fall photos fail to capture the vibrant colors they see in the landscape. Just like in other times of year, color in autumn is greatly affected by the quality of light. Fall photos shot in mid-day sun will appear flat, with a blue cast, but if you shoot during the Golden Hour, the warm light will enhance the colors into the vibrant reds, yellows, and oranges that our eyes see. As I have mentioned before, forest scenes are richly saturated when shot in diffuse, overcast light. This is true in fall as well—just be sure to use that polarizer (see page 59) and keep bright spots of cloudy sky out of your compositions.

Fall is also a great time to explore reflections. Look for colorful hillsides reflected in still water. The moving water of streams and rivers can take on the look of liquid red, yellow, or gold in fall; all it takes is one colorful tree on the opposite bank of a river to give you hours of shooting opportunities.

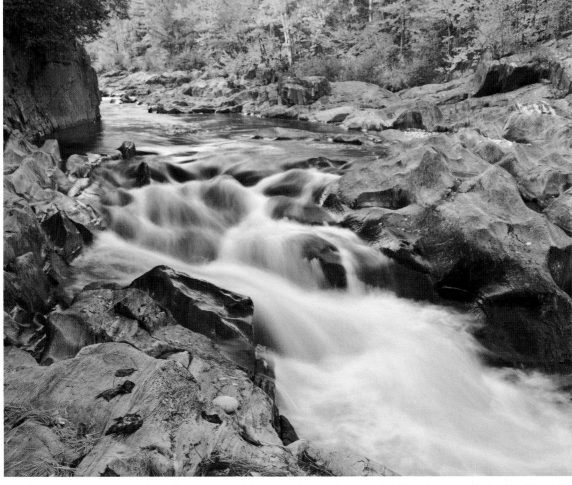

On drizzly or overcast days, seek out forest or waterfall compositions that work well without including the bright white of the sky, and be sure to use a polarizer to reduce glare on the water and foliage.

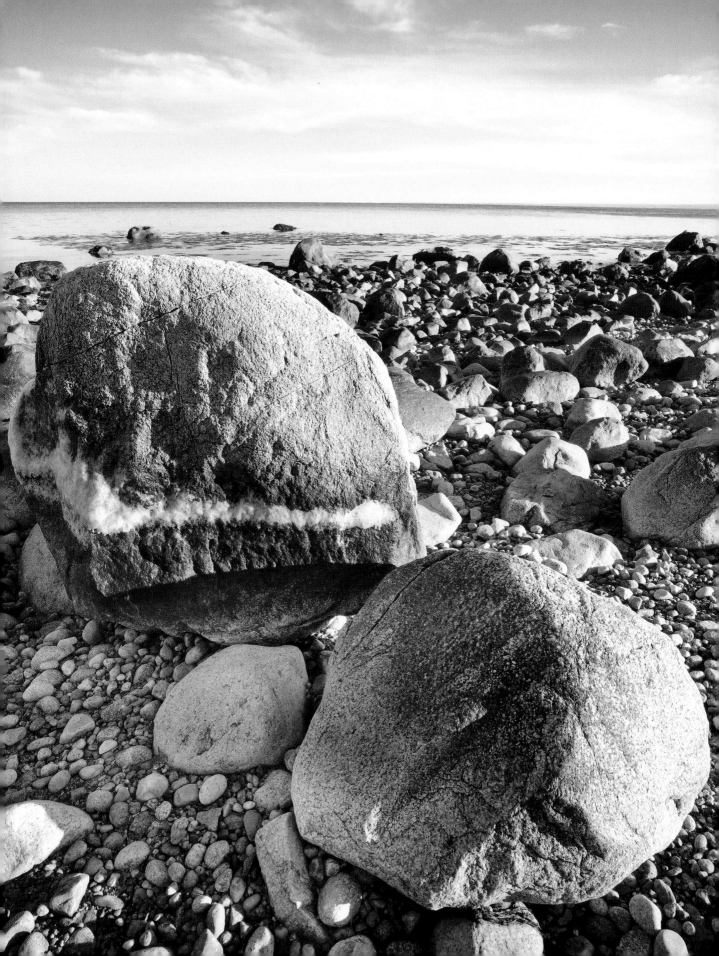

THE CHALLENGE WHEN DIGITAL PHOTOGRAPHY came along was what happened after tripping the shutter. Taking pictures hasn't changed that much with the switch from film, but now photographers have to contend with managing large amounts of digital data as well as optimizing images in the computer. Most outdoor photographers would rather be enjoying the wilderness than sitting in front of a computer monitor, and I'm no different. The "digital darkroom" aspect of photography can be daunting, but it is an important part of the craft. Before digital, the best photographers were those who knew how to maximize their images through developing and printing techniques. The same is true today, except those processes happen with computers and digital printers. Spending the time to learn the basic skills outlined in this chapter will go a long way toward improving your photography and enhancing your enjoyment of the process.

As with my photographic compositions, I try to keep my computer workflow as simple as possible. Instead of containing an exhaustive treatise on Lightroom, this section focuses on the digital workflow processes that I find to be absolutely necessary as well as those that streamline my work. This section also describes some post-processing techniques that are fun and let you create photographs that just weren't possible in the days of film, such as blending exposures with High Dynamic Range (HDR) software, stitching together panorama images, and extending depth of field with software.

In this section, I will be describing the use of several software programs, but I do the bulk of my image management and image processing in Adobe Lightroom, which I highly recommend. Lightroom was developed with photographers in mind and allows you to easily organize and manage your images, as well as optimize them for printing or web display. It has features for creating web galleries and slideshows, and a robust print engine for creating custom print packages. Other programs have similar features, most notably Apple's Aperture and Microsoft's Expression Media. Most of the processes I outline in regard to Lightroom work similarly in these other programs.

I also use Adobe Photoshop, though I increasingly use it only for specialized processing that Lightroom can't perform. It is expensive, and I feel it is unnecessary for many photographers. While it is a powerful tool, it was designed primarily with graphic designers in mind and is overkill for most photographers. However, Photoshop Elements, which offers a subset of Photoshop's tools, is a less expensive alternative that works well for many photographers.

STAYING ORGANIZED

Managing your digital images is probably the least exciting aspect of photography, but it is imperative that you develop a consistent, workable system for archiving and keeping track of your images. I have more than 60,000 digital images in my archive, which presents two challenges.

Lightroom was used to convert this image of rocks on the beach from color to sepia tone.

The first is ensuring that I don't lose any of that data. The second is being able to find any one image or a specific group of images quickly when I need to. With a little up-front work, both of these challenges can be handled easily without taking too much time.

Archiving

Image management and archiving go hand in hand, but what I want to talk about here is backing up your data. Losing data due to hard drive or other media failure has happened to just about anyone who has used a computer. There is a common saying that there are two types of computer users: those who have experienced a hard drive crash and those who will. I have had three hard drives crash in the past eight years. You should expect this to happen, and if you plan for it, you should be able to weather any crash without significant data loss.

The generally accepted theory regarding data archiving revolves around the 3-2-1 concept. This states that you should have three copies of your data on at least two types of media, and that one of those copies should be stored in a different location than the other two in case of fire, flood, or other disaster. For most people, this means having two copies on hard drives (these are basically duplicate drives) and a third copy on optical media such as a DVD or Blu-ray Disc. For my third copy, I use my website, where I store high-res versions of all of my images. My website host also has duplicate copies of this data so there is additional redundancy built into this option. This gives me great peace of mind—even if my studio happens to explode (hopefully I won't be there!), I know I'll still be in business.

There are basically two ways to back up data using hard drives. The first is to use removable hard drives. I buy drives in pairs, with one drive always connected to my computer. The second drive is periodically connected to my computer and I run a backup program that duplicates the first drive onto the second. (I use EMC Retrospect software to do this.) You can also leave this second drive connected and set up the software to automatically make backups on a regular basis. The other option is to configure multiple hard drives in a RAID setup, which automatically backs up data as it is changed. Basically a RAID setup works so that as you add or change data on one drive your computer is simultaneously making a mirror image of those changes on a second drive. RAID has the advantage of backing up changes in real time, but it is generally more expensive. It is a little more complicated from a technical perspective as well, but newer products such as the Drobo make using RAID technology a much easier process. However, if the RAID controller fails, you will lose both copies of your data, so you still need to regularly make a third copy on a separate drive.

Image Management

Below is a description of my workflow for archiving my image data, to give you some ideas for how to tackle this issue. You may or may not want to follow my exact workflow, but I highly suggest you take the time to develop your own procedures for editing and backing up your data.

1. File Naming and Folder Structure

When setting up an image management system, developing a file naming convention and folder structure is an important step for keeping track of your images. Before image management programs like Lightroom and Aperture were commonly used, it was important to develop a folder structure on your hard drive (or multiple drives) to keep your images organized. This usually in-

volved a series of folders and embedded subfolders that were organized by subject and/or date. Many photographers still use this technique, but I find that since image management programs keep track of where your data is, this is no longer really necessary. I simply store my image files in one "images" folder on my hard drive, and organize them using Lightroom's collections feature, which I'll explain in more detail in a later section.

Descriptive file names are also less important than they used to be due to the use of collections and the ability to search your image catalog using caption, date, and keyword information. However, I still use a file naming convention I developed 15 years ago when I shot slide film. Back then, having all the images for one subject physically in one place was more important than it is now, but by sticking with this system I can find any image in less than a minute just because of the file name. I recommend taking the time to think about how you usually search for your images (locations, people's names, species names, etc.) and develop a naming convention that fits your usual search criteria. Ninety percent of the time I need to find an image based on location, so my naming convention is location specific, with the exception of flora and fauna images that are species specific. For example, an image from New Hampshire's White Mountains will have a prefix of NHWMS, with NH signifying New Hampshire and WMS noting the location. I then add a five-digit sequence number to give all images a unique name. You can certainly use more or less information in your file names. Mine are relatively short because all those letters and numbers used to have to fit on slide mounts. By following this naming convention, it is easy for me to sort my image catalog by file name and quickly get to the images that were shot in a specific location.

2. Importing from a Memory Card

You can plug your camera directly into your computer and download images, but I suggest using a memory card reader instead. This is usually faster and you don't have to worry about your camera running out of power during download (which can corrupt your memory card and make it unreadable). Once your card is plugged into

▶ IMPORTING IMAGES IN LIGHTROOM

The Lightroom Import dialog is fairly intuitive. On the left side of the window, choose the source location of the images you are adding to your catalog (it defaults to a memory card if one is plugged in). The center panel lets you choose images to import. At the top of this panel, you are given the choice to Copy, Move, or Add your images. When downloading from a memory card, you should choose Copy, which will leave the images on your card after import. I usually wait to format my memory card (which deletes the images) until after I've confirmed that the import succeeded and that I have two copies of each image on separate hard drives. You select where to import your photos to on the right side of the window. This panel also lets you make a second copy, which I almost always do in order to automatically create a backup.

The panel also has an Apply During Import section that lets you instruct Lightroom to add keywords or other metadata information as it imports photos. This is a terrific feature for adding information to your images that makes them easier to search for. There is also the option to rename photos at import, although I usually rename my photos later in the process.

your computer, access the import feature of your image management software. In Lightroom, there is an import button in the Library module that brings up the Import dialog. (See "Importing Images in Lightroom," page 87.) I use a matched pair of removable hard drives for this purpose. One drive contains the files that will be used as I work on the images in Lightroom. The second drive contains backups of my original images that remain untouched. After importing, some photographers will make their third copy by copying the images onto a DVD or Blu-ray Disc, but I suggest doing this later in the workflow so that you are not backing up hundreds of images that you don't need to keep.

▶ **WHAT IS A CATALOG?**

Lightroom (or Aperture and other programs, for that matter) is a database that stores information about your images. Lightroom calls this database a catalog and it stores both textual information, like captions and the date an image was shot, and processing information, such as tone and color settings. The catalog itself does not contain the image files, but rather keeps track of where those image files are stored. When you import an image into your catalog, it adds the file location for that image to the database and creates thumbnail and preview versions of the image that are displayed in Lightroom when you are editing. This is an important distinction to understand—since the image itself is not contained within the catalog, Lightroom needs the actual image file to be where it thinks it is. For this reason, it is imperative that you do *not* move an image file from outside of Lightroom. If you need to move a photo to a different folder, do it from within the Library module in Lightroom. If you use the Finder on a Mac or in Windows Explorer (or another image database like Picasa) to move an image file, Lightroom will lose track of it and you will no longer be able to use Lightroom to edit your photo or make copies of it.

Lightroom is divided into five modules, which are separate programs that perform different functions. The Library module is where you manage your images by importing and exporting images, building image collections, adding metadata, and using powerful search tools to locate and filter your images. The Develop module is where you make tonal and color corrections to an image as well as perform tasks like cropping, dust spot removal, and burning and dodging images. The Slideshow module lets you create custom slideshows. The Web module uses templates to create custom web galleries that can be uploaded to a website directly from Lightroom. The Print module lets you use a variety of preset or custom-designed print packages that make printing multiple images at one time a breeze.

3. Creating a Collection and Editing Photos

Once Lightroom has completed importing images from my memory card for a particular photo shoot, I create a collection containing these new images, and give the collection a name that describes the photo shoot. (You will notice when you create a collection that you can also create collection sets—this gives you the ability to further organize your images. For instance, you can create a "New Hampshire" collection set and then create several collections within this set for different New Hampshire locations. By immediately adding new images to an aptly named collection, they are easy to find later on, whether you have time to edit them immediately or in six months.)

Keep in mind that collections are not the same as file folders on your computer. By adding images to a collection, you are not physically moving the image files on your computer. Instead, you are linking images together in a group. You can add any single image to multiple collections without making additional copies of that image. For example, I might assign an image I recently shot during a workshop on Mount Washington to several collections—one for the specific workshop, as well as a "Mount Washington" collection, a "White Mountains" collection, and a "Best of New England" collection. Each collection will contain the image, but there is still only one copy of it on my hard drive.

After adding my new images to a collection, I go into that collection and do a quick selection of the images, choosing those that I feel are worth keeping based on composition, exposure, focus, and overall impact. Lightroom gives you several options for marking photos as keepers—ratings, color labels, and flags—and you can use all three on any image. You can rate an image by giving it from one to five stars, and you can also give an image one of five color labels. These are excel-

lent for ranking your images based on how good you think they are. In Lightroom, you can flag a photo simply by pressing the "P" (for pick) key on the keyboard when that image is highlighted.

After "picking" the keepers, I can filter the collection to display only those images that are flagged, making it easier to work on the collection while adding captions and "developing" the photos in the Develop module. When a collection is filtered, it displays only images meeting the filter requirements, but it doesn't delete other images or remove them from the collection. (I don't delete any images until I've finished processing my keepers in the Develop module, as I find I sometimes need to go back to non-flagged images to work with a different exposure or one that might be in better focus.)

4. Adding Metadata

Once I've edited a photo shoot down to my keepers, I go through and add caption and other metadata to all of my images. How much of this information you add depends on your needs. Since I distribute my photos to stock photo agencies and I maintain a website where photo buyers need to search my images by keywords and find detailed caption information, I include quite a bit of metadata. If your photos are primarily for personal use, you will need to spend much less time on this aspect of managing your images. However, I recommend that every photographer add three or four keywords (noting the location and subject) to images to make photos much easier to locate as their collection grows. Captions and other information are optional in this case, but I still recommend adding detailed captions if you have the time, as that information can be automatically displayed when using Lightroom's Slideshow, Web, and Print modules.

To create a collection in Lightroom, click on the "+" sign in the collection panel and choose "Create Collection." Then click and drag image thumbnails into the collection from the lightbox or filmstrip.

The filter bar above Lightroom's filmstrip lets you filter a collection by flagged status, ratings, and/or color labels.

By clicking on the Sync Metadata button, you can apply metadata information from one image to one or more additional images. In this screenshot, two images are selected, but the image on the left is "more" selected (as indicated by a brighter "slide mount" outline). Lightroom will apply the metadata from this image to the second image.

Adding metadata is probably the least fun part of managing an image archive, but Lightroom has several features that make it easy to streamline the process by applying metadata changes to multiple images at one time and by allowing the creation of metadata presets. For example, let's say you have multiple images of the Appalachian Mountain Club's Lakes of the Clouds Hut shot from Mount Washington in winter. You can type in a caption on one image in the Metadata panel on the right side of the Library module, and then synchronize that caption across a wider selection of images. You can syn-chronize any group of metadata fields that you want. For example, you can sync just the caption information, or the caption, keywords, city, and state all at once.

If you find yourself applying metadata information on a regular basis, you can create a metadata preset, which can then be applied to any images in your catalog simply by selecting that preset from the preset window while an image (or group of images) is selected. The preset I use most is one I created with all of my contact and copyright information. I actually apply this preset at import, so as soon as an image is added to my

▶ WHAT IS METADATA?

Metadata is information about an image that is stored either in the image file itself or in a companion "sidecar" file. The Library module in Lightroom gives you access to two types of metadata: EXIF data and IPTC data. Exchangeable Image File Format, or EXIF, data is the data captured by your camera when you take a picture and includes information such as the time and date the photo was taken, as well as the settings used to take the photo (such as ISO, shutter speed, or aperture). In general, you don't want to change this information; it comes in handy when looking for photos in your catalog or for seeing what settings you used to make a particular photo. Lightroom's filtering options let you find photos by EXIF data, making it easy to search by date, ISO, etc. (Hitting the backslash key brings up the Library filter near the top of the Preview panel.)

The Library filter also allows you to search your catalog by IPTC metadata, which includes all of those fields where you add your own information about an image—keywords, caption, location, copyright, etc. I highly recommend adding a few keywords and a caption to all of your images to make them easy to find using the filter. (IPTC stands for "International Press Telecommunications Council," named for the organization that created the standard.)

Another type of metadata is created by the changes you make in the Develop module. All of the changes that you make there (e.g., tone or color) are stored as instructions in the metadata. All of this metadata is stored within the Lightroom database, but can be made available to external programs as well, via sidecar files or embedded in the image files themselves at export. When you export an image (more about this later), you are basically making a new copy of an image using the settings you used in the Develop module and in the Export dialog. If you are exporting a RAW file, those settings and textual metadata are put into a sidecar file (which will have the same name as your original file, but with an .xmp extension.) If you export a JPEG or TIFF version of your image, the metadata is embedded into the image file itself, and can be read by programs like Photoshop or websites like Flickr. (For example, when you open an image in Photoshop and use the File Info menu item, it brings up a window that displays all of your metadata. A website like Flickr will read an image's date, caption, and keyword metadata, automatically adding that information to the Date Taken, Description, and Tags fields on the Flickr version of the image.)

Metadata is entered and displayed in the Metadata panel on the right side of the Library module. To switch between IPTC and EXIF (and other metadata sets), click on the arrows in the pull-down menu to the left of the word "Metadata."

catalog it already has this information attached to it. You can create a metadata preset in Lightroom by clicking on the arrows next to the Preset window on the Metadata panel. These presets can then be applied to any image in your Lightroom catalog or applied to new images in the Import dialog. Presets are also a good way to add groups of keywords to images, but Lightroom also has a separate Keyword panel located just below

the histogram on the right side of the Library module, which provides several ways to add keywords to images and groups of images quickly.

5. Developing Images

After I've added all of my keyword, caption, and other metadata, I switch to Lightroom's Develop module and make my tonal and color corrections. This is where you perform all the tweaks

that make your images look like you imagined when you tripped the shutter. Lightroom's Develop module is fairly intuitive, but I describe my developing workflow in greater detail in "RAW Processing Workflow" on page 98. One thing I'll note here is that changes made to images in the Develop module are "non-destructive," which means they don't actually affect the original image file. Develop settings are saved as instructions in the Lightroom database and are applied when you print images or export them as JPEGs or TIFFs. (This is also true of editing in Aperture, Adobe Camera RAW, and other programs.)

6. Exporting Images

If you never do anything but look at your photos in Lightroom, you don't have to go through the process of exporting your images, but most of us take pictures in order to share them with others, which means we need to make JPEG or TIFF versions of our images to email, upload to the web, or burn onto a disc to be displayed on a monitor or printed. Before exporting an image or a group of images, I perform two preliminary tasks. First, I'll rename my images to fit my naming convention. This is done in Lightroom's Library module via the Library–Rename Photos menu option. Second, I click on the Metadata–Save Metadata to Files menu option to physically write all my metadata and develop settings to an images sidecar file (up until this point, all of those changes were saved only in the Lightroom database). This ensures that my metadata changes will go with any exported RAW versions of the image.

To export an image or series of images, select the images you want to export and click the Export button on the lower left side of the screen in the Lightroom Library module. This brings up the Export dialog, which gives you several options

for using export presets, plug-ins, etc. For a typical export, select the Export to Hard Drive option.

You need to tell Lightroom where to put the new files, which file type to use, and what size you want the images to be.

In the File Settings section, choose "original" format if all you want is an exact copy of your original. If you are preparing a file to e-mail or upload to the web, choose JPEG. Other options are TIFF and PSD (Photoshop file), which are best if you plan to do additional editing of the image in Photoshop, and DNG, which is Adobe's open-source version of a RAW file. If you choose the JPEG version, you must also choose a quality setting. A higher-quality setting creates a file of higher quality with a larger file size. I usually choose a quality setting of 100 (highest quality) if I am creating a high-resolution version of the image to be used for printing. If I am making smaller files for web or email display, I'll use a quality of 70 to 80 to get a smaller file size that is easier to upload, without sacrificing too much image quality.

Also under File Settings is an option for choosing Color Space (I explain Color Space in the Color Management section on page 95). In general, I recommend choosing sRGB (Standard Red Green Blue) for images that will be displayed on a computer screen; Adobe RGB (1998) for images that you'll be sending to a lab to print or to a client for offset printing; and ProPhoto for images you will be working on in Photoshop and/or printing on your inkjet printer.

You choose the size of your exported images in the Image Sizing section. Leave the Resize to Fit box unchecked if you want your images to be the native size that is created by your camera. Check that box if you plan to make images that are larger or smaller than the native size. For example, my camera's images have a native

size of 5616 x 3744 pixels, but when I upload images to my Facebook or Flickr page, I'll check the Resize to Fit box and set it to export images that are 600 pixels on the long edge. Lightroom automatically adjusts the short side of the image, keeping the proportions of the image intact. For monitor display, I'll set the resolution to the industry standard of 72 pixels per inch. For print uses, I'll use 300 pixels per inch. (Be aware that if you tell a processing program to export images at a size that is larger than an image's native size, it must interpolate the extra data it is creating by enlarging the image. This is called "uprezzing" an image, and the more you uprez, the more data the software has to make up, eventually resulting in an image that looks pixelated, unsharp, or both.)

You will notice a few other options in the Export dialog. The ones I use the most are File Naming, which I use to create file names for my exported images that are different from my originals, and Output Sharpening, which I generally use only to sharpen images going up on the web or that will be made into small prints at a local or web-based lab. (For my large fine-art prints, I either sharpen them directly in the Print module or in Photoshop.) After you enter all of your settings and click the Export button, Lightroom applies your develop settings to the original files and makes new files based on your export settings. Your original files remain unchanged,

and your new exported files are not part of your Lightroom catalog (you can import them into it after export if you want).

7. Deleting Images

Once I have completed work on a collection of images from a photo shoot by adding my metadata, optimizing the images in the Develop module, and renaming them according to my file naming conventions, I then delete any rejects from that shoot. This frees up significant hard drive space, as I typically keep only 20 to 50 percent of the images from any shoot. Like when moving image files, you should delete your files from within Lightroom itself and not from the Finder or Windows Explorer. Otherwise, Lightroom doesn't know they are deleted and will still display their thumbnails in your catalog, which can get very confusing if you try to access one of them.

To delete an image, you must first highlight it while viewing it in All Photographs in the Catalog panel of the Library module, or while viewing it in its specific folder in the Folders panel. (If you try to delete an image from within a Collection, it will only remove it from that collection, and it won't delete the file or remove it from the catalog.) I find the easiest way to delete images is to highlight them while within a collection, then while the images are still selected, click on All Photographs. Use the Photo–Delete Photos menu option (or hit the backspace key) and click the Delete From Disc button in the ensuing pop-up window.

8. Overall Workflow Review

I actually maintain two Lightroom catalogs—one for my new photo shoots (which I call my Production Catalog) and one for my general archive, which contains all of my fully captioned and optimized images. I find this useful for keeping track of those images that still need to be edited, processed, captioned, etc., but it may not be necessary for all photographers. It also allows me to work on shoots in progress on my laptop while I'm traveling.

Using this system, I use the following workflow procedures for organizing my archive:

1. Import photos into the Production catalog, copying the images onto both the primary drive for new images and a backup drive. Once photos are imported and you can see the previews in the Lightroom catalog, reformat the memory card in the camera. Add the newly imported images to a new collection.
2. Flag the keepers as picks using the "P" key.
3. Add all metadata information to keepers.
4. Optimize all keepers in the Develop module.
5. Rename all the keepers using a naming convention (from within the Library module).
6. Save the metadata of the keepers using the Metadata–Save Metadata to File menu option.
7. Export the images as original RAW files onto a removable hard drive. (The metadata sidecar files will be automatically exported with the RAW files.)
8. Open the primary archive catalog and import the keepers from the removable drive, copying them to the images folder used by the primary archive.
9. Create a new collection in the primary archive with these newly imported photos.
10. Back up the drive containing the primary archive images, so that there are two copies of these new photos, one on the primary archive drive and one on the archives backup.
11. Upload high-res versions of these images to a website (usually native-size JPEGs, set to

a quality of 100 and a color space of Adobe RGB) or other third backup.

12. Open the Production Catalog and delete the images, which have been added to the primary archive catalog.

13. Use the Finder or Windows Explorer to delete the images from the backup copy of my new images drive.

This section is just a basic introduction to managing an image archive, but by nailing down these fundamentals, you can rest assured that you won't lose your valuable image data and that you will be able to find and enjoy your photos easily.

IMAGE PROCESSING

Image processing involves all the techniques for optimizing the look of your photos. Whether that means simply tweaking your images or using more complicated procedures to combine multiple images or create photo illustrations, image processing requires understanding one or more photo editing programs. For most people just entering the world of "post-processing," I recommend sticking to the basics of a program like Lightroom or using Adobe Camera RAW with Photoshop; you can move on to the full version of Photoshop or technique-specific programs like Nik HDR Efex Pro as your needs and creative vision grow.

Color Management

Before getting into the details of optimizing your photos, it is important to understand the concept of color management. Digital images are stored as numbers, with each pixel in an image represented by three values—one each for red, green, and blue (this is called RGB color). These values are translated by software and displayed on a monitor or in a print as a certain shade of color that is defined by a profile developed specifically for a particular monitor or printer/paper/ink combination. To ensure that what you see on your monitor is what you get in a print, it is necessary to properly calibrate your monitor and to use the correct printer profiles. Take these steps before doing significant editing of your images, because you should make tone and color decisions based on what you see on a calibrated monitor and a properly profiled printer—otherwise your final result won't look true to the file you've been working on.

Calibrating a monitor requires the use of a piece of computer hardware called a colorimeter, a device placed over your monitor and connected to the computer's USB port. As the software sends a series of colors and tones to your monitor, the colorimeter has an electronic eye that reads these swatches and sends information back to the software. This feedback loop continues for several minutes as the software automatically adjusts your monitor's brightness and contrast based on the information it receives from the colorimeter. When the process is complete, the calibration software creates a monitor profile that is automatically loaded when your computer boots up. In general, the factory settings for monitors are much brighter and higher in contrast than they should be for proper image editing. Your calibrated monitor will appear a little darker at first, but you will get used to it and you will find your prints look much more like the on-screen images you are editing. There are several brands of colorimeters to choose from, with many now selling for less than $100. My favorite is the Spyder3Pro by Datacolor. Depending on how picky you are about your color, you may need to also invest in a high-quality monitor. In general, more-expensive monitors are easier to calibrate and have a wider color gamut. (See Appendix A for monitor suggestions.)

Calibrating your monitor is the first step in proper color management, and it is the last step if you want only to display your images on a computer or you send your images to a lab to be printed. However, if you make your own ink-jet prints, you need to learn how to use printer profiles. Printers come with profiles built into their print drivers, but they are generic in nature. You should use a separate printer profile for each kind of paper you use. You can find these profiles on the paper manufacturers' websites. For each paper, there will be a separate profile you can download for your printer. After you download and install a profile, the profile will be visible from within your image editing program when you go to print. By choosing this profile at print time, you will end up with a print that looks very close to the image you see on your monitor. It will rarely look exactly the same because you are comparing the reflected light on a print to the backlit light of a monitor, and because monitors and inks display a different gamut of colors, but your print will be close if you are following this color management workflow.

To truly understand color management, you should also be aware of two other technicalities of computers and colors: bit depth and color space. Bit depth refers to how much information is stored in an image file, while the color space describes how that information is defined. JPEG and TIFF files are stored as either 8-bit files or 16-bit files. As I mentioned before, each pixel in a digital image is given a number for each color channel—red, green, and blue (RGB). In 8-bit files, this number ranges from 0 to 255 (with 0 representing pure black and 255 representing pure white), while in 16-bit files, this number ranges from 0 to 65,531. Obviously 16-bit files contain much more nuanced color information and this extra data gives 16-bit images much more malleability when making tonal and color changes. The downside of 16-bit images is that the file size is generally twice as large as an 8-bit file, so they can fill up hard drives much faster. JPEGs are always 8-bit images, while TIFF and PSD files can be either 8-bit or 16-bit. RAW files are stored as 12-bit or 14-bit images (depending on the camera) and they are converted to either 8-bit or 16-bit when you convert them to other file formats.

Since I do most of my image editing on RAW files, I worry about bit depth only when I have to convert an image to upload it to the web or send it to a lab or client. For the web, I always use 8-bit JPEGs. When I send a high-resolution file to a client, I generally also send 8-bit JPEGs or TIFFs, as this is still the industry standard for offset printing. I use 16-bit files only when I need to do heavy Photoshop work on an image that requires processing that can't be done on a RAW file.

I briefly mentioned color space when describing the Export feature in Lightroom. While bit depth defines how much color data is stored in an image file, color space defines what those three RGB numbers look like. This is known as color gamut, and different color spaces have different color gamuts.

Dozens of color spaces are used in image editing, but most photographers need to know only three standards: sRGB, Adobe RGB (1998), and ProPhoto. sRGB has a relatively small gamut of colors, ProPhoto has a very wide color gamut, and Adobe RGB is somewhere in between. Since most computer monitors cannot display all of the colors represented by Adobe RGB and ProPhoto, sRGB should be used for images meant for monitor display. As I mentioned before, Adobe RGB is still the standard for commercial publishing and any images you send to printing labs or for offset publishing should be

► USING PRINTER PROFILES

After installing a printer profile that matches your printer and paper, there are a few other steps you need to take to ensure you are using it properly. When printing an image from your image editing program, you need to tell the program to manage the color from within the program (as opposed to letting the printer manage the color) and tell it which printer profile to use.

After you send an image to print from within Photoshop or Lightroom, your computer will bring up your Printer dialog, where you need to check a few more boxes. In general, you should turn off any color management settings in your print driver. Since you've told Lightroom or Photoshop to apply your printer profile, the printer shouldn't apply it a second time. You also need to select the paper type that matches the paper you are printing on (which should match the printer profile you selected!). Lastly, you need to select the print resolution, which is usually something like 720, 1440, or 2880 dpi (dots per inch). In general, I find 1440 dpi works fine for matte papers and 2880 for glossy papers, but you can experiment with this setting for your printer and papers.

(A note about printer resolutions: They are not the same as your image resolution. Image resolution defines how many pixels per inch are in the image file, while printer resolution describes how many dots of ink are sprayed onto the paper. In general, I recommend using an image resolution of 300 dpi for images you are printing on an inkjet printer, though anything in the 240 to 360 range should work fine.)

When printing from Lightroom, go to the Print Job panel in the Print module, and select the correct printer profile in the Color Management section.

Your printer driver may look different from mine (I use an Epson), but you should be able to find the similar boxes and buttons to check off. For an Epson, check ICM (integrated color management), and then choose "No Color Adjustment" under ICC Profile. Then select your paper and output resolution (in this case, I've selected Enhanced Matte and 1440 dpi).

When in the Print dialog in Photoshop, choose "Photoshop Manages Color" under Color Handling, and then choose your printer profile.

set to Adobe RGB. However, since ProPhoto has the widest color gamut, I recommend working in this color space for your own image editing work and inkjet printing, since it preserves the most accurate color information.

Switching between color spaces is relatively easy. When using a program like Lightroom or Adobe Camera RAW (ACR), you can set the color space when you export (in Lightroom) or save (in ACR) your image files. If you are working on an image in Photoshop, you convert to a different color space using the Edit–Convert to Profile menu option.

If you are shooting JPEGs as opposed to RAW files, most cameras let you choose between sRGB and Adobe RGB (1998). Be sure to set your camera to Adobe RGB (1998). Otherwise, you are throwing away valuable color data that can't be recovered in the computer.

RAW PROCESSING WORKFLOW

Okay, I'll admit that up to this point, Section 4 has been fairly technical, but it is all information that anyone serious about digital photography needs to know. However, we're probably both glad that stuff is out of the way, because now we can get to the fun part: making images look great. In the next few pages, I'll outline my RAW processing workflow using Lightroom, but these techniques can be performed in almost exactly the same way using Adobe Camera RAW (ACR) and very similarly using other programs like Aperture. While I call this RAW processing, the same techniques can be used on JPEGs, TIFFs, or PSD files. Since RAW files contain the original image file data, you can make more drastic color and tone changes on these files compared to JPEGs, TIFFs, and PSDs before the image starts to degrade (usually visible as banding or pixelation).

For the vast majority of images you shoot, you will be able to get them to look great just by using the Basic panel in Lightroom's Develop module. The Basic panel lets you adjust an image's basic tone (contrast, exposure, etc.) and color (white balance and presence, or color satu-

The Basic panel in Lightroom's Develop module is where you'll do most of your image editing.

ration). In general, performing tasks in the order they appear in the panel the best workflow to follow, which means adjusting your white balance, then your tone, then your presence. I deviate from this only if an image needs significant tone changes. In those cases, I'll make my tone changes first, then tackle white balance. It's good to leave presence for last because your white balance and tone changes will usually fix or change an image's color.

White Balance

RAW processing programs typically handle white balance by offering white balance presets to choose from and a pair of sliders called Temperature and Tint. The presets have similar names to the presets on your camera (e.g., daylight, cloudy, shade), but they give you somewhat different results than your camera presets. I try these presets if my white balance is obviously wrong, but I find if I use proper white balance settings in the field, I may need to make only subtle adjustments using the Temperature and Tint sliders. The Temperature slider will make an image warmer (more orange) or cooler (more blue) when you slide it to the right or left. The Tint slider makes an image greener when you slide it to the left and more magenta when you slide it to the right.

Adjusting the white balance is fairly straightforward if the majority of the image is shot in the same kind of light—all direct sunlight, all cloudy light, or all shady light. The challenge comes when you have a mixed lighting situation, with a portion of the image in shade and a portion in direct light. Unfortunately, there is no

Photographing a white balance card can make it easy to adjust white balance in the computer using the White Balance tool.

way to get a proper white balance in both types of light in one image. Optimizing the white balance for direct sunlight will make the shadows bluer than they should be, while optimizing for shadows will make your highlights seem unnaturally warm. In these cases, I usually set a white balance based on the direct light and let my shadows go cool. This looks more natural to me than the other way around.

If your image contains an object that's neutral in color (gray or white), you can use the White Balance tool to automatically set your white balance. Click on the White Balance tool, move your mouse over the neutral object (make sure it's in the light you want to balance for), and click. Lightroom will adjust the White Balance sliders to make this object neutral in color, so its RGB values are equal. (For example, a pixel that has a value of 50 for each color channel will be neutral in color, but if the green channel has a value of 60, that pixel will have a green color cast.) While there is a correct white balance setting for every image, you can also use white balance for creative effect, warming or cooling the image to create a specific mood.

Tone

Tone refers to the brightness and contrast found in an image. Lightroom and ACR use six sliders to adjust tone in the Basic panel, though you can make additional tonal adjustments using the Tone Curve panel. Above the tone sliders is an Auto Tone button. This button does a pretty good job with most images, and is worth a click as a starting point. The top four sliders affect the brightness of different parts of the tonal range as defined by the histogram. (As mentioned in Section 2, a histogram is a bar graph that charts exposure by showing you the number of pixels in your photo at each tonal gradation, from black on the left to white on the right.) Adjusting the Exposure slider changes the exposure of the entire image, brightening or darkening all of the pixels. If you paid attention to your histogram in the field, you won't need to make major adjustments with this slider, but if you underexposed an image by a stop or more, use this slider to bring up the overall exposure of your image.

The next three sliders, Recovery, Fill Light, and Blacks, affect narrow ranges of tonality in an image. The Recovery slider affects only the

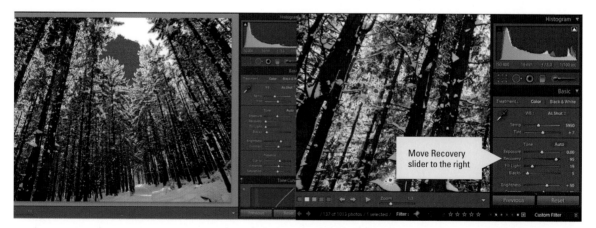

Left: Much of the sky in this image is overexposed, which is noted by the red pixels in this screenshot. By mousing over the triangle at the top of the right side of the histogram in Lightroom, you can display this red mask to see what parts of an image are overexposed. Right: By moving the Recovery slider to the right (to 95 in this case), I recovered the highlights in much of the sky, which now shows a nice shade of blue instead of detail-free white. There are a few remaining blown-out highlights behind the trees where the sun is located, but this area is small enough not to detract from the overall image.

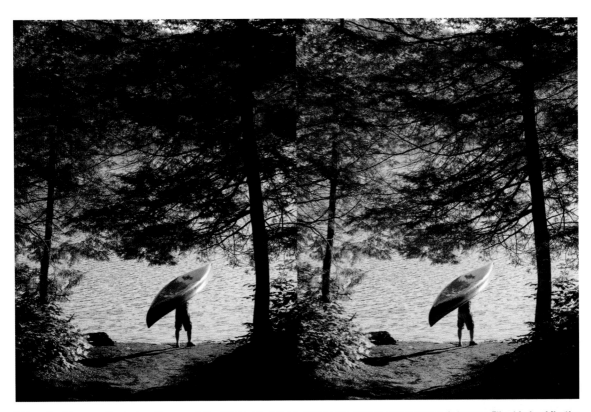

This pair of images illustrates the use of the **Fill Light slider** in Lightroom. The image on the left has no fill added, while the image on the right was processed using a fill light value of +50. This brightened the green of the trees nicely without drastically affecting the highlight areas of the image.

brightest pixels in an image. By moving this slider to the right you can recover detail lost in blown-out (overexposed) highlight areas within your image, without affecting the brightness of properly exposed pixels. This slider works best when just a small area of an image is overexposed. It can reduce contrast in the brighter parts of an image in a negative way as well, so pay attention to the overall look of your image when making recovery changes.

The Fill Light slider brightens only the darker areas of a photo that are between midtone gray and almost black. By moving this slider to the right you can brighten shadow areas while leaving highlights unaffected. It is like adding a giant fill flash across the image area after the fact. It works best on areas that aren't too dark, and must be used with caution because brighten-

ing dark pixels can introduce unwanted noise to your image. After adjusting the Fill Light slider, zoom in to shadow areas to make sure they are not too noisy.

The Blacks slider serves two purposes: to recover lost shadow detail and to increase blacks in a lower-contrast photo. In Lightroom and ACR, the Blacks slider is set to a default of 5. By moving it to the left, you can brighten the darkest parts of an image without affecting the rest of the scene. Clicking on the triangle on the top left of the histogram will display pure black pixels as blue, and as you move the slider to the left these will gradually disappear. This technique is helpful if you need to bring out important detail in shadow areas, but like the Fill Light slider, it can add noise to an image. I find I use the Blacks slider more often for adding blacks to a scene that

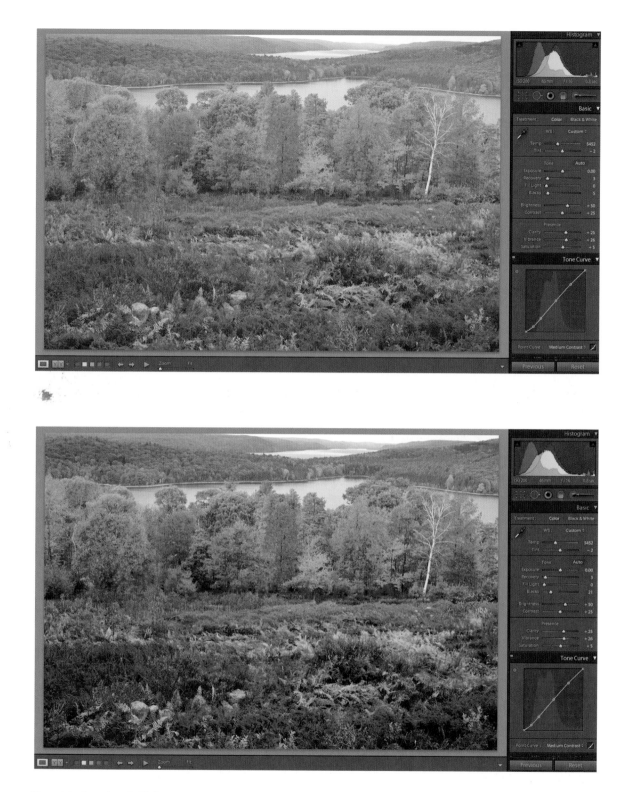

The original version of this image (top) has a gap on the left side of the histogram, indicating a lack of blacks. By moving the Blacks slider to the right, I added black to the image (bottom), which increased contrast and gave the image more "pop" by saturating colors without affecting the highlight areas.

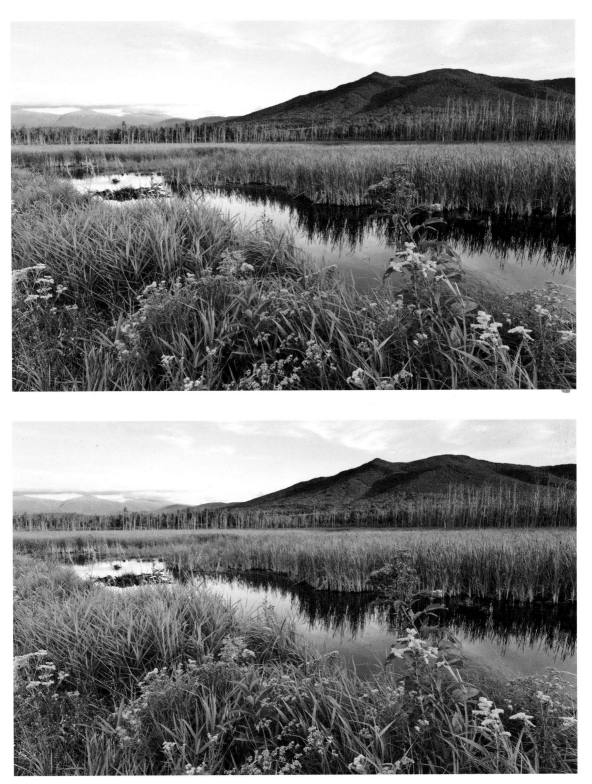

The photo on top shows this image before adding vibrance. In the second version, I moved the Vibrance slider to +60 in Lightroom, which added some nice saturation to the blues and greens in the image without oversaturating the already-vibrant yellow flowers.

is lacking in darker tones. When you see a gap on the left side of the histogram, you can usually improve the look of a photo by moving the Blacks slider to the right, which will add blacks and contrast to an image, making colors more vibrant.

The last two sliders for tone are Brightness and Contrast. They are fairly self-explanatory, and I find that I rarely need to change these from the defaults because the first four sliders do most of the work. However, I have changed the default value on the Contrast slider from +25 to +35. Most RAW files, especially those shot in natural light, need a little boost in contrast and +35 works well for most of my images. If I find an image needs an extra boost in contrast, I am more likely to do that via the Tone Curve, which I'll explain soon.

Presence

There are three sliders in the Presence section of Lightroom and ACR—Clarity, Vibrance, and Saturation. Clarity affects the detail found in a photo, while Vibrance and Saturation affect color saturation. All three sliders can have a dramatic impact on a photo, and used well they can greatly improve your images.

With the Clarity slider you can increase or decrease the local contrast in an image, which sharpens or softens details. Most nature photos with a lot of detail can use an increase in clarity. I usually start at a clarity setting of +25, and I crank it up to +50 or higher for landscape photos with a lot of detail. When using high-clarity settings, zoom into a photo to make sure you are not creating an over-sharpened appearance. You can also add negative clarity by moving the slider to the left. This softens the overall appearance of an image and can be a nice effect for abstracts that are more about light and form than about detail, making the light seem to glow.

The Vibrance and Saturation sliders add or subtract color saturation from a photo. The Saturation slider will saturate or desaturate all of the colors an equal amount and should be used judiciously because oversaturated colors can quickly look gaudy and unnatural. I prefer to use the Vibrance slider to add saturation to an image, as it saturates only those colors that are not already highly saturated. You can add quite a bit of Vibrance to some photos before they start to look oversaturated.

Making Local Adjustments

Both Lightroom and ACR give you the ability to make local adjustments in an image. (Local adjustments affect only a portion of the image.) The local adjustment tools are Crop, Dust Spot Removal, Red Eye Reduction, Grad Filter, and Adjustment Brush. In Lightroom, these tools are located right below the histogram in the Develop module, while in ACR, they are in the upper right of the ACR window.

The local adjustment tools are found under the histogram in Lightroom. Clicking on a tool makes it active and displays an Options panel for that tool.

The Crop tool is fairly straightforward to use—just click and drag the crop window around the part of the image you want to crop to. One handy feature is the angle adjustment. When you click on the ruler, you can then draw a line in your image along a slanted horizon line, and Lightroom will automatically rotate the image to make the line you drew horizontal. I always try to get my horizons level in the camera, but this tool makes it easy to fix problems later.

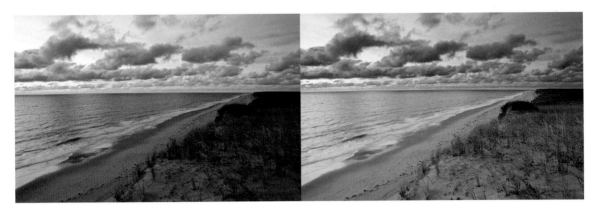

I liked this image as shot (above, left), but thought it would look even better by applying two Grad Filters to the image in Lightroom. First, I darkened the sky by .49 stops (below). I then applied a second Grad Filter on the foreground, adding .68 stops to arrive at the finished version (above, right).

The Dust Spot Removal tool is invaluable for removing spots that show up in an image because of dust on your camera's sensor. These spots aren't always visible at the standard preview size, so I zoom in to check for them. With the Dust Spot Removal tool active, the cursor changes to a circle. Mouse this circle over a dust spot in your image and click. I usually use this tool in Heal mode, which automatically copies nearby pixels and blends them around the inner edge of the circle. There is also a Clone mode for areas that are more challenging to fix. You can also turn this tool on and off by clicking the "Q" key. After clicking on a dust spot, Lightroom places two circles on the screen. The first circle represents the part of the image that has changed, while the second circle is the area of the image that the program sampled in order to decide what to replace the first area with. Both of these circles can be moved and changed in size after your original click. (If you find these circles distracting like I do, you can hide them by pressing the "H" key.)

The Grad Filter is one of my favorite tools in Lightroom. It simulates the use of a graduated split neutral density filter, so it works best on images with a dark foreground and bright sky. (The tool can't recover blown-out highlights or blocked-up shadows, so your image needs to have detail in both areas for it to work well.) Using this tool is simple. Once active, six sliders appear that let you dial in exposure, brightness, contrast, saturation, clarity, and sharpness amounts. For example, to darken the sky in an image by 1 stop, drag the Exposure slider to the left to -1.00. When you move your mouse over the image a crosshair will appear. When you click and drag down using this crosshair, Lightroom will apply the full exposure change to the image above where you first clicked. Everything below where you let go of the mouse button will remain unchanged, and everything in between will be a gradual change from the full effect of the filter to no effect.

After you've applied your filter, you can fine-tune it by readjusting the sliders. You can move the filter up and down by clicking and dragging the button that appears on the middle of the filter on your image. Clicking and dragging the top or bottom line in the filter adjusts the height of the gradation. You will notice when applying this filter that it doesn't need to be a perfectly horizontal line; you can rotate it at any angle

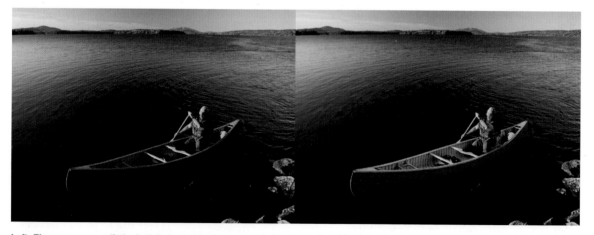

Left: The canoe was a little dark in the original exposure to be the main subject, but I couldn't brighten the entire scene without blowing out part of the sky. Right: I used the Adjustment Brush with the Exposure slider set to +88 (with Auto Mask checked) and painted over the canoe to bring out more detail.

you need. It can actually be a challenge to keep the line horizontal. To do this, hold the shift key down while dragging the filter. For the image to the right, I darkened my sky as explained above, but I also brightened my foreground by applying a second Grad Filter with the Exposure slider set to a positive value. When you click and drag this filter up in an image, it works in reverse, applying the full filter effect to the part of the image below where you first clicked.

The Adjustment Brush works in a similar way to the Grad Filter, letting you make the same sorts of tone and color changes. When the Adjustment Brush is active, click and "paint" your changes on your image. This works great for burning and dodging specific areas of a photo. You can also use the brush to paint negative clarity into a portion of an image. Ever wonder how photo retouchers soften wrinkles on a model's face? This is how they do it. One key to using the Adjustment Brush is to make sure the Feather slider is set to 100 and Auto Mask is checked. This helps keep the brush's effect contained within the edges of the area you are painting.

Other RAW Processing Features

There are several other panels in the Lightroom and ACR RAW processors. The panels I use most often are Tone Curve, HSL, Details, and Effects. The Details panel (which handles sharpening and noise reduction) is covered on page 126.

The Tone Curve panel is another way to fine-tune tone adjustments. As I've mentioned, adding contrast to an image can be a good way to add some "pop," as it increases the tonal differences between dark and bright areas. A Tone Curve is a more nuanced way of adding this contrast than using the Contrast slider — it lets you brighten or darken specific tonal values in an image as opposed to affecting the whole image.

When you look at the Tone Curve panel, you will see a grid superimposed over the image's histogram, with a diagonal line going from the bottom left corner to the top right. By clicking on that line and dragging down, you will darken the tones in that area of the histogram. By clicking and dragging up, you brighten those tones. You can also make the same changes by using the sliders below the tone curve and histogram. To add contrast, just darken the shadow tones and brighten the highlights. You can also brighten or darken the tone in a specific region. For example, to brighten the midtones of an image, click and drag up (or use the sliders) the curve in the darks and/or lights regions. You can also adjust the width of each individual region by dragging the triangles at the bottom of the tone curve/histogram grid.

The Tone Curve in Lightroom is divided into four regions. You can brighten or darken tones in each region by using the sliders or clicking and dragging on the curve itself. Darkening shadows and brightening highlights will add contrast to an image.

For this image, I added a tone curve using Lightroom to add contrast, which enhances the color saturation of the scene.

There are three preset curves you can use (Linear, Medium Contrast, and Strong Contrast), which you can select in the Point Curve window at the bottom of the panel. Not sure which tone region contains a specific part of your photo? Click on the Targeted Tone Adjustment button in the upper left corner of the panel and then click and drag on that area of your photo.

The HSL (Hue, Saturation, Lightness) panel lets you make color adjustments to specific colors within a photo. I tend not to touch the Hue portion of this panel, because it makes big color changes that rarely look natural for nature and outdoor photos. The Saturation and Lightness sliders work like you would expect. For example, drag the Blue slider while Saturation is active and you will increase or decrease the saturation for all of the blues in an image. While Lightness is active, you can brighten or darken a specific color in an image. These sliders are ideal for doing things like darkening a blue sky or increasing the saturation of a red canoe or kayak in a photo without affecting the other colors. Like in the Tone Curve panel, the HSL panel has a Targeted Adjustment button in the upper left

corner of the panel that lets you click and drag on the image to adjust certain colors. (One note of caution: Making large changes with these sliders can produce a halo effect around the edges of objects that are changing, so zoom in to check your work.)

I use the Effects panel primarily to add or remove vignettes from my images, though you can also use it to add grain to a photo for a grittier look. Vignettes (darkenings in the corners of an image) can occur in an image under special lighting conditions at very large or small apertures, especially on wide angle lenses and when using lens accessories like extension tubes or teleconverters. These vignettes can easily be removed by moving

Adding a vignette to a photo to darken the corners can focus the viewer's attention on the main subject in the center of a photo.

Click on HSL to bring up the Hue, Saturation, and Lightness sliders to adjust specific colors within an image.

the Amount slider on the Vignette tool to the right. By moving the Amount slider to the left, you can add vignettes (which I sometimes like to do to focus the viewer's attention on the main subject of an image). By adjusting the Midpoint, Roundness, and Feather sliders, you can fine-tune the shape, position, and feather of the vignette.

Resetting RAW Changes and Creating Efficiencies

As I mentioned earlier in this section, using a RAW processing program like Lightroom has two big advantages. First, all edits are non-destructive, which means that any changes to images you make in the Develop module do not affect the original image file, and you can always

discard those changes. Second, you can apply edits or subsets of edits across several images at one time, which is done by creating develop presets and synchronizing changes from one image to another.

There are several ways to remove any develop edits you make. To go back to your original image, simply click on the Reset button at the bottom right of the Develop module. To reset only the changes in a specific panel, hold down the alt (option) key and the title above any set of sliders will change to reset, which you then click on. You can also double-click on any slider triangle to return it to its default. Lightroom (and ACR) also keeps a history of all of your changes, which are listed

The Presets, Snapshots, and History panels make it easy to create and apply develop settings presets and go back to specific editing actions. The Sync button lets you synchronize develop settings from one image to one or more others. Hold down the alt key to change the Reset button to a Set Default button in order to create new default develop settings for your camera.

in the History panel found on the left side of the screen. Click on an action in the History panel, and your image will revert to the changes that were active at that time. You can also make snapshots at any point in the editing process by using the Snapshots panel, which is located above the History panel. While you are editing in the Develop module, you can see a side-by-side comparison of your original image and the edited version. Click on the two rectangles with a "Y" in them on the toolbar under the image preview.

You can avoid spending hours editing images by utilizing the Sync and Preset tools in Lightroom or ACR. Synchronizing develop changes in Lightroom works the same as synchronizing metadata changes. Select the image with the settings you like, then ctrl-click (command-click on a Mac) or shift-click to select additional images. Clicking the Sync button (lower right of the screen) brings up a pop-up window where you can select the develop changes you want to synchronize.

Click on the Before & After button on the toolbar on the Develop module to see your original image and the edited version side by side.

If you find yourself making develop changes that you repeat over and over, create a develop preset by clicking on the "+" in the Presets panel, which is located on the left of the screen below the navigator. Like Sync, this brings up a pop-up window where you select the develop settings you want to save in the preset. Just check off the appropriate boxes, give your preset a name, and click the Create button. To apply a preset to an image, select that image, then click on the preset name in the Presets panel.

If you find you make certain develop changes to almost every image you take, you can create a new develop default that Lightroom automatically applies to every image when it is imported into your catalog. To do this, start with an unedited image and make the develop changes that

you want to use as a default. Then hold down the alt (option) key, and the Reset button on the bottom right of the screen will change to Set Default. Click on this button and confirm your changes. Defaults are camera specific, so if you shoot with more than one camera model, you will want to create a default for each camera (Lightroom determines which camera was used for each image you shoot by reading the EXIF metadata). For my Canon DSLRs, I created a default that uses a contrast of +35, clarity of +25, vibrance of +15, and saturation of +5. I leave all other settings at their factory defaults.

SPECIALIZED IMAGE PROCESSING

While the above RAW processing workflow works well for the majority of images, there will be times when you may want to take things to another level. In the next several pages, I'll describe some common photo processing techniques, like combining multiple versions of the same image to extend dynamic range or depth of field, stitching together panoramas, and converting images from color to black and white. I'll also explain how to sharpen an image properly and to apply noise reduction for images that were shot at high ISOs or had noise introduced when exposure, fill light, or brightness were added in post-processing. Some of the following techniques can be done in Lightroom or Adobe Camera RAW, but others require the full version of Photoshop or other software specifically created for the job at hand.

Converting an Image to Black and White

Gone are the days when we had to swap color film for black and white. With digital images, it is easy to convert a color image to black and white. Not surprisingly, I like to do this in Lightroom or ACR. At the top of the HSL panel in Lightroom's Develop module, click on "B & W," and your image is converted. You'll see a group of color sliders under the Black and White Mix label. By moving these sliders, you can fine-tune the brightness of a specific color in the photo, even though it shows as black and white. For example, you can darken the sky in an image by dragging the Blue slider to the left, or lighten a field of green grass by moving the Green slider to the right. You can also activate the Targeted Adjustment button and click and drag directly on an area of the photo if you can't remember exactly what color it is. Once I get my image looking about right in this panel, I usually apply additional contrast with the Contrast slider or by applying a tone curve. Adobe Camera RAW (ACR) has the same black-and-white conversion feature as Lightroom. It is found in the HSL panel, but it is called "Convert to Grayscale." ACR also has a Targeted Adjustment button, located in the tool bar in the upper left of the ACR window. In Photoshop, you can make a black-and-white conversion using a similar interface as in Lightroom and ACR. Choose the Layer-New Adjustment Layer-Black & White command to bring up the black-and-white conversion panel, which looks very similar to the one in Lightroom.

If you do a lot of black-and-white conversions, you may want to invest in software designed for this task. Several options are available, but the industry standard at this time is Silver Efex Pro by Nik Software.

Layer Masks

Photoshop has a feature called Layer Masks that lets you do things like place one photo on top of another and reveal only parts of each photo. You can also add a layer to a photo with an adjustment, like a black-and-white conversion, and then paint away part of that adjustment layer to

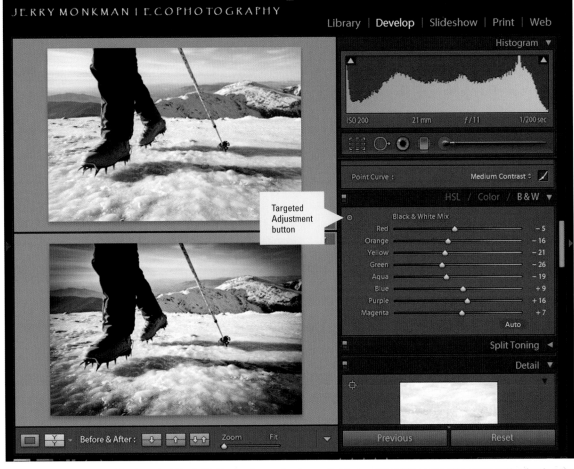

Converting an image to black and white in Lightroom is as simple as clicking on "B & W" in the HSL panel and adjusting the color sliders.

show the original version of the image for just part of the photo. I'll show you both techniques with specific examples; once you master layer masks, you can use them to make changes that are limited only by your imagination.

The most common reason I use layer masks is to combine two images to simulate the use of a graduated split neutral density filter. I will do this when I don't have my filter with me in the field or when the light is changing so fast that I don't want to take the time to get the filter out of my camera bag. For this technique to work, you have to plan in the field by shooting two exposures, one that properly exposes your highlights (blocking up the shadows) and one that properly

exposes your shadows (blowing out your highlights.) Though Photoshop has a feature that will auto-align two photos, it is easier and works better if you lock your camera in place on a tripod between photos. Also, when shooting, adjust your exposure by changing the shutter speed, not your aperture (which will change the depth of field between shots, making it hard to combine them well). Here are the Photoshop steps:

1. Open both images.
2. Copy the bright exposure and paste it onto the dark exposure. The quickest way to do this is to place the image windows side by side and activate the Move tool (by pressing the "V" key). Now, click and drag your bright

image onto the dark image while holding the shift key (this aligns the photos). Your dark image will now look like the bright image, and you should see two layers in the layers palette of the dark image. (The layers palette is in the lower right of the screen—if you don't see it click on the Window–Layers menu item.) You can now close the brighter image.

3. A layer in Photoshop will cover up the layer underneath it, which is why all you will see right now is the bright version of the image, which is on top of the dark layer. This bright layer should be the active layer (it will be highlighted in blue), but if it's not, click on the top layer in the layers palette to select it. To add a layer mask to this layer, click on

This is the Brush tool.

This is the Gradient tool.

Make sure these squares are black and white, with black on top. If they're not, press the "D" key.

Here's the Layer Mask button

I opened these two photos in Photoshop so I could combine them using a layer mask. I wanted the foreground from the top photo and the sky from the bottom photo. These images were shot on a tripod (so they would align perfectly) with the same f-stop. I adjusted the shutter speed between exposures to capture foreground details in one and sky details in the other.

the Layer Mask icon at the bottom of the layers palette. It is a gray rectangle with a white circle in the center. Your bright image layer should now show a white rectangle in the layers palette, which represents the layer mask.

4. Hit the "D" key to set your foreground color to black. Now you can create a hole in the bright layer to reveal what is underneath by adding black to the layer mask. This can be done a number of ways: You can use the Brush tool and paint black over the areas where you want to reveal what's underneath. You can also select areas of the photo using the various selection tools, and then fill the selection with black (using the Edit–Fill menu command). By changing the opacity of the Paint or Fill tools, you can fine-tune the blending of the two layers, revealing part of the bottom layer while retaining part of the top layer. This is basically the same as painting with varying shades of gray. For an image with a well-defined horizon, you can take advantage of this fact by using the Gradient tool to draw a black-to-white rectangular gradient over the layer mask, simulating the use of a graduated split neutral density filter. The Gradient tool works

When drawing a gradient on a layer mask, be sure you select the black-to-transparent gradient in the gradient toolbar.

much like the Grad Filter in Lightroom and ACR. With the tool active, click and drag down near your horizon line, creating a black-to-transparent gradient on your layer mask. Like when using the Grad Filter in Lightroom, everything above where you first clicked will be pure black, while everything below where you let go of the mouse button will be left untouched, with a gray gradient in between. Of course you won't see the black-and-gray gradient, you will see the bottom photo showing through the mask in varying strength. It can take a few tries to get your combined image to look right, and you may need to fine-tune your mask using the paintbrush. You can always remove parts of the mask by painting in white (you can switch your foreground color between black and white by pressing the "X" key), effectively re-covering the bottom image. As you create your mask, you will see the Layer Mask icon on your layer change to show the black and gray that you have added.

The above steps describe creating a layer mask using two different photos, but you can also add a layer mask to an adjustment layer. When you make an adjustment like adding a curve or changing the color balance, you can add the adjustment as a layer so that you don't permanently affect the original pixels in the image. By using an adjustment layer to make these sorts of changes, you can always go back and change the adjustment or delete it completely. Whenever you add an adjustment layer to an image, it automatically has a layer mask attached to it, so as soon as you add the layer you can start painting in black to specify the mask. You can add an adjustment layer in Photoshop in two ways: by using the Layer–New Adjustment Layer menu option, or by clicking on one of the adjustment

In this example, I added a black-and-white layer adjustment and then painted a hole in the layer mask to reveal the color version of the mountain biker. Layer masks are automatically added when you create a new adjustment layer, so this technique can be used for any adjustment, including curves, vibrance, and color balance.

icons in the Adjustments panel. This palette should be above your layers palette, but if you can't find it, click on Window–Adjustments.

In the example shown in the Photoshop screen shot above, I opened a color image of a mountain biker and converted it to black and white by adding a black-and-white adjustment layer. I then simply selected the Paintbrush tool, set my foreground color to black, and painted over the biker and his bike, effectively cutting a hole in the mask and revealing the original color image that was hidden by the black-and-white adjustment layer. One key to painting a mask such as this is to use a brush with a feathered outline so that you get a natural look around the edges of objects you are painting. To do this, click on the arrow next to the brush size in the brush toolbar (see screen shot) or right-click on

the image to open up the Brush Preset Picker. In this window, set the Hardness slider to 0 to get a nice feathered edge on your paintbrush. You can adjust the brush size by hitting the bracket keys on your keyboard. The left bracket reduces the size of your brush, and the right bracket makes the brush bigger. This shortcut works for most similar tools in Photoshop and Lightroom. If you accidently paint over an area that you meant to keep as is, switch your foreground color to white and paint away your mistake.

High Dynamic Range Photography

High Dynamic Range, or HDR, photography has become popular during the past several years due to the introduction of specialized software that combines two or more exposures of a scene to increase the dynamic range of the photo. The technique I outlined above in which you combine two exposures of an image using a layer mask is a crude form of HDR processing. That technique works well when there is an obvious demarcation between the bright parts of a scene and the shadow areas. However, with many scenes, objects such as trees and buildings create so many edges that creating a layer mask can be a very tedious process. Thankfully, HDR software solves that problem by automatically blending shadow detail from bright exposures with highlight details from darker exposures.

Creating good HDR photos starts in the field. If you encounter a scene where you can't properly expose for both highlights and shadows in one exposure, you have a candidate for an HDR photo. You'll know this when your histogram shows a spike on the right or the left (or both), and changing the exposure only shifts the problem from the highlights to the shadows or vice versa. When you encounter a situation like this, follow these steps:

1. Compose your scene and lock the camera on a tripod.
2. Focus your camera once and then turn off autofocus, as a change in focus between exposures will make it impossible to properly blend the images.
3. Shoot in RAW format for best results. If shooting JPEGs, turn off auto white balance.
4. Choose an exposure that will properly capture midtones in the scene.
5. Shoot three exposures: the mid-tone exposure, then one 2 stops brighter and one 2 stops darker. (Change your shutter speed, not your aperture.)
6. Check your histograms. If your dark exposure is still clipping highlights, take another photo 2 stops darker. If your brightest exposure is still clipping shadows, take another exposure 2 stops brighter.

Note: If the wind is blowing your subject or part of the scene is constantly moving (like crashing waves), the resulting HDR image is less likely to work.

I've used several HDR programs over the years with good success, including Enfuse (a Lightroom plug-in), Photomatix Pro, and the Merge to HDR feature in Photoshop. My current software of choice is Nik HDR Efex Pro, which does everything Photomatix (my second choice) does, plus a little extra. It works as a stand-alone program, but it can also be directly accessed from within Lightroom and Photoshop as a plug-in.

After I've imported my images into Lightroom, I select a series I shot for HDR processing and use the File–Export with Preset menu option and select HDR Efex Pro (Photomatix works the same way), without making any develop changes in Lightroom except synchronizing the white balance settings. This opens HDR

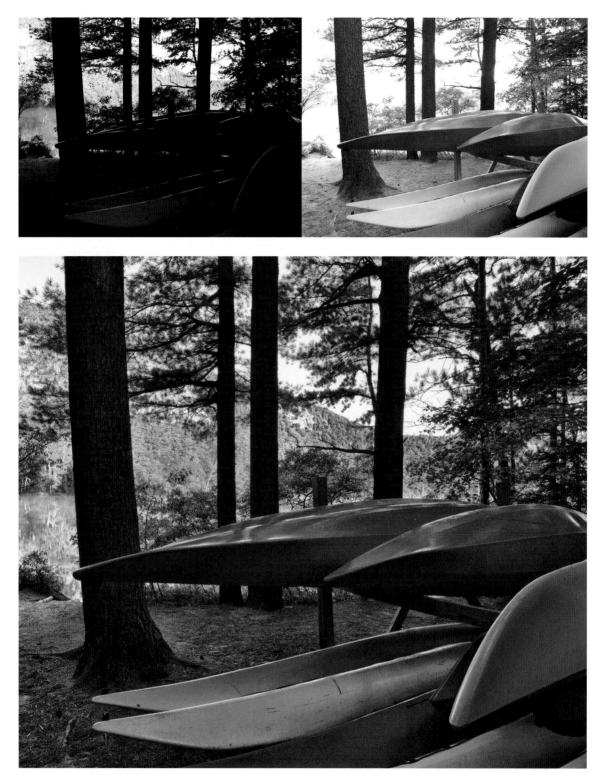

Capturing the tonal range from the highlights on the distant cliffs to the dark tree trunks in shadow was impossible in one exposure or with a graduated split neutral density filter, so I shot 4 exposures at F11, with shutter speeds of 1 second, 1/2 second, 1/8 second, and 1/30 second. I then used Nik HDR Efex Pro to combine all four images into one HDR photo.

USING LAYER MASKS IN PHOTOSHOP ELEMENTS

Layer masks for pixel layers have just been introduced in Photoshop Elements 9.0. However, if you are using a previous version, you will find that you can use a layer mask only with adjustment layers, which means you can't easily combine two photos and use a layer mask to simulate a split neutral density filter. However, there is a work-around technique that makes it possible. To give this a try, start by following the same steps I outlined for Photoshop: Open your two images, and copy the bright version onto the dark version. Like in Photoshop, in Elements you will see the two versions of your image in separate layers in the layers palette. Since you can't add a layer mask to your top layer, follow these steps:

1. Add any adjustment layer (I'll use Layers in this example, but any adjustment will do because you won't actually make any adjustments) by using the Layer–New Adjustment Layer–Levels menu option. When the Levels pop-up window appears, just click OK without making any adjustments.

2. The Levels adjustment layer will now be at the top of the layers palette. Click on this layer and drag it down so it is between your two image layers.

3. Click on your bright image layer, which should now be the top layer in the layers palette again. Once it is highlighted, click ctrl-G or command-G, which will group this layer with the Levels adjustment layer.

4. Click on the Levels adjustment layer so it is highlighted. You'll notice that like in Photoshop, Elements created a layer mask when the adjustment layer was created.

5. Use the Paint, Fill, and/or Gradient tools to refine your mask, just as in Photoshop. Since your top image layer is grouped with the adjustment layer, the layer mask now affects both layers.

By placing an adjustment layer between your two pixel layers in Photoshop Elements, and grouping the adjustment layer with the top pixel layer, the layer mask on the adjustment layer will apply to the top layer as well.

On the left of the Nik HDR Efex Pro interface are thumbnails that represent different preset options. On the right are the Adjustment panels that let you change the HDR settings. In this image, I've placed a control point in the center where I can make localized color and tone corrections.

Efex Pro, which spends a few minutes processing the images into an HDR composite. The program's interface opens with a starting version of your HDR image in the center of the screen, with options on the left and right that let you fine-tune the photo. On the left is a series of thumbnails showing how the image will look using various presets. These presets range from natural-looking composites to surrealistic and gritty interpretations that look more like illustrations than photographs. I like to keep things looking as natural as possible. My favorite preset is 02 Realistic (Balanced).

After starting with a preset, you can make further refinements using the Adjustment panels on the right side of the screen. The first slider in this section is called Tone Compression, which basically changes the strength of the HDR processing. Moving it to the right darkens highlights and brightens shadows, while moving it to the left does the opposite. The Global Adjustment sliders are similar to those in the Basic panel in Lightroom or ACR. The only slider that is different is Structure, which is similar to clarity, increasing local contrast and bringing out more detail in a photo. By playing with the HDR Method menu and Method Strength slider, you can get almost any look you want.

The next section, Selective Adjustments, is what sets Nik HDR Efex apart from other HDR programs, because it lets you apply those global adjustment sliders to only a select portion of your image. You can add one or more "control points" to your image, adjust the size of that control point, and make adjustments like exposure, structure, and method strength to the area defined by that control point. This is a very powerful way to fine-tune an image.

Other features you will need to use when you have movement in the scene between exposures

are Alignment and Ghost Reduction, which are accessed by clicking on the button above the main image. With the alignment box checked, the program will attempt to fix misaligned images (this actually works pretty well, so it is possible to hand-hold your HDR exposures as long as your shutter speeds are fast enough to offset any camera shake). The Ghost Reduction option will attempt to account for things moving in your photo. The Global option is meant for large objects (like people) moving between exposures, while Adaptive works with things like blowing tree branches and rolling waves.

Panorama Photography

Many landscape scenes work best as a panorama, a format in which a photograph is much wider than it is tall. Before digital, making panorama photographs meant using a camera specifically designed to make these wide images over two and a half to three frames of film. With photomerge software, it is now possible to use any camera, make several images, and stitch them together into one large panorama.

If you have Photoshop or Photoshop Elements, you already have software that can stitch images together. If not, you can use a specialized program called Panorama Maker by ArcSoft. All do a good job if you follow some basic shooting guidelines in the field:

1. Use a tripod. While you can hand-hold a series of images and stitch them together fairly well, you'll have greater success if you use a tripod and a bubble level. (To be even more precise, you can buy one of several tripod heads designed to rotate around the nodal point of the lens, which reduces the occurrence of parallax distortion between images. These heads are expensive, and I find that today's software is pretty good at compensating for this distortion, especially with medium-length telephoto and longer lenses. However, if you want to make a lot of panorama images with wide angle lenses, you may need to invest in a specialized tripod head.)

2. Focus the camera once and then make sure autofocus is turned off. If you are shooting in JPEG mode, be sure to use the same white balance for each photo in your series.

3. Set your exposure using manual exposure mode and don't change exposure settings between shots.

4. Shoot your series of images, making sure each image overlaps the previous one by 25 to 50 percent—this gives the software more pixels to work with when aligning the images.

5. Import the images to your computer, then use Adobe Camera RAW or Lightroom to make any tone and color adjustments to one image. Synchronize those changes to all the images in the series.

6. Open your series of images in Photoshop using the File–Automate–Photomerge menu option. (In Photoshop Elements, the command is File–New–Photomerge Panorama.) You can also select your series of images in Lightoom's Library module, and use the Photo–Edit In–Merge to Panorama in Photoshop menu option, which will automatically open the images in Photoshop's Photomerge window.

7. Select your source files in the Photomerge window (if not already selected by Lightroom) and choose a layout option. (I find the Auto layout option works for most images, but if you shot your images with a wide angle lens, you may need to experiment with some of the other options, as well as check the Geometric Distortion Correction box at the

bottom of the window.) Once your files are selected and you've chosen a layout option, check the box for Blend Images Together and click OK.

Depending on how many images you are stitching together, the size of your image files, and the processing power of your computer, Photoshop will spend the next 1 to 15 minutes doing the work needed to stitch your images together. Once it's done, your panorama will probably have uneven edges unless you used a panorama tripod head and your camera was perfectly leveled. If the image looks strangely distorted, try the process again using another layout option (the Perspective option often works well). If all looks well, crop your image to even out the edges, and use the Layer–Flatten Image menu option to combine your layers (there will be a separate layer for each individual shot) into one. This will greatly reduce the file size of the image.

You can combine as many images as you want using this technique, and you don't have to stick with the standard horizontal format. You can make vertical panoramas this way, as well as stitch together a series of images with several rows and columns, effectively making a large-format image.

Objects that move between exposures can make it tough to create a good panorama (like with HDR photos). Scenes with moving water

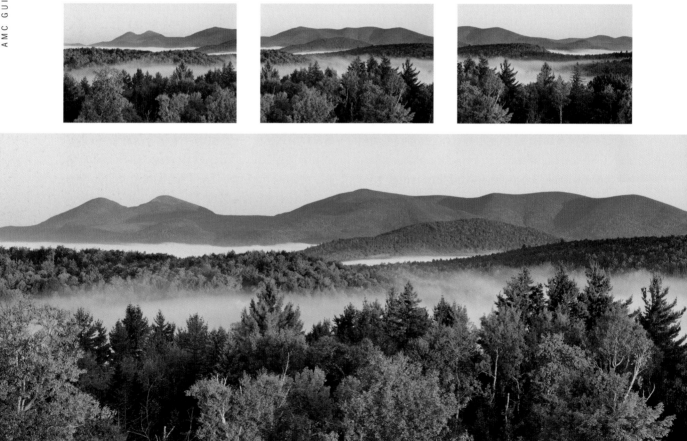

To make this panorama of fall in northern New Hampshire, I made five exposures, each overlapping subsequent images by about 30 percent. (Note: When Photoshop stitches a series of images like this together, it usually creates uneven edges that need to be cropped.)

or fast-moving clouds are particularly challenging, and in some cases the only way to get a good panorama of these subjects is to go "old school" and use a panorama film camera that captures the scene in one exposure.

Extended Depth of Field. Software makes it possible to combine a series of images to create a final image with greater depth of field than is possible in a single exposure. This technique involves shooting several frames of a subject with each frame focused at a different point in the scene. It is not as widespread as HDR or panorama processing, but is becoming popular among macro photographers since the high level of magnifica-

tion in macro photography inherently has a very narrow depth of field. (See "Macro Photography and Depth of Field," page 33.) However, you can use this technique on landscape images too.

Photoshop's Auto-Blend feature can combine images in this way, but I find it often creates results that need a lot of cloning and fine-tuning after the fact. Instead, I use a specialized program called Helicon Focus. Another popular program is Zerene Stacker. Each costs less than $100.

Like other composite techniques, stacking photos for extended depth of field requires that you plan and shoot a series of images in the field with the composite goal in mind. (Use the steps on the following page.)

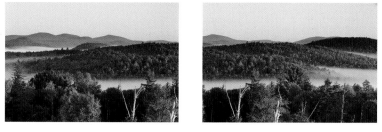

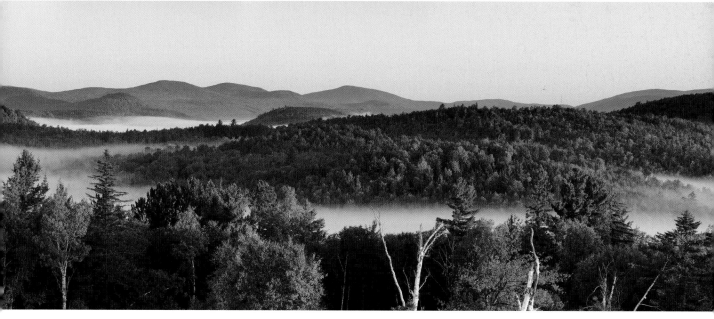

1. Compose your scene and lock the camera on your tripod.

2. Shoot in RAW format for best results. If you are shooting in JPEG mode, be sure to use the same white balance for each photo in your series.

3. Shoot a test exposure (shoot in manual exposure, using a small aperture like F11 or F16). Check your histogram and adjust.

4. Focus on the part of the scene closest to you that you want in focus in your resulting image.

5. Make additional images, focusing farther into the scene for each exposure and finishing with an image that is focused at a point farthest from the camera that you want in focus. Depending on the scene, you will need anywhere from four to ten shots. Be sure not to change your exposure settings between shots. Note that if the wind is blowing your subject around, it will be very hard to make a successful image.

You can select your series of images from within Helicon Focus or select them in Lightroom and export to Helicon Focus, which will automatically open with your image series ready to go. Helicon Focus is fairly simple to figure out, and it also has an excellent help function to guide you. There are two basic steps you need to take. First, click on the Files tab and check off the images that you want to use in your composite, from the filmstrip on the right side of the screen. Then click on the Parameters tab, and choose a Parameter (Method B is the one I usually use) from the Parameters panel on the lower right side of the screen. Click the Run button on the top right of the screen to start the process. The program combines the images with a series of layer masks. For some images, you may notice halos or softness around some of the detailed edges in the scene, but you can control this by using the Radius and Smoothing sliders in the Parameters panel.

Here's what to do if you want to try this in Photoshop (unfortunately, this feature is not available in Elements): Use the File–Scripts–Load Images into Stack menu option to bring up a window where you can choose your image files (in Lightroom, select your images then use the Photo–Edit In–Open as Layers in Photoshop menu option). This opens all of your images as one image, with each original image in a separate layer. Select all of the layers by clicking on the top layer then holding down the shift key and clicking on the bottom layer (they should all be highlighted in blue now). Use the Edit–Auto Blend Layers menu option to bring up the Auto Blend Layers window. Click on Stack Images and Seamless Tones and Colors and then click OK.

Image Sharpening. A RAW image file has some inherent softness and needs sharpening before printing (and sometimes for online display as well) to better define the edges within the photo. (I am talking about sharpening images that are perfectly focused and not about images that are blurry because of camera movement or poor focus—I delete those!) If you shoot in JPEG mode, the camera applies whatever sharpening level you specify in the camera settings, and these images may or may not need sharpening in post-processing.

Lightroom and ACR give you sharpening options in the Details panel. For most of my images, I leave this at the default setting (Amount=25, Radius=1.0, Detail=25, Masking=0). This applies an appropriate amount of what is called "capture sharpening," which sharpens an image just enough for you to be able to make good decisions when making tone and color changes. With these defaults, your images will

In Helicon Focus, load your series of images after clicking on the File tab. Next, click on the Parameters tab. Select a method (Method B works with most images). Nature images with fine details look best with a low level of radius (3–6). A high level of smoothing creates sharper images, but produces artifacts. Lower smoothing will have fewer artifacts, but may be softer. Start with 3 or 4. Once you've selected your parameters, click on the Run button to create your image.

The four images above were original exposures, all shot at F16, but focused at different distances—note the shallow depth of field in each image. The image below has both flowers in focus and was created by stacking the original four images in Helicon Focus.

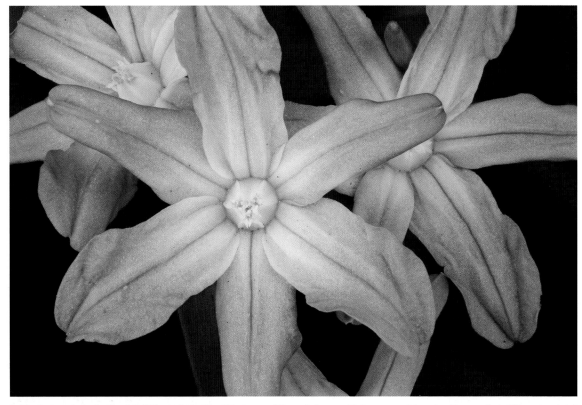

Achieving enough depth of field in a photo like this is possible only by combining several images (focused at different points) with photo stacking software.

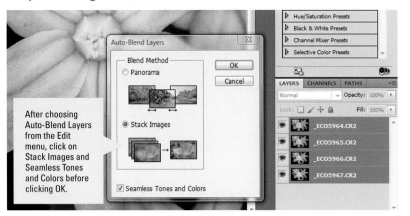

After choosing Auto-Blend Layers from the Edit menu, click on Stack Images and Seamless Tones and Colors before clicking OK.

In Photoshop, you can open a series of images into one document and then use the Auto-Blend Layers command to combine them into an extended depth of field composite.

automatically have capture sharpening applied when they are accessed by Lightroom or ACR. However, you want to apply additional sharpening when you are preparing an image for output, whether as a print or for online display, because how much you sharpen an image depends on the size of the final image file. For example, an image displayed online in low resolution will need less sharpening than a 4″ x 6″ print, which in turn will need much less sharpening than a 20″ x 30″ print. This is called "output sharpening."

When I make low-res images (600 to 1200 pixels wide) for web display or e-mailing, I'll just check off the Sharpen for Screen option in the Export dialog in Lightroom. Low-res files don't need much sharpening, and this option does an excellent job on most images. The Lightroom Print module also has a "print sharpening" option when printing images directly from Lightroom. I find this also works well for many images up to about 8″ x 12″ in size. For bigger prints and for images that need more nuanced sharpening, I open the photo as a TIFF in Photoshop and use the Unsharp Mask filter.

Unsharp Mask is a term left over from the film darkroom, when a blurred version of a photo was used as a mask to give the appearance of a sharper photo when enlarged. A digital version of this technique has been in Photoshop almost since the beginning, and it is still

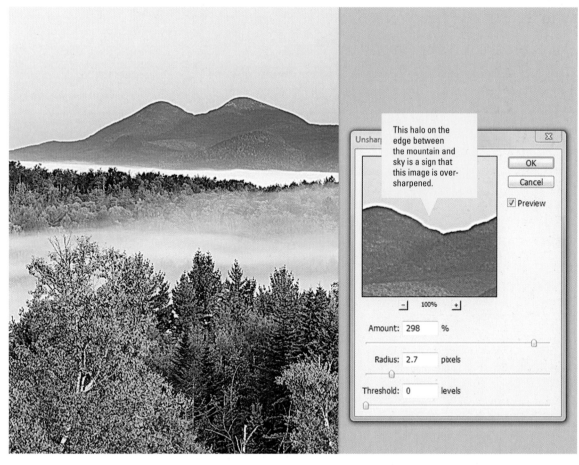

When sharpening, be sure to look at your photograph at **100** percent or larger and look for halos on edges within your image—a telltale sign of oversharpening.

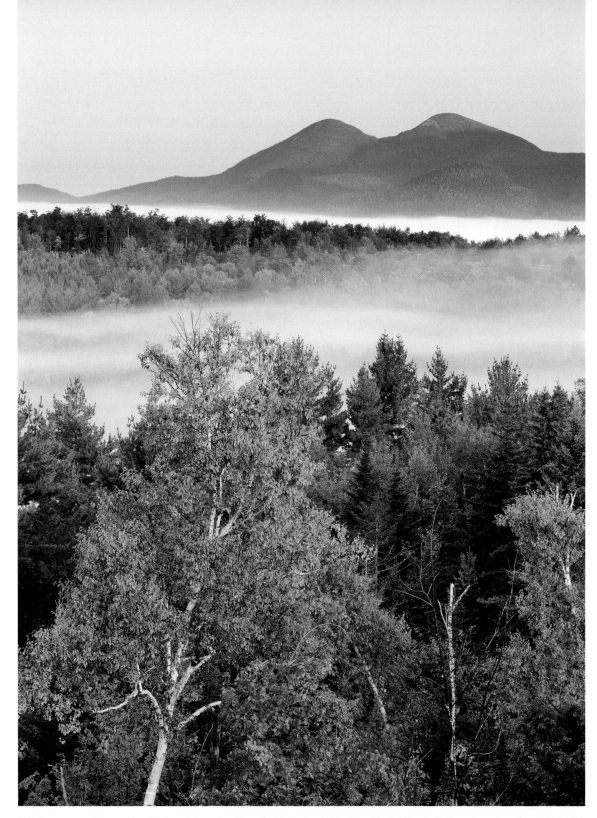

This image was sharpened using two different settings in Photoshop's Unsharp Mask filter. Left: Here I used an Amount of 152, a Radius of 1.0, and a Threshold of 0—this is properly sharpened. Right: This version was sharpened with an Amount of 395, Radius of 2.8, and Threshold of 0—this is oversharpened. Notice the halo along the edge between mountains and sky and the breakdown of color in the trees, caused by the extra contrast added by too much sharpening.

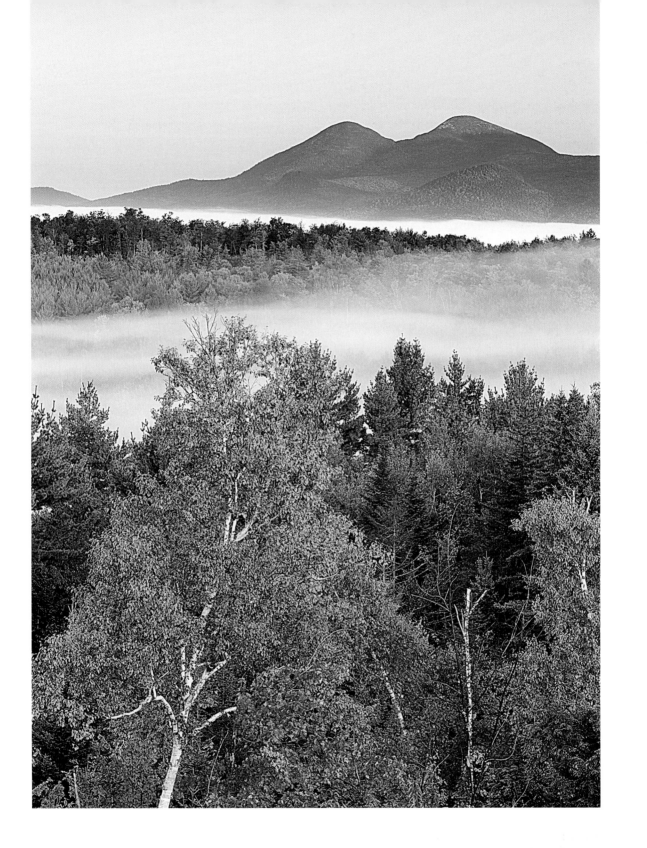

my preferred method for sharpening an image. Applying sharpening should be your last step before outputting an image, so do any color and tone corrections first. Then resize the image to the desired output size and use the Filter–Sharpen–Unsharp Mask menu option to bring up the Unsharp Mask window.

This window contains a 100 percent preview of a small portion of the image, and three sliders: Amount, Radius, and Threshold. Adding to the Amount and Radius sliders will increase sharpening, while Threshold will decrease sharpening. For most digitally captured images (as opposed to film scans), I use a Radius between 1 and 2 and a Threshold of 0, and then adjust the Amount slider to increase or decrease the sharpening effect. For film scans, increasing the Threshold setting can reduce the amount of sharpening applied to any grain in the image. My goal with sharpening is to move the Amount slider to the right until the image looks sharp and crisp, but before it starts to look oversharpened. If you see halos around the edges in the 100 percent view, you have gone too far. Oversharpened images can start to look like they have too much contrast in highly detailed areas. These areas will also begin to lose some of their color—I always check my images at both the 100 percent detail level and in full-screen mode to make sure my sharpening is having the desired effect.

After sharpening with the Unsharp Mask filter, you can make further adjustments by choosing Fade Unsharp Mask from the Edit menu. By changing the mode to luminosity, the filter is applied only to detail areas of the photo based on luminosity as opposed to color. This results in fewer halos, allowing the image to take more sharpening than would otherwise be possible.

Once you apply the Unsharp Mask filter and save your image, you can't undo the sharpening.

However, there is a way to make the filter non-destructive. Before applying the filter and with the background layer selected, use the Layer–Smart Objects–Convert to Smart Object menu option. Then apply the Unsharp Mask filter, which will appear in the layers palette as a smart filter. You can then go back at any time, double-click on Unsharp Mask in the layers palette, and refine your sharpening controls (or delete the filter altogether).

If you choose to sharpen using the Sharpening sliders in Lightroom or ACR, you will find slightly different controls than in the Unsharp Mask filter. The Amount and Radius sliders are the same, increasing sharpening as you move them to the right. The Detail slider mainly increases sharpening on fine-detail edges. I tend to keep the Radius set to 1 and adjust Amount and Detail to add sharpening. The Masking slider looks for areas of the photo without edges and masks them out so that they are not affected by the sharpening applied by the other sliders. Increasing masking will reduce the amount of sharpening done to any noise found in continuous-tone areas in an image. Hold down the alt (command) key while using the sliders to see which edge areas are being affected.

Noise Reduction. Depending on what camera you are using, shooting at a high ISO (800 or higher for newer cameras) will introduce noise, which is most noticeable in continuous-tone areas in the midtones and shadows. Using the Fill Light and/or Blacks sliders to bring out shadow detail will also introduce noise. The noise might not be visible in small prints or at the standard-size preview on your monitor; before making large prints, zoom in to at least the 1:1 view to check for noise.

Noise-reduction controls have been available in Lightroom and Adobe Camera RAW (ACR)

for several years, but it wasn't until the introduction of ACR 6.0 and Lightroom 3.0 that quality noise reduction was possible in these programs. Before then, serious noise reduction could be done only in separate software like Noise Ninja, but Lightroom and ACR are now adequate for most images.

In ACR and Lightroom, you will find the Noise Reduction sliders just below the Sharpening sliders in the Details panel. There are two sets of sliders, one for luminance noise and one for color noise. Luminance noise looks similar to film grain—little black and gray specks—while color noise looks like tiny colored dots. The default setting for the Color Noise slider of 25 seems to take care of color noise in most images, but by moving the slider farther to the right you can remove any remaining color noise that might

be present in an image. To remove luminance noise, move the Luminance slider to the right.

Reducing noise will soften your image by varying amounts, and even make some objects take on the look of plastic. To counter this effect, you can use the Detail and Contrast sliders. By moving the Detail slider to the right, you reduce the amount of noise reduction in fine details, which brings back some of the sharpness in those details. Moving the Contrast slider to the right will reintroduce contrast that may have been lost when moving the Luminance slider.

Like with sharpening, every image requires a different amount of noise reduction. If you are new to this technique, I suggest going out and shooting a batch of images at ISO 1600 or higher, and trying the different noise-reduction sliders on a variety of images to see the results.

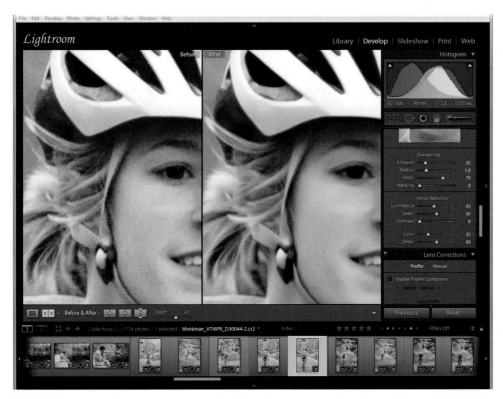

Shot at ISO 1600, this image had a moderate amount of noise in the shadows and continuous tones in the background, which can be seen in the 1:1 view of the image on the left. Applying a luminance noise reduction value of 38 did a good job of smoothing out this noise, while using a Detail slider setting of 50 preserved enough of the details for the image to still appear sharp.

SECTION 5 ▶ CASE STUDIES

IN THIS SECTION, I HAVE CHOSEN fifteen images to use as case studies, to provide some insight into how I take all the concepts in this book and put them together to create a photo. You will see that sometimes a photo is a simple capture of a moment in time, while others take more forethought, field techniques, and post-processing skills.

A full moon rises over Chauncey Creek in Kittery, Maine.

Subdivisions encroach on wetlands near the mouth of the Connecticut River in Old Saybrook, Connecticut. Original, bottom right.

1. TAKING A GRAPHIC APPROACH

Camera Settings: 24–70mm lens set to 30mm, ISO 400, F3.2, 1/1600 second.

This image was part of a substantial photo documentary project I shot about the Connecticut River watershed for the Trust for Public Land and The Nature Conservancy. I was interested in photographing urban sprawl and how it is slowly eating away at the watershed habitat. This scene of a subdivision next to wetlands in Old Saybrook illustrated this concept well. I shot the photo from a small airplane with the door taken off so I did not have to shoot through a window, which can introduce all kinds of problems, especially glare reflecting off the window. Most small planes have only a lap belt, so if sitting next to an open door while flying with just a lap belt makes you uncomfortable, you should opt for a plane where you can simply open the window to shoot. Also, hire a pilot who has experience flying photographers, as they often know how to position the plane for the best photos. It can get pretty loud in a plane with the window or door open, so it is imperative that the pilot has a working headset you can wear so you can indicate where to position the plane.

When shooting aerials, I try to get the fastest shutter speed possible (1/800 second or faster) so I can keep my images sharp despite hand-holding and engine vibrations. I also keep the camera inside the cabin so it's easier to hold steady against the wind rushing by the window or door. Since depth of field isn't much of an issue when shooting from 1,000 feet above the ground, I use a large aperture (F3.2), which lets me use a shutter speed of 1/1,600 second at ISO 400. For this particular scene, I wanted to highlight the rich greens of the wetlands and the graphically interesting lines created by the tidal creeks. The forested island in the center of the wetland also adds to the symbolism of wilderness surrounded by development.

Post-Processing: Since this image was shot in mid-day light with a strong blue cast, I added some warmth and green with the White Balance sliders in Lightroom to bring out the lush green of early summer in the wetland. I also used a clarity setting of +50 to enhance the details in the landscape.

136

Morning mist rises from the Connecticut River in Massachusetts's Pioneer Valley. Original, top right.

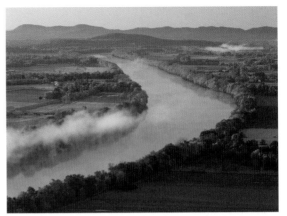

2. REVISITING A CLASSIC

Camera Settings: 70–200mm lens set to 120mm, ISO 100, F16, 1/5 second.

This view of the Connecticut River from Mount Sugarloaf in Deerfield, Massachusetts, is a popular one for photographers; this photo is a fairly straightforward interpretation of a classic subject. The curve of the river adds a dynamic element to the photo and provides a leading line that the viewer can follow to the distant mountains. I chose to shoot this scene at sunrise for two reasons. Since we were in a stretch of beautiful fall New England weather with warm days and cool nights, I was hoping to capture some fog by rising early, and was rewarded with a few wisps of mist rising from the river. Second, shooting in Golden Hour light enhanced the warm colors of what little fall foliage was left and provided low-contrast light that allowed me to retain detail in both my highlights and shadows, which was important for showing the agricultural setting of the scene.

Post-Processing: My original exposure was slightly underexposed, so I added +60 to the Exposure slider in Lightroom. I also bumped up the Vibrance to +33 and added a strong contrast curve to give the colors in the image a little more pop.

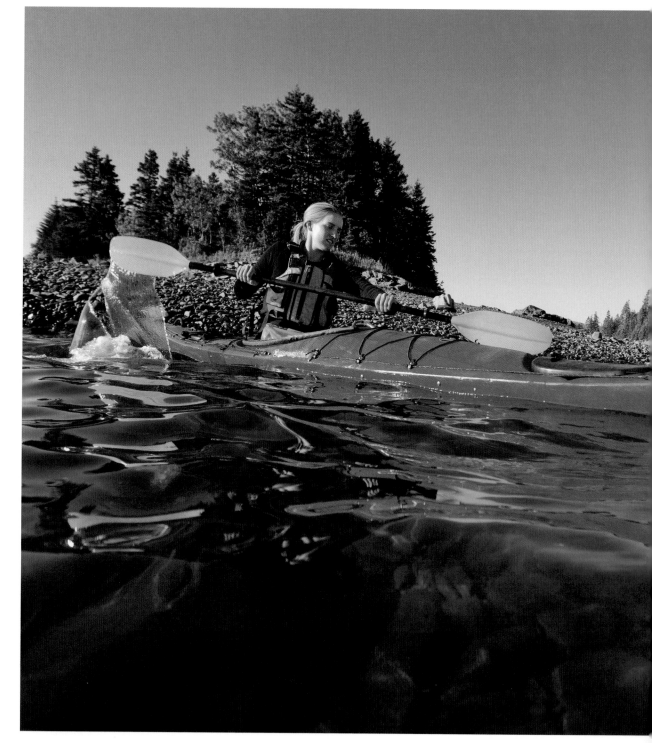

A sea kayaker paddles in the bright sun of early morning. Original, top right.

3. CAPTURING THE ENERGY

Camera Settings: 16–35mm lens set to 16mm, ISO 200, F5.6, 1/400 second.

To capture the motion and energy of sea kayaking, I decided to shoot this image from a low angle, which required me to stand belly-high in the water and crouch down to look through the camera near the water level (fortunately, it was a warm summer day). There's no other way to be looking up at a paddler (unless you're underwater), but this perspective made the woman and kayak more prominent while also filling much of the frame with red reflections from the boat. (I had seen these reflections while paddling next to my subject and I realized I needed to get in the water to capture them well.)

Post-Processing: While we started this particular shoot before sunrise, by the time of this photo, the sun had been up for an hour and the light had lost its golden qualities. The extra contrast of the higher sun led me to make a few post-processing changes in Lightroom to make the image more pleasing. First, I reduced the overall exposure by a little more than half a stop. After doing that there were still some blown-out highlights on the lettering on the boat as well as on part of the model's face, so I dragged the Recovery slider to 38. I then added a little bit of fill light (15) to bring out details in the darker areas of the photo. Lastly, I moved the Vibrance slider to +50, which increased the saturation in the sky and trees without having much effect on the already saturated red kayak. Finally, I added a slight crop to the photo to remove some unnecessary blank space on the left side of the image.

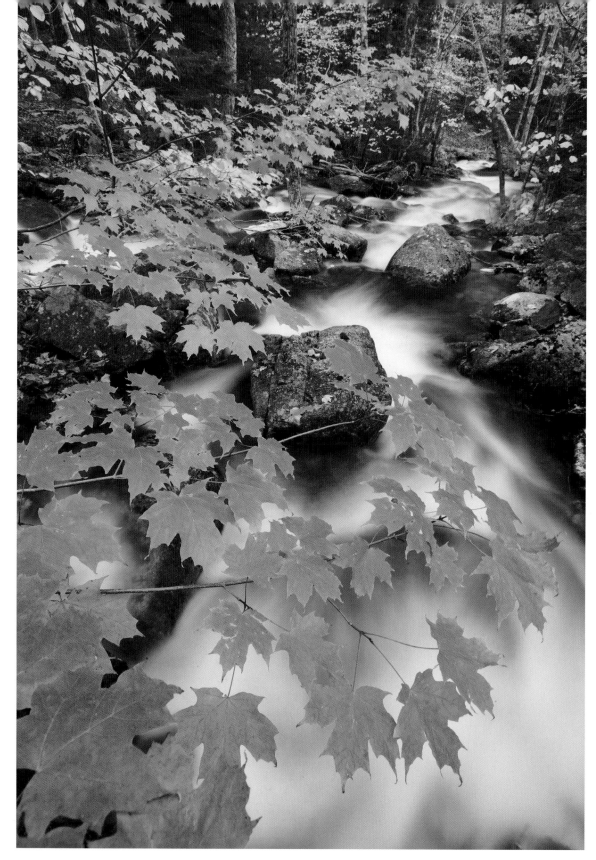

The orange leaves of a sugar maple tree reach over Jordan Stream in Maine's Acadia National Park. Original, right.

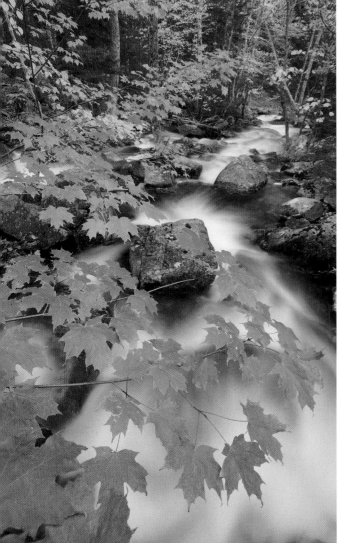

4. MAKING THE BEST OF THE WEATHER

Camera Settings: 16–35mm lens set to 18mm, ISO 100, F16, 6 seconds, polarizer.

This image combines the dramatic colors of fall with the rushing waters of a stream to create a dynamic interpretation of autumn in a New England forest. The year I made this photo, a week of rain and wind had knocked many of the leaves off of the sugar maples in Acadia National Park, making it impossible to find sweeping vistas that captured the essence of foliage season. However, the constant cloud cover provided ample opportunity for making photos, and the diffuse light worked perfectly for rendering the color found along Jordan Stream.

When first composing this image, I used a tree trunk beside the stream to anchor my shot and add depth to the photo, but those first compositions seemed to be lacking the vibrant colors I was hoping to use to tell the story of peak foliage season—overall the color was too muted. The bright-orange leaves of this small maple tree caught my eye, so I worked to reposition the camera in a way that featured this color. I planted my tripod on a rock in midstream and placed it high enough that I could point my camera down and fill more of the image with orange leaves. I used a polarizer to reduce glare on the leaves and the stream, which resulted in a shutter speed of 6 seconds with an aperture of F16. This gave me plenty of depth of field and created a pleasing blur in the rushing water of the stream. My position also created a strong diagonal line in the image in the form of the stream. It took several tries to get this shot because the wind was blowing the limbs of the maple and blurring the leaves.

Post-Processing: In Lightroom, I added some pop to the colors by moving the Contrast slider to +40 and the Vibrance slider to +20, and added a strong contrast curve.

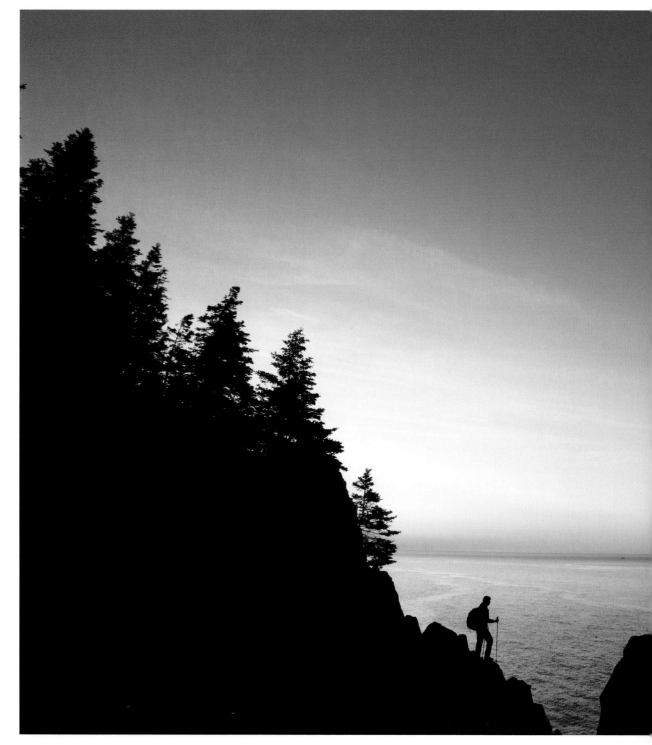

A hiker looks to the sea at dawn on the "Bold Coast" in Cutler, Maine. Original, top right.

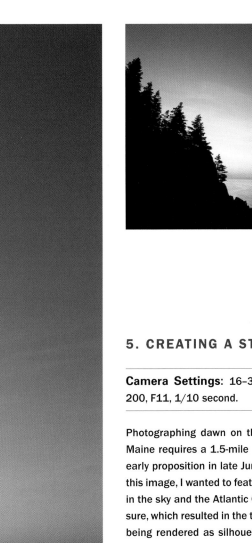

5. CREATING A STORY

Camera Settings: 16–35mm lens set to 16mm, ISO 200, F11, 1/10 second.

Photographing dawn on the "Bold Coast" of Down East Maine requires a 1.5-mile hike in the dark, which was an early proposition in late June when I made this photo. For this image, I wanted to feature the saturated predawn light in the sky and the Atlantic Ocean, so I used a darker exposure, which resulted in the trees and rocks on the shoreline being rendered as silhouettes. I included just enough of the trees and sky to show their outline without filling the frame with too much black space. This resulted in a very simple composition—which I decided was too simple. To add more of a story to the image, I used my camera's self-timer and photographed myself as a silhouette against the blue of the ocean. I included my presence as a small part of the image to define the scale of the scene. I also enhanced the sense of wide-open space by using a very wide angle lens.

Post-Processing: In Lightroom, I made no changes other than using the RAW processing defaults I had previously set up for my camera.

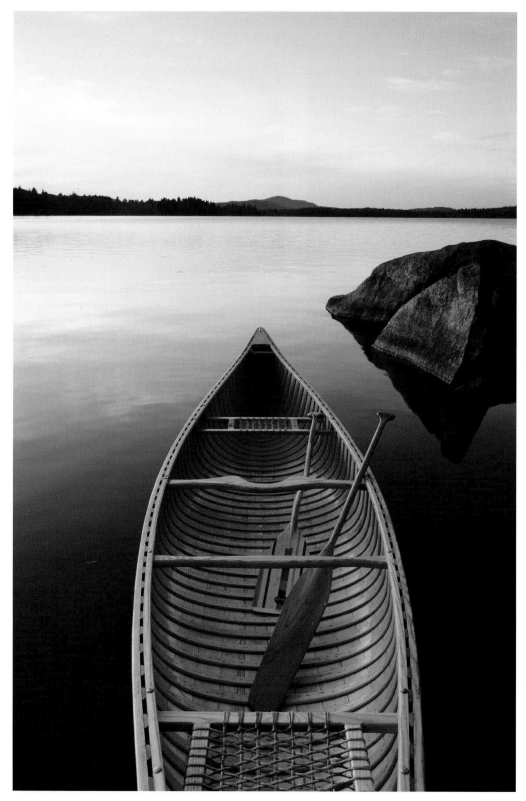

A wooden-canvas canoe rests at the shoreline of a peaceful lake. Original, right.

6. COMPOSING CAREFULLY

Camera Settings: 16–35mm lens set to 29mm, ISO 400, F16, 1/5 second, 2-stop graduated split neutral density filter.

This beautiful canoe dominated several of my photos during a three-day canoe camping trip. By placing the camera directly over the canoe, I was able to feature the detail of its wood construction. The boat also anchored this wide angle view of the scene, giving viewers the feeling that they could step right into the boat. Placing my horizon in the top third of the frame further featured the boat and stretched out the scene, adding depth. In order to keep the pastel colors in the sky from being overexposed, I used a 2-stop graduated split neutral density filter, which allowed me to keep those sky colors while retaining detail in the boat.

Post-Processing: In Lightroom, I found my exposure was a little too dark, so I moved the Exposure slider to +40. I also enhanced the warmth of the wood in the boat by moving the Temperature slider from 5000 to 5765. Lastly, I boosted the colors by using a Vibrance setting of +25 and a Saturation of +11.

7. TAKING ADVANTAGE OF TIME AND PLACE

Camera Settings: 24–70mm lens set to 70mm, ISO 100, F22, 5 seconds.

This is one of those photos that was unplanned. I had spent a couple of days searching for iconic landscape photos and had been stymied by poor weather. While hiking to a small outcropping to check out the views, I found this small stream in a patch of forest where sugar maple leaves had carpeted the forest floor. I noticed a small whirlpool in the stream and decided to shoot some long exposures to blur the leaves in the stream. I used a polarizer to reduce glare on the stream and enhance the color of the leaves. This filter also helped slow down my shutter speed, which I got to 5 seconds using the minimum aperture on my lens, F22. Shooting digitally was a big plus for this shot, as I was able to see the effect of the blur right on the spot. It took about ten tries to get this particular shot where the blurring leaves formed a circle.

Post-Processing: Once I brought the image into Lightroom, I decided to reduce the overexposure by .76 stops, which darkened the water and added some color saturation to the leaves. I increased the color saturation by moving the Vibrance slider to +38 and the Saturation slider to +15. Lastly, I added a strong contrast curve, which further defined the difference in tonality between the bright leaves and the darker water and rocks.

Fallen leaves swirl in a small stream. Original, top left.

8. REGAINING COLOR

Camera Settings: 70–200mm lens set to 100mm, ISO 100, F11, 0.3 second.

This scene of New Hampshire's Presidential Range had all the elements for a beautiful photograph: Golden Hour light on alpine peaks, fog covering the valley floor, and vibrant fall colors. By using a 100mm focal length, I slightly compressed the scene so I could include the foreground trees and fog while making the distant peaks look big enough to show the drama I was seeing in the scene. I probably should have used a graduated split neutral density filter to bring out more detail in my foreground while retaining details in the sky, but I had made one of those early-morning, pre-cup-of-coffee mistakes and left the filter in my car. Fortunately, the dynamic range of the scene was narrow enough that I could get both highlight and shadow detail in one exposure, which let me make some important changes in post-production.

Post-Processing: On the computer, the image looked much less vibrant than what I saw while making the shot in the field. I made several changes in Lightroom to get to the finished image. None of the changes was big, but the sum of these changes produced a much more colorful image. First, I increased the overall exposure by half a stop. I then added two grad filters, one that darkened the sky by half a stop, and a second that brightened the foreground by half a stop. I also used the White Balance tool, clicking on the bark of the birch tree in the bottom of the frame, which slightly warmed the scene and added back some magenta that was important for bringing out the color of alpenglow on the peaks. My last change was adding a strong contrast curve to give the image some pop.

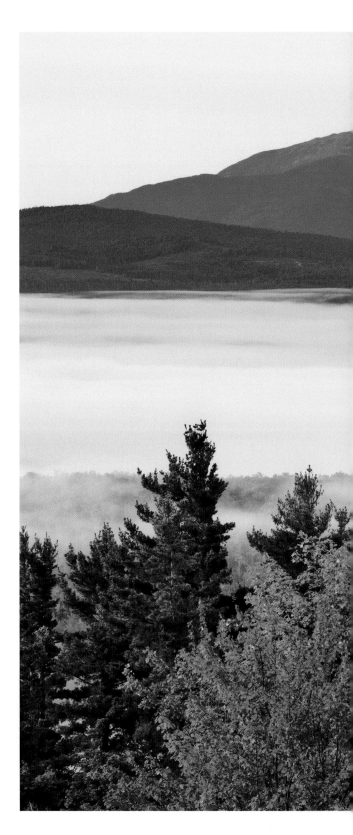

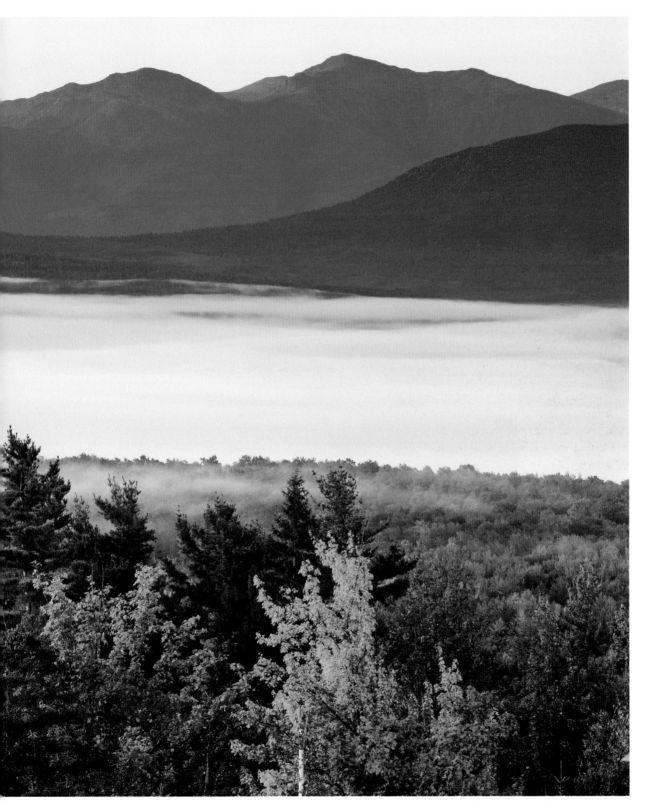

Morning fog fills the valley in this fall view of the Presidential Range in New Hampshire's White Mountains. Original, top left.

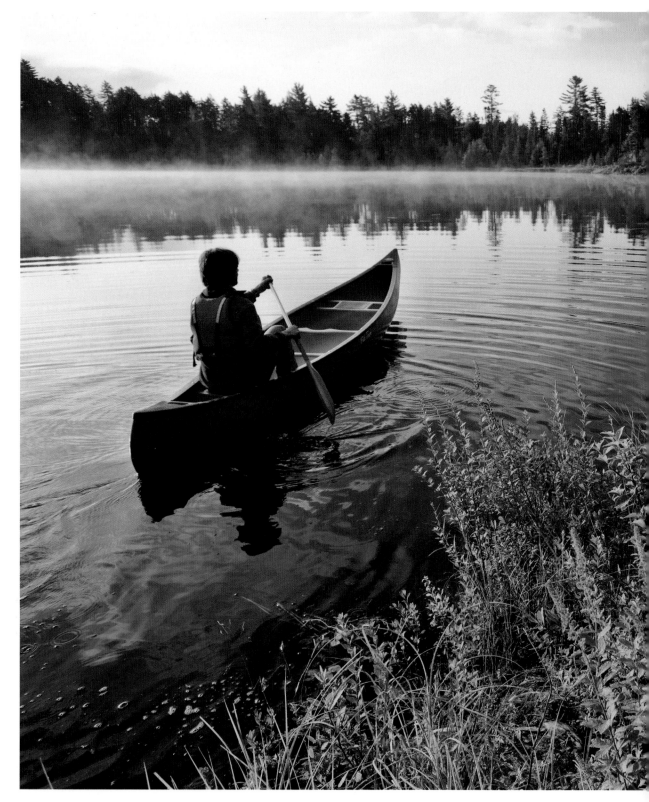

A man paddles a canoe on a small pond just after sunrise. Original, top right.

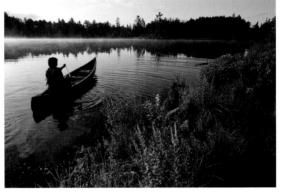

9. MODELING

Camera Settings: 16–35mm lens set to 22mm, ISO 200, F8, 1/320 second.

When I set up my camera to shoot this early-morning scene of a remote pond, I was excited about two elements: the pink wildflowers on the shoreline and the mist rising from the pond. I positioned my camera so that the shoreline created a nice diagonal line in the right third of the frame, but I still found the image lacking in impact. I decided including a paddler would turn a decent-looking scene into a good story image. Being alone, I had to be the model, so I used a special cable release called an intervalometer to set up the camera to take one picture every second while I got in my canoe and paddled around. Of the 200 or so photos that resulted, this one had me positioned in just the right place to complete the photo. Also, because I was using a very wide angle lens (22mm), I was able to get good depth of field stopping down to only F8, which meant I could keep my ISO relatively low and still get a fast enough shutter speed to stop the action.

Post-Processing: Even though the sun had been above the horizon for only about 45 minutes, by shooting in a direction close to the sun, I had some trouble with the exposure. It was impossible to retain detail in the brighter parts of the image in the upper left without making the canoe too dark. I was able to fix this in Lightroom by moving the Fill Light slider to +29 and using the Adjustment Brush set to +.50 to paint over the shadow areas on me and the canoe. I also moved the Recovery slider to +11 to recover a small amount of lost highlight detail. Lastly, I warmed up the scene by moving the Temperature slider from 5450 to 5929.

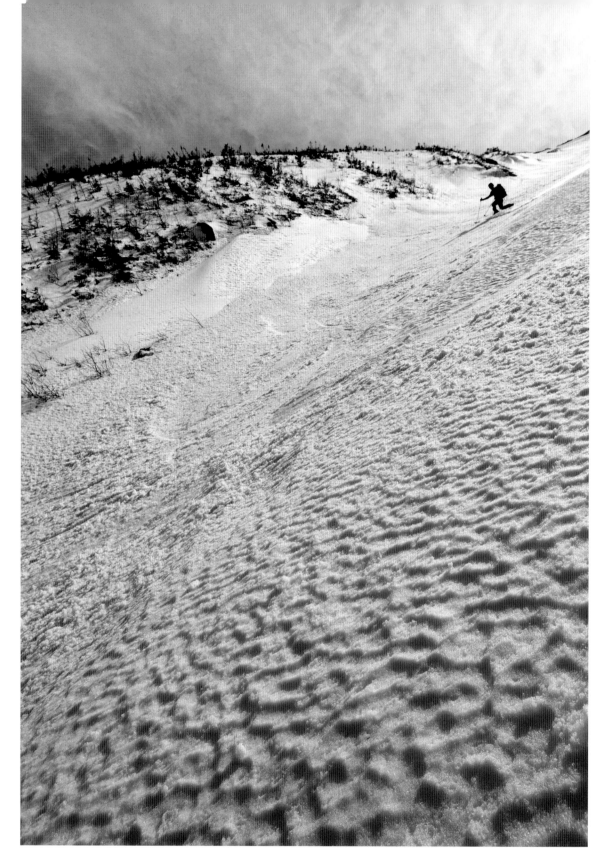

A backcountry skier descends King's Ravine on New Hampshire's Mount Adams. Original, right.

10. USING BLACK AND WHITE

Camera Settings: 24–70mm lens set to 24mm, ISO 200, F9, 1/800 second.

The biggest challenge to making this photo was hiking the steep headwall of this ravine in deep, soft spring snow. In terms of photography, one challenge was the relatively harsh mid-day light. I knew the skier would be in shadow and appear as a silhouette against the bright white of the snow. However, because I kept him small in the frame and captured a classic telemark turn, the silhouetting worked well; the skier adds to the story and defines scale. By using a wide angle lens and placing my horizon in the top third of the scene, I was also able to create a sense of place that features the deep-furrowed texture of the snow.

Post-Processing: I felt the mid-day light looked kind of bland in the color version, so I converted this image to black and white in Lightroom by clicking on B & W in the HSL panel, and then added a strong contrast curve. The strong contrast in this scene works well in black and white, which, combined with the telemark turn, gives this image a historical mood.

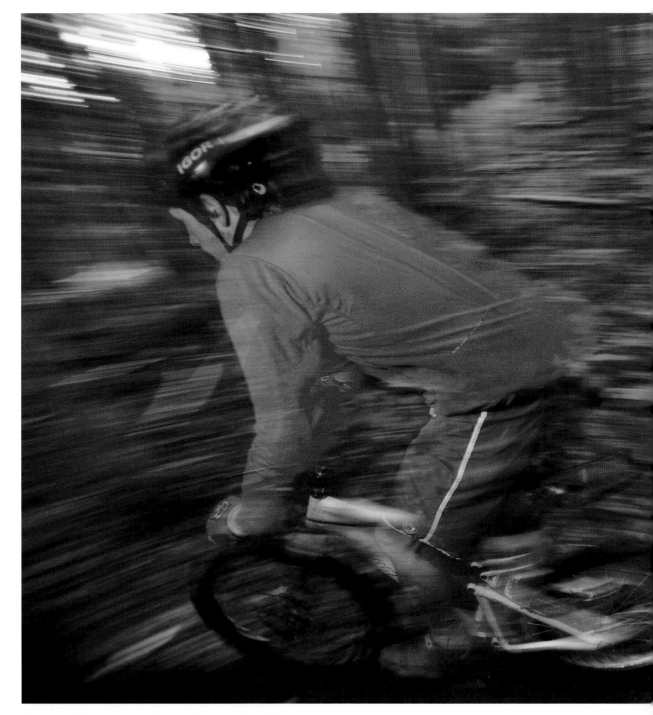

A mountain biker traverses a forest trail. Original, top right.

11. WORKING WITH THE LIGHT

Camera Settings: 16–35mm lens set to 16mm, ISO 640, F2.8, 1/25 second, fill flash set to -1.0 stop.

Photographers shooting adventure images in a forest have to find enough light to stop the action, which is difficult, especially on a dark, overcast day like the one I encountered on this photo shoot. In this case, it was so dark I decided not to try to stop the action, but instead to create motion blurs by panning the camera. For this shot, I used a very wide focal length (16mm) and asked the mountain biker to ride past me as close as he felt comfortable doing, which gave me the unique perspective present in the photo. Fortunately, he was wearing a red shirt, which helped to separate him from the background, but I also added some fill flash (holding the flash above and to the right of the camera) to increase this separation and to add a little more definition to the rider and his bike. I chose a shutter speed of 1/25 second after experimenting with different settings and checking the blur effect on my LCD.

Post-Processing: In Lightroom, I used the White Balance tool and clicked on the gray frame of the bike, which warmed up the photo quite a bit. I also added a little extra Vibrance (+24) to further enhance the red shirt and green foliage.

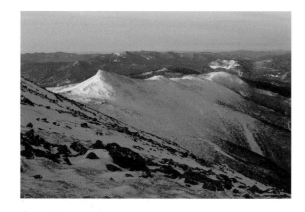

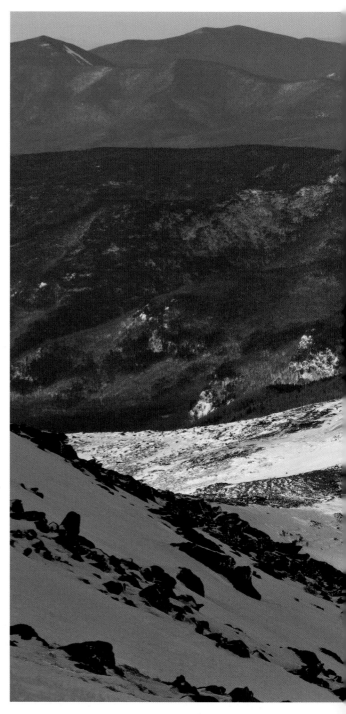

12. RECOMPOSING TO CREATE DRAMA

Camera Settings: 70–200mm lens set to 95mm, ISO 100, F16, 1/40 second.

I took this photo in winter, about an hour after sunrise. At northern latitudes, the winter sun stays lower in the sky than during the summer months, creating nice shadow light for longer periods of time. When I first composed this image, I was interested in the long alpine ridge covered in snow stretching from left to right in the scene. However, I felt this wider-view interpretation lacked the drama I was feeling in this mountain environment. By switching to a longer focal length, I was able to isolate the craggy summit of Mount Monroe set against a backdrop of receding mountain ridges.

Post-Processing: The auto white balance from the camera created a cold, blue mood that I liked and kept in post-processing. I enhanced it by increasing the Vibrance to +40 and the Saturation to +8.

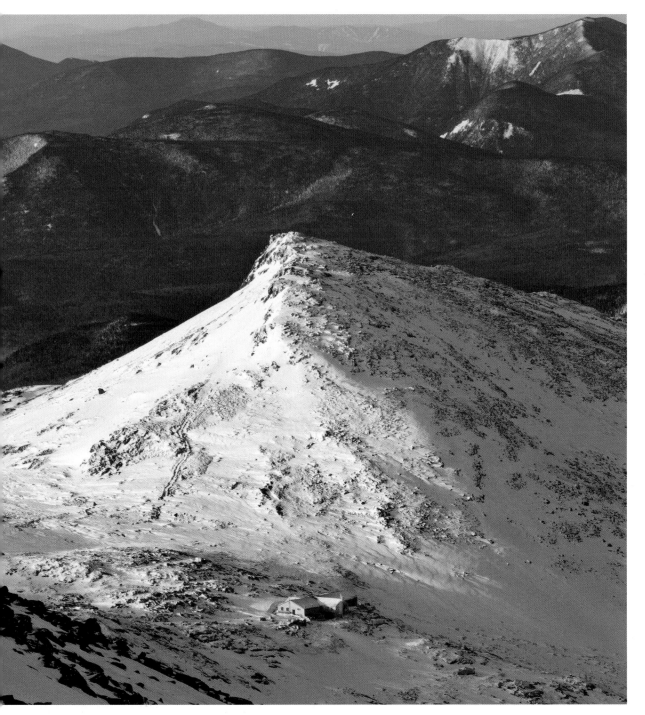

Morning light touches the Appalachian Mountain Club's Lakes of the Clouds Hut at the base of New Hampshire's Mount Monroe in winter. Original, top left.

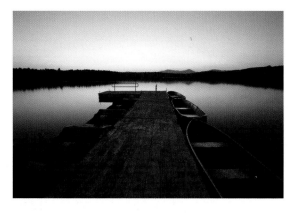

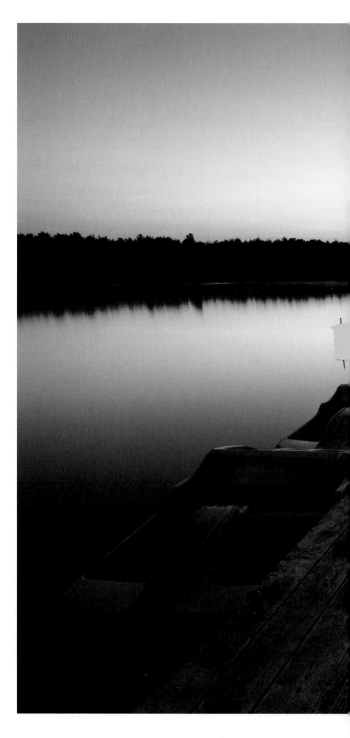

13. WAITING FOR THE LIGHT

Camera Settings: 16–35mm lens set to 16mm, ISO 100, F16, 2 minutes.

Sometimes, the most interesting light happens well before sunrise or after sunset. The beautiful blue and oranges in this photo were captured about 30 minutes after a late-summer sunset. I used a wide angle lens with the horizon placed at the top of the frame to extend the depth of the photo and give the viewer the sense of standing on the dock.

Post-Processing: The original image was a little too dark in the foreground so I added a Grad Filter in Lightroom to brighten the bottom two-thirds of the frame about 1/3 of a stop. I added a second Grad Filter to darken the sky by about the same amount and moved the Vibrance slider to +50 to further enhance the colors.

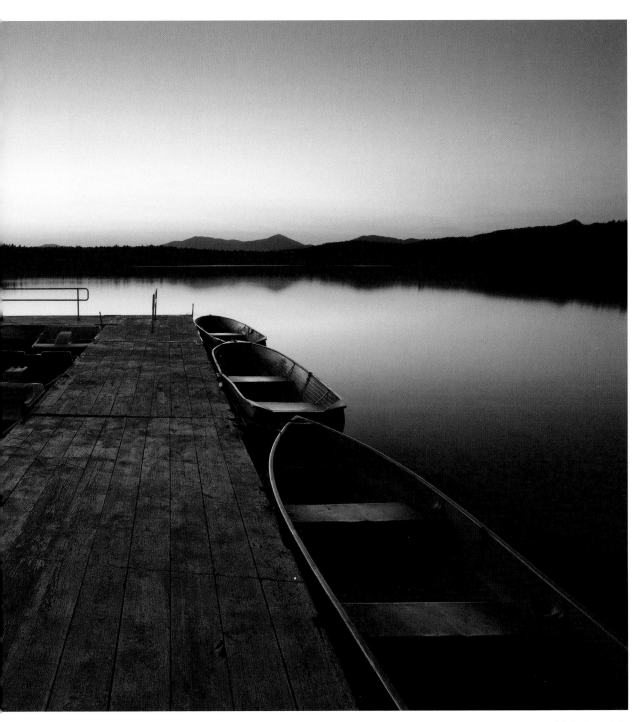

Sunset falls across boats and a dock. Original, top left.

Fall colors frame this gravel road in Vermont's Green Mountains. Original, right.

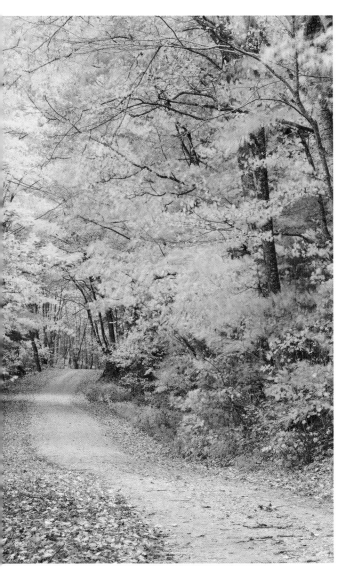

14. HARNESSING THE WIND

Camera Settings: 70–200mm lens set to 140mm, ISO 100, F16, 4 seconds, polarizer.

Kelly Stand Road, which traverses the Green Mountains in southern Vermont, is a favorite place for photographers looking to get that classic look of a gravel road during fall in New England. On the day I made this shot, occasional rain was accompanied by 30 mph wind gusts. The overcast light was ideal for creating a saturated look during foliage season, but the wind made it impossible to capture sharp images of the blowing leaves. I decided to use the wind to my advantage by using a slow shutter speed and letting the leaves blur as much as possible. The polarizer subtracted 2 stops of light, which helped slow my shutter speed in addition to reducing glare on the leaves.

Post-Processing: I liked the resulting photo, but it needed a little help in Lightroom. First, I enhanced the warmth of the scene by moving the Temperature slider from 4000 to 4619. There was also a gap on the left side of the histogram, so I increased Blacks to 19, which added contrast, saturating the colors. The change to Blacks darkened the overall look of the image slightly, so I then increased the Exposure slider to +20. I also felt that while the leaves in the trees were blurry, they could look even softer. To accomplish this, I used the Adjustment brush, set Clarity to -100, and painted over the trees in the scene. This blurred the leaves further while leaving the road sharp.

Sun streams between paper birch trees. Original, top right.

15. FOREST LIGHT

Camera Settings: 24–70mm lens set to 43mm, ISO 200, F11, 1/50 second.

Shooting in the forest in direct sunlight can be a challenge because of the high contrast between highlights and shadows, but it can be done if the sun is low enough in the sky, as in this image, which was shot about an hour before sunset. I spent a fair amount of time searching this stand of birch trees for a composition that would be simple enough while retaining the patterns of repeating birches. The leaves were moving slightly in the gentle breeze, so I increased my ISO to 200 to get a shutter speed fast enough to stop the movement while still giving me enough depth of field to keep the birch trees in the background sharp.

Post-Processing: Even with the relatively low angle of the sun, my resulting exposure had both pure black shadow areas and blown-out highlights (on the edges of the birch trees). In Lightroom, I moved the Recovery slider to 32 to recover the blown-out highlights and used a Fill Light setting of 40 to brighten the forest details. This gave the image a flat look, so I added some blacks back in to the image by moving the Blacks slider to 15. I also adjusted the White Balance to add warmth to the scene and bring out a little extra green in the fresh spring buds. I finished by moving the Vibrance slider to +57, which saturated the green in the image nicely without bringing out too much blue in the shadows.

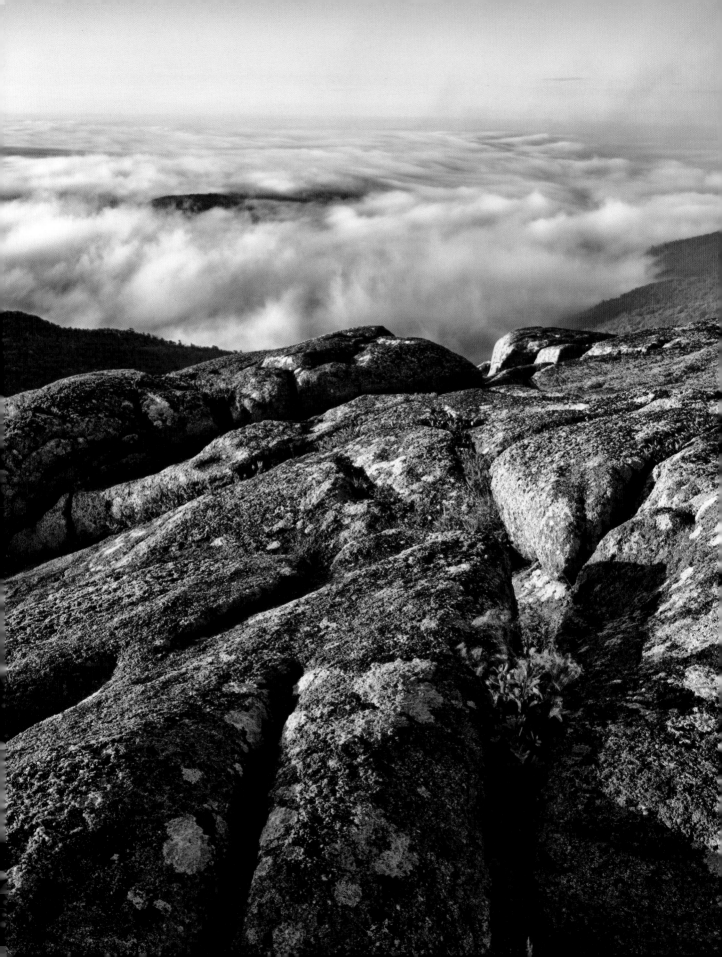

ONLINE GEAR REVIEWS, FORUMS, AND HOW-TO'S

Digital Photography Review, dpreview.com
Photography news, camera and lens database, gear reviews, gear forums.

Rob Galbraith Digital Photography Insights, robgalbraith.com
Photography news, gear reviews, memory card reviews.

NatureScapes, naturescapes.net
Nature photography articles and forums.

Nature Photographers Online Magazine, naturephotographers.net
Nature photography articles, forums, and online courses.

The Luminous Landscape, luminous-landscape.com
Landscape photography articles, tutorials, and forums.

North American Nature Photography Association, nanpa.org
Nature photography forums.

Strobist, strobist.blogspot.com
Blog with resources for learning to use flash in the outdoors.

ONLINE PHOTOGRAPHY CLASSES

Nature Photographers Online Magazine Courses, naturephotographers.net/onlinecourses

BetterPhoto, betterphoto.com

Kelby Training, kelbytraining.com

ONLINE SOFTWARE TUTORIALS

Kelby Training, kelbytraining.com

Adobe Photoshop Lightroom Killer Tips, lightroomkillertips.com

Julieanne Kost, Senior Digital Imaging Evangelist, Adobe Systems, jkost.com

Adobe TV, tv.adobe.com

Lynda Weinman and Bruce Heavin, lynda.com

DESKTOP AND SMARTPHONE APPS

The Photographer's Ephemeris, photoephemeris.com
Desktop or iPhone app that calculates sunrise/sunset and moonrise/moonset times and locations.

LightTrac, lighttracapp.com
iPhone and Android app that calculates sunrise/sunset and moonrise/moonset times and locations.

PhotoCalc, adairsystems.com/photocalc
iPhone app that calculates depth of field, flash exposure, and sunset/sunrise times.

Animoto, animoto.com
Desktop and iPhone app that automatically creates slideshows of your photos, and adds a soundtrack.

Morning fog rises in the distance, as seen from the summit of Maine's Cadillac Mountain. (This is a three-exposure HDR composite image.)

MotionX, motionx.com
> iPhone and Android app that lets you use your phone as a GPS and store GPS tracks that can later be used to geotag your photos.

Audubon Guides, audubonguides.com/field-guides/mobile-apps
> Audubon field guides in app form for iPhones and Android phones.

PHOTO SOFTWARE RESOURCES

Adobe, adobe.com
> Software such as Photoshop, Lightroom, and more.

Nik Software, niksoftware.com
> Specialized software for using digital filters, creating HDR photos, sharpening photos, or converting color images to black and white.

Topaz Labs, topazlabs.com
> Specialized software for making tone and color corrections, performing noise reduction, and sharpening photos.

HDRsoft, hdrsoft.com
> Photomatix HDR software.

ArcSoft, arcsoft.com
> Panoramamaker photo stitching software.

HeliconSoft, heliconsoft.com
> Software for combining images to extend depth of field.

Zerene Stacker, zerenesystems.com/stacker
> Software for combining images to extend depth of field.

Photographer's Toolbox, photographers-toolbox.com
> Plug-ins that add to the features of Lightroom.

Jeffrey Friedl, regex.info/blog/lightroom-goodies
> Blog with more plug-ins that add to the features of Lightroom.

PictureCode, picturecode.com
> Noise Ninja noise reduction software.

PHOTO SHARING AND STORAGE WEBSITES

Flickr, flickr.com
> Noncommercial photo sharing site (like Facebook for photographers).

Photobucket, photobucket.com
> Noncommercial photo sharing site with photo competitions.

Picasa, picasaweb.google.com
> Noncommercial photo sharing site.

Photoshelter, photoshelter.com
> Commercial online photo storage that offers e-commerce options for photographers and integrates with photographers' websites.

SmugMug, smugmug.com
> Commercial online photo storage that offers e-commerce options for photographers and integrates with photographers' websites.

Zenfolio, zenfolio.com
> Commercial online photo storage that offers e-commerce options for photographers and integrates with photographers' websites.

MANUFACTURER WEBSITES

Cameras
Canon, canon.com
Nikon, nikonusa.com
Sony, sonystyle.com
Olympus, olympusamerica.com
Panasonic, panasonic.com

Lenses
Sigma, sigmaphoto.com
Tokina, tokinalens.com
Tamron, tamron-usa.com

Memory Cards
Sandisk, sandisk.com
Lexar, lexar.com
Delkin, delkin.com

Filters
Singh-Ray, singh-ray.com
Lee, leefilters.com
B + W, schneideroptics.com/filters

Tripods and Heads
Kirk Photo, kirkphoto.com
Gitzo, gitzo.us
Manfrotto, manfrotto.com
Feisol, feisol.net
Really Right Stuff, reallyrightstuff.com
Wimberly, tripodhead.com

Lighting Accessories
LumoPro, lumopro.com
Metz, metz.de/en
Photoflex, photoflex.com
Sunpak, sunpak.jp/english
Lumiquest, lumiquest.com
Gary Fong, garyfongestore.com

Camera Packs
Clik Elite, clikelite.com
LowePro, lowepro.com
Cotton Carrier, cottoncarrier.com
Think Tank, thinktankphoto.com

Camera Covers
Vortex Media, stormjacket.com
AquaTech, aquatech.net
LensCoat, lenscoat.com
Camera Armor, cameraarmor.com

White Balance
ExpoDisc, expoimaging.com
WhiBal, whibal.com
SpyderCube, spyder.datacolor.com/product-cb-
 spydercube.php

RAID Storage
Drobo, drobo.com
Buffalo, buffalotech.com

Monitor Calibration
Spyder3Pro, spyder.datacolor.com/index_us.php
X-Rite, xrite.com

Monitors
NEC, necdisplay.com
Apple, apple.com/displays
Eizo, eizo.com
LaCie, lacie.com

APPENDIX B ▶ RECOMMENDED READING

Clevenger, Ralph, *Photographing Nature: A Photo Workshop from Brooks Institute's Top Nature Photography Instructor*, Berkeley: New Riders Press, 2010.

Frye, Michael, *Digital Landscape Photography: In the Footsteps of Ansel Adams and the Great Masters*, Burlington, Ma.: Focal Press, 2010.

Peterson, Bryan, *Understanding Exposure, 3rd Edition*, New York: Amphoto Books, 2010.

Rotenberg, Nancy and Michael Lustbader, *Close-ups in Nature*, Mechanicsburg, Pa.: Stackpole Books, 1999.

Rowell, Galen, *Galen Rowell's Vision: The Art of Adventure Photography*, San Francisco: Sierra Club Books, 1995.

Shaw, John, *John Shaw's Nature Photography Field Guide*, New York: Amphoto Books, 2001.

Tharp, Brenda, *Creative Nature and Outdoor Photography*, New York: Amphoto Books, 2010.

As a member of the North American Nature Photography Association (NANPA; nanpa. org), I am bound by their ethical field practices. I believe all photographers should consider the welfare of their subjects to be more important than "getting the shot," and I encourage all of my readers to follow NANPA's principles:

PRINCIPLES OF ETHICAL FIELD PRACTICES

NANPA believes that following these practices promotes the well-being of the location, subject, and photographer. Every place, plant, and animal, whether above or below water, is unique, and cumulative impacts occur over time. Therefore, one must always exercise good individual judgment. It is NANPA's belief that these principles will encourage all who participate in the enjoyment of nature to do so in a way that best promotes good stewardship of the resource.

Environmental: Knowledge of Subject and Place

· Learn patterns of animal behavior so as not to interfere with animal life cycles.
· Do not distress wildlife or their habitat.
· Respect the routine needs of animals.
· Use appropriate lenses to photograph wild animals.
· If an animal shows stress, move back and use a longer lens.
· Acquaint yourself with the fragility of the ecosystem.
· Stay on trails that are intended to lessen impact.

Social: Knowledge of Rules and Laws

· When appropriate, inform managers or other authorities of your presence and purpose.
· Help minimize cumulative impacts and maintain safety.
· Learn the rules and laws of the location.
· If minimum distances exist for approaching wildlife, follow them.
· In the absence of management authority, use good judgment.
· Treat the wildlife, plants, and places as if you were their guest.
· Prepare yourself and your equipment for unexpected events.
· Avoid exposing yourself and others to preventable mishaps.

Individual: Expertise and Responsibilities

· Treat others courteously.
· Ask before joining others already shooting in an area.
· Tactfully inform others if you observe them engaging in inappropriate or harmful behavior.
· Many people unknowingly endanger themselves and animals. Report inappropriate behavior to proper authorities.
· Don't argue with those who don't care; report them.
· Be a good role model, both as a photographer and a citizen.
· Educate others by your actions; enhance their understanding.

INDEX

A fern unfurls in a Vermont forest.

ABOUT THE AUTHOR

JERRY MONKMAN IS A conservation photographer based in Portsmouth, New Hampshire. His nature and adventure photographs have appeared in magazines and books around the world, including *National Geographic Adventure*, *Outdoor Photographer*, *Audubon*, *Men's Journal*, and *National Wildlife*.

With his wife, Marcy, he has co-authored eight books, including *Discover the White Mountains*, *Discover Acadia National Park*, and *A Photographer's Guide to Acadia*.

Monkman has been teaching destination photography workshops since 2002 and is the treasurer of the North American Nature Photography Association. He is a contributor to the blog at outdoorphotographer.com and maintains two websites: ecophotography.com and jerryandmarcymonkman.com.

Appalachian Mountain Club

Founded in 1876, AMC is the nation's oldest outdoor recreation and conservation organization. AMC promotes the protection, enjoyment, and understanding of the mountains, forests, waters, and trails of the Northeast outdoors.

People

We are more than 100,000 members, advocates, and supporters, including 12 local chapters, more than 16,000 volunteers, and over 450 full-time and seasonal staff. Our chapters reach from Maine to Washington, D.C.

Outdoor Adventure and Fun

We offer more than 8,000 trips each year, from local chapter activities to adventure travel worldwide, for every ability level and outdoor interest— from hiking and climbing to paddling, snowshoeing, and skiing.

Great Places to Stay

We host more than 150,000 guests each year at our AMC lodges, huts, camps, shelters, and campgrounds. Each AMC destination is a model for environmental education and stewardship.

Opportunities for Learning

We teach people skills to safely enjoy the outdoors and to care for the natural world around us through programs for children, teens, and adults, as well as outdoor leadership training.

Caring for Trails

We maintain more than 1,500 miles of trails throughout the Northeast, including nearly 350 miles of the Appalachian Trail in five states.

Protecting Wild Places

We advocate for land and riverway conservation, monitor air quality, research climate change, and work to protect alpine and forest ecosystems throughout the Northern Forest and Mid-Atlantic Highlands regions.

Engaging the Public

We seek to educate and inform our own members and an additional 2 million people annually through the media, AMC Books, our website, our White Mountain visitor centers, and AMC destinations.

Join Us!

Members meet other like-minded people and support our mission while enjoying great AMC programs, our award-winning *AMC Outdoors* magazine, and special discounts. Visit outdoors.org or call 800-372-1758 for more information.

APPALACHIAN MOUNTAIN CLUB
Recreation • Education • Conservation
outdoors.org